ecovention

Inquires should be addressed to:

the contemporary arts center
spiral.org
115 East 5th St.
Cincinnati, OH 45202

voice: 513 . 345 . 8400
fax: 513 . 721 . 7418

ecoartspace
ecoartspace.org

voice: 845 . 440 . 0625
fax: 212 . 219 . 8636

greenmuseum.org

voice: 415 . 945 . 9322
fax: 415 . 945 . 9332

04 03 02 5 4 3 2 1

Library of Congress Cataloging-in-Publication Data

Spaid, Sue
ecovention: current art to transform ecologies
includes index
ISBN 091756274-7

1.Ecology 2.Art 3.Pollution 4.Restoration 5.Biodiversity

Book Design by Micah Hornung & Christian Wilhelmy
Seemless Design & Printing, LLC.
seemlessdesign.com

NEW LEAF PAPER
ENVIRONMENTAL BENEFITS STATEMENT

ecovention is printed on New Leaf Reincarnation, made with 100% recycled fibers, 50% post-consumer waste, processed chlorine free. By using this environmentally friendly paper, greenmuseum.org saved the following resources:

trees	water	electricity	solid waste	greenhouse gases
42 fully grown	4211 gallons	5492 kilowatt hours	11 cubic yards	6957 pounds

Calculated based on research done by the Environmental Defense and other members of the Paper Task Force.

© New Leaf Paper Visit us in cyberspace at www.newleafpaper.com or call 1-888-989-5323

ecovention

current art to transform ecologies

by Sue Spaid

This book is published on
the occasion of *ecovention*,
June 9 - August 18, 2002

curated by Amy Lipton
and Sue Spaid

Co-published by:

greenmuseum.org

The Contemporary Arts Center

ecoartspace

director's foreword

In one sense, all artists seek to change the world. To make things, even to propose ideas, is intrinsically a hopeful act. The most cynical artist, describing the least attractive alternative to the unmediated world, harbors at least a feeble hope that his dark view will prompt some transformation—whether of consciousness or of substance—that will save us all.

Yet, over the last 200 years, the artist has largely given up the role of builder, in favor of metaphor and critical analysis. Notwithstanding the cyclical revivals of interest in architecture and design as social action, to make something useful in the Modern world is more or less suspect as art.

And so it is remarkable that in one arena, at least, there are artists who have resisted the passive role of commentator, pursuing an active strategy that requires the production of concrete, positive change in the natural environment. If this book, and the exhibition it accompanies, were to do nothing more than identify a significant number of such artists it would be a noteworthy curatorial achievement. That the artists so identified have produced such ingenious, expansive and (as author Sue Spaid demonstrates here) practically and politically effective works is proof of the value of ecological intervention—"ecovention"—as a contemporary art tactic.

Any thoughtful person involved in the arts must balance his poetic concerns against the weight of Real World need. As an art museum, the Contemporary Arts Center frequently concerns itself with an international critical dialogue that may have profound implications for the way we see each other and ourselves, but can seem small in terms of the day's lead story. When, therefore, the Center engages topics of artistic relevance that also touch on the daily life of the community, as it has in this project and in many other instances, it is a matter of great pride to all of us involved in the CAC's management and governance. For the members and trustees of the Contemporary Arts Center, I express deep thanks to Sue Spaid and her co-curator, Amy Lipton of ecoartspace, for once again bringing us this pride.

Any work as complex as this project is the product of many hands. At the CAC, a small staff of unparalleled enthusiasm and ability supports every such effort with little recognition. For this project, those most involved include research intern Jessica Flores; chief preparator Tom Allison and his crew, who installed the show; and senior curator Thom Collins, who edited the book and led the team. Former CAC curator Ruth Meyer was instrumental in editing the text and providing her insight. Trustee Alice Weston, for many years one of the Center's staunchest supporters and herself an environmental artist of substantial accomplishment, was a great resource and an enthusiastic cheerleader.

The show was sponsored by the Cinergy Foundation which, under the leadership of its President, J. Joseph Hale, has made extraordinary contributions throughout the region and is certainly among the most

strategic and enlightened corporate foundations anywhere. Also supportive were the Maxwell Weaver Foundation, Federated Department Stores Foundation, Delta Airlines, and Pro Helvetia.

Terry Boling and Marc Swackhamer, architects on the faculty of the College of Design, Art, Architecture and Planning at the University of Cincinnati, contributed the innovative design of the exhibition. Christian Wilhelmy and Micah Hornung of Seemless Design created the marvelous product that the reader now holds in his or her hands.

In addition to her curatorial work on the exhibition, Amy Lipton made many material contributions to this book, gathering information and suggesting dozens of artists and securing the book's co-publisher. Sam Bower at greenmuseum.org showed such faith in the ideas presented here that he arranged for the book's funding and agreed to co-publish the book sight unseen; he has also published much additional information on the subject at the greenmuseum.org web site.

There are many contributors to this effort who cannot be individually acknowledged for lack of space; we thank them all, and recognize their share in the project's success. For their help with research and photographs we would also recognize Pam Whitten of the Harrison Studio; Peggy Kaplan and Ronald Feldman, Ronald Feldman Fine Arts; the Museum of Contemporary Art, Chicago; Allegra Raff at Alan Sonfist Studio; the Phoenix Arts Commission; Hafthor Yngvason, Director of the Cambridge (Mass.) Arts Council; Poldi Gerard, Lemna International; Nancy Thorpe, Aspen Art Institute; Joe Face, University of Cincinnati; Barbara Matilsky, University of North Carolina, Ashville; Adrian Sas, City of New York Parks & Recreation; Gwen Chanitz, Denver Art Museum; and Wendi Goldsmith, Bioengineering Group, Inc.

In Cincinnati many people assisted with logistics and research, including Glen Brand, Associate Director of the Sierra Club, Cincinnati; Cynthia Colebrook, Director of the Regional Greenspace Initiative; Holly Utrata-Halcomb, Hamilton County Soil & Water; Robin Carathers and Susan Schultz, Mill Creek Restoration Project; and Ryan Taylor, East Fork of Little Miami River Watershed Manager, Clermont County. Another reader who provided invaluable assistance was Alicia Wilhelmy.

Of course, the efforts of all these contributors would have no effect were it not for the works of the artists featured in the exhibition and book. To the artists, therefore, I extend in advance the gratitude of the many people who will profit from what they learn in this book, and of the many others who will—perhaps without ever knowing it—benefit from both the work's tangible results and its implications.

Charles Desmarais
Alice & Harris Weston Director
Contemporary Arts Center

table of contents

ecovention

introduction

getting it built

I'm very subversive, and that is why it's so important to eventually build the projects.

— Patricia Johanson[1]

Coined in 1999, the term ecovention (ecology + invention) describes an artist-initiated project that employs an inventive strategy to physically transform a local ecology. *Ecovention*, the exhibition, focuses on realized ecoventions, because artists' proposals, or "visionary fantasies," rarely change public attitudes the way novel experiences do. While *Ecovention* and its catalog cannot simulate such experiences, participants hope that a greater awareness of these projects will encourage viewers to visit these sites and invite artists to propose ecoventions for their communities. Of course, artists don't produce their projects on their own. They collaborate with community members and local specialists such as architects, botanists, zoologists, ecologists, engineers, landscape architects, and urban planners to realize and evaluate their scientifically complex projects.

ACCORDING TO
LUCY LIPPARD,
ELLEN SWALLOW RICHARDS
COINED THE WORD ECOLOGY
FROM THE GREEK WORD
FOR HOME,[2]
THOUGH MOST ATTRIBUTE THE
WORD TO 19TH CENTURY GERMAN
NATURALIST ERNST HAECKEL.

Local citizens' role as stakeholders is of paramount importance to an ecovention's survivability, since citizens are the stewards who will protect and maintain the ecovention once it's built. Of course, there are numerous fascinating stories about citizens or specialists who initially doubted the feasibility of a particular ecovention and underwent a 180-degree turn to become its biggest advocates. These are the stories this catalog discloses. So if you too have your doubts, you may be in for some surprises!

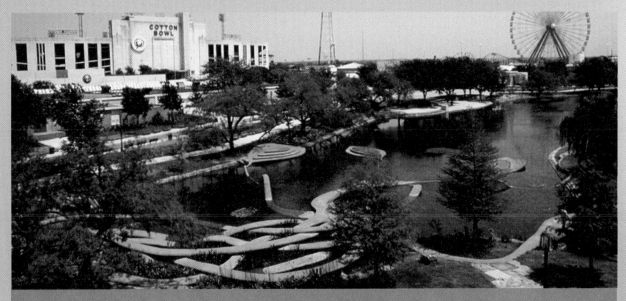

Patricia Johanson, *Fair Park Lagoon ("Saggitaria Platyphylla")*, 1981-1986, Dallas, Texas

When Johanson first visited Fair Park Lagoon, years of local lawn fertilization had washed fertilizer into the lagoon, causing algal bloom. A green slime covered the water, and there were hardly any plants or animals, let alone a sustainable food chain. Johanson's proposal to create "living exhibits" in the lagoon itself, rather than segregating natural artifacts in glass cases at the adjacent Dallas Museum of Natural History, excited the museum's scientific staff so much that they took an active interest.

As Harry Parker, Dallas Museum of Art's former director recalls, "[t]he environmental needs of turtles, fish, birds and a host of native aquatic plants were outlined. Possibilities never before considered were incorporated into the dream for a healthy new urban pond. Years of field work in Texas now paid off as lists were compiled of the localities where native aquatic plants could be collected and transplanted into the refurbished lagoon."[3]

2

There is the pesky question of why an ecovention is art and not just some aesthetically pleasing reclamation project. Co-curator Amy Lipton and I spent a lot of time discussing the "artfulness" of each project presented here. Before deciding whether to include a project in the book, we applied the same standards that we would use to judge the success of an ordinary work of art. This is why the standard of inventiveness matters. In Plato's *Symposium*, the subversive Diotima argues with Socrates about the significance of divine beauty, which entails imagination and brings forth not beautiful images, but new realities, which are presumably original or inventive. Diotima actually describes creators, such as poets and artists, who seek wisdom and virtue as deserving of the name inventor.

> But, what if man had eyes to see... divine beauty... not clogged with the pollutions of mortality and all the colors and vanities of human life... Remember how in that communion only, beholding beauty with the eye of the mind, he will be enabled to bring forth, not images of beauty, but realities... and bringing forth and nourishing true virtue to become the friend of God and be immortal, if mortal man may. Would that be an ignoble life?[4]

In this book and exhibition, the standard of inventiveness isn't only applied in relationship to art history, but in terms of current ecological practices in the public sphere. In the case of ecoventions, artists either employ or invent novel techniques that have yet to be tested in such instances. This requires them to convince communities and specialists to support their local experiments.

Helen and **Newton Harrison** (bolded names indicate the first time an artist's work or idea is referenced in this section), two of the best known eco-artists, have stressed the significance of invention. Not only do they publicly articulate the inventive aspects of each of their projects, but they believe that every artist's role is:

> to search, to discover value, to value discovery, to discover qualities of value...to bespeak those values, to be self-critical...to re-speak the values more clearly, to be self-critical again. From this process, new metaphors emerge and old ones are tested for value.[5]

As scientific experiments carried out in the context of the art world, ecoventions are able to withstand a higher level of risk than typical scientific experiments. Such experiments usually cost less as works of art and garner broad support as community-building public projects, a feature that gives ecoventions a distinct advantage over pure science. Furthermore, their success isn't judged by the artist's ultimate ability to publish the results or pay back sponsors like the National Science Foundation, as would be the case for scientists. **Mel Chin**'s *Revival Field* (1990-1993), perhaps the best known ecovention, began as an incredibly inexpensive experiment that a United States Department of Agriculture (USDA) scientist couldn't get funded. When it comes to art, sponsors don't weigh practical priorities or expect to make a profit, the way funders of scientific research do. Art is viewed as a positive contribution that makes a long-term restoration project immediately attractive to a wider audience. In the symposium that accompanied *The Natural Order* at Texas Tech's Landmark Gallery, artist **Lynne Hull** remarked:

> I would also like to suggest that ecological art will often differ from ecological restoration science in its process rather than its intent. As I said, the scientist has to go through this scientific method, which can narrow perspective, and therefore he or she can lose track of the larger picture. The artist, on the other hand, is encouraged to be wide-ranging and open to all possibilities. The artist **Mierle Laderman Ukeles** suggests that once an artist gets involved in science or some other kind of technological process, the artist can question and re-define anything at any step, and the scientist won't do that.[6]

While art/science collaborations offer certain advantages over pure science, not all artists consider artists' attempts to tackle ecological problems a positive trend. On a panel discussion in conjunction with the Seattle Art Museum's 1979 exhibition "Earthworks: Land Reclamation as Sculpture," **Robert Morris** remarked that he found it bizarre that:

> art was going to cost less than restoring the site to its 'natural condition.' What are the implications of that kind of thinking...that art should be cheaper than nature? Or that site-works can be supported and seen as relevant by a community only if they fulfill a kind of sanitation service.[7]

Only the year before, **Alan Sonfist** created *Natural and Bronze Time Enclosures* (1978) which paired a bronze branch, valued at $4, with a real tree branch, valued at $4,000, and required them to be purchased together, to demonstrate nature's intrinsic value over art. To be fair, this exploration of ecoventions doesn't aim to support the view that industry is free to pollute, since artists are relatively cheap and eager to clean up after polluters. Rather, this book introduces case-studies to elucidate the variety of approaches and range of innovations that artists are currently implementing in conjunction with their scientific and community collaborators. The following case studies illustrate an intentional and an accidental ecovention. Both began as unpredictable experiments.

Mel Chin (with Dr. Rufus Chaney), *Revival Field*, 1990-1993
Pig's Eye Landfill, Saint Paul, Minnesota

Funded by a $10,000 grant from the National Endowment for the Arts (NEA), *Revival Field* was the first experiment in the United States to use plants to absorb toxic metals from the soil. This launched the nation's burgeoning phytoremediation industry, which one business analyst predicts will be a $400 million dollar business by 2005.

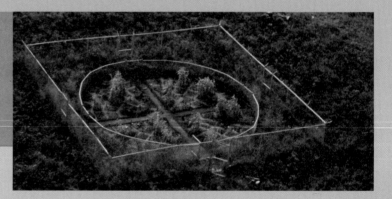

Immersed in a period of free-ranging research during the late 1980s, artist Mel Chin came upon an article about the use of plants as remediation tools and immediately considered such a process as a sculptural tool capable of bringing into reality the return of life to devastated landscape. Determining which hyperaccumulators — plants that have evolved the capacity to selectively absorb and contain large amounts of metal or minerals in their vascular structure — worked best was quite another issue. Not content to stop, he fortunately found Dr. Rufus Chaney, a USDA senior research scientist, who had proposed phytoremediation (using plants as remediation agents) as early as 1983, but never implemented a field test. The rest is both ecological and art history. While Chaney was inspired by the possibility to test this biotechnology, Chin found himself in a battle with the

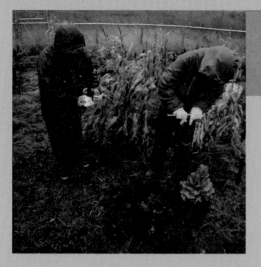

National Endowment for the Arts (NEA), which originally agreed to award the project a grant, but reneged when the chairman deemed it more of a science project than a work of art, even though it was being created in conjunction with the Walker Art Center, Minneapolis, Minnesota.

Fortunately, Chin met with NEA Chairman John Frohnmayer to articulate the project's artistic merits and its historic possibility in the history of conceptual art, and the grant was restored. Chin has compared the plants' absorption of toxic metals to the art of carving. Furthermore, once the toxin-laden weeds are harvested, incinerated and resold as ore (to pay for the process), the "aesthetic" is revealed in the return of growth to the revitalized soil.[8] It's amazing to consider how much a $10,000 NEA grant inspired. Although Chin expresses his doubts about the sophistication and effectiveness of most current phytoremediation techniques, one business analyst predicts that the new phytoremediation industry will become a $400 million business by 2005.[9]

In June 1991, after six months of negotiations for sites all over the country, Chin and Chaney chose Pig's Eye Landfill in Saint Paul, Minnesota. They then planted *Revival Field*, the first such on-site experiment in the United States and one of only two in the world. Dr. Chaney selected one cadmium and one zinc hyperaccumulator (Thlapsi caerulescens) and two other

The recent collapse of the World Trade Center created a number of environmental hazards, most involving airborne pollutants. In the wake of the disaster, the Florida Nursery and Growers Association donated a shipment of 1000 philodendrens, palms and peace lilies (top air cleaners) to nearby Stuyvesant High School. Such plants have been proven to absorb airborne pollutants such as formaldehyde, benzene, xylene, and ammonia. According to environmental scientist Dr. William Wolverton, "to purify indoor air, plants have to be grouped in a planter that draws air through a filter of clay and activated carbon, and the beneficial micro-organisms around the roots have to feast continually on pollutants."[10]

known indicators of metals (Silene cucubalus and hybrid Zea mays). "Merlin red fescue and romaine lettuce were also included to test for metal tolerance and food chain influence."[11] From the 96 plots designed to assess different soil and pH treatments, they discovered that Thlapsi samples absorbed the most zinc and cadmium. The results provided data essential to confirm laboratory tests and create a new technology.

Concerned that environmental factions such as the Green Party in Germany had begun to doubt the validity of the science due to the confidential (private industry and government) research initiatives in the U.S. that limited information, Chin returned in 2001 to initiate the tenth anniversary planting of *Revival Field*. Working with Dr. Chaney and other parties involved in the research, Chin successfully negotiated a transfer of new varieties of "super"accumulating plants to another collaborator, Dr. Volker Römheld. Chin and Römheld projected long term tests to further the science in Germany and to work on public lands, as well as in the Hohenheim University plots. With the first year's progressive tests over in 2001, the field will be replanted in 2002.

A founding father of the native plant revolution, Alan Sonfist first publicly articulated the need for urban forests in 1969, but it took another nine years for *Time Landscape*, a 45 feet x 200 feet patch of pre-Colonial wilderness (oaks, hickories, junipers, maples, and sassafras) planted in Manhattan, to get off the ground. *Time Landscape* has evolved into an ecovention, but it began as a monument to celebrate a less familiar, non-human history. According to Eleanor Heartney:

> Sonfist's success in persuading city planners and bureaucrats to approve the construction of time landscapes is based on arguments that derive, not from conventional justifications for public art, but from the discussion that surrounds issues of architectural preservation. Sonfist's stance has been that it is as important to preserve historical landscapes as to preserve historical buildings.[12]

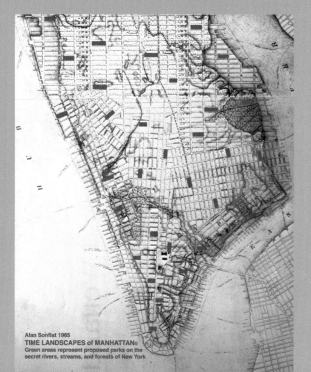

Alan Sonfist 1965
TIME LANDSCAPES of MANHATTAN®
Green areas represent proposed parks on the
secret rivers, streams, and forests of New York

Sonfist believes that it is not enough to repair the landscape: one must also "repair the hole in the psyche which is left when all traces of our biological and ecological roots are obliterated."[13] Since Sonfist's *Time Landscape* remains a visible but locked park, *Time Landscape* fails to offer a "social site filled with human content," though it does satisfy Jeff Kelley's condition that "places are where time takes root."[14] Paradoxically, nay-sayers thought the plants Sonfist selected would never grow, let alone survive a contemporary metropolis, yet now his pre-Colonial list has joined the city's approved plant list. *Time Landscape* has transformed the local environment in ways that Sonfist could never have anticipated.

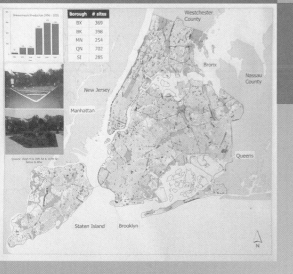

Alan Sonfist's 1965 plan for mini-landscapes juxtaposed against City of New York Parks & Recreation's *Greenstreets Map*, 2002

In 1965, Sonfist first proposed placing mini-landscapes in lower Manhattan. Recently, the New York City Parks Department, in conjunction with New York City's Department of Transportation, began to convert unused landmasses into *Greenstreets*, a program that parallels Sonfist's original idea.

Unfortunately, the New York City Parks Department, which has owned *Time Landscape* since 1989, has neglected to monitor its ecological benefits, which include absorbing rainwater, releasing oxygen, and absorbing pollutants such as airborne metals

1. Both the Metropolitan Museum of Art, New York City (1969) and Finch College Museum (1970) renege on their commitment to sponsor *Time Landscape*.

2. Planning board of Greenwich Village finds out about it and offers Sonfist a site.

3. Sonfist is required to secure insurance and community approval.

4. Department of Highways, the supervising agency, shows resistance.

5. Sonfist conducts research in the New York Public Library to discover indigenous plant species (oak, sassafras, wild rose, red cedar, gray birch, hickory and wild grass), none of which were available in city nurseries. They had to be scavenged from New York forests.

6. In 1978, Sonfist gains the contract to the land and begins planting.

7. Several species identified as native plants are not on the Parks Department list of trees approved for planting on city streets.

8. City officials insist that the forest be surrounded by a fence for insurance purposes, which ultimately aids the park's preservation.[15]

and carbon dioxide, due to emissions from cars zipping along the busy Houston Street artery, which links the Hudson River Parkway to the West Side Highway. In conjunction with the New York City Department of Transportation, the Parks Department has transformed hundreds of unused landmasses in streets into mini-landscapes, known as *Greenstreets*, which coincidentally affirms Sonfist's original proposal to place mini-landscapes in lower Manhattan.

Alan Sonfist, *Time Landscape: Greenwich Village,* 1965/1978 to present, La Guardia Place, New York City, New York

Recognizing the ecological benefits of mini-landscapes sprouting around New York City, New York City's Parks Department eventually folded Sonfist's *Time Landscape,* the first urban forest to feature pre-Colonial plants, into its *Greenstreets* program.

land art, earthworks, environmental art, ecological art, ecoventions...

It should be stressed that there are several different categories for art that involves nature— land art, Earthworks, environmental art, and ecological art. Where does an ecovention fit within these different categories? An ecovention is the most particular case, since it is designed with some intended ecological function. Though like all art, many ecoventions take on a life of their own to become something unanticipated. In fact, ecoventions fit into each of these categories. Land art, the most general category, encompasses any work that activates the land, however temporarily. Earthworks, ecological art and environmental art are all examples of land art, as are **Dennis Oppenheim's** and **Ana Mendieta's** interventions, most works by **Chris Drury** and **Andy Goldsworthy**, and the nature walks of **Richard Long** and **Hamish Fulton**.

Earthworks, an art historical category, was devised to describe works like **Robert Wilson's** *Poles* (1967-1968), **Michael Heizer's** *Double Negative* (1969-1970), **Robert Smithson's** *Spiral Jetty* (1970), **Walter de Maria's** *Lightning Field* (1974-1977), and many of the works installed at Artpark in Lewiston, New York. Earthworks are primarily permanent, large-scale, non-natural forms sited in "wide open

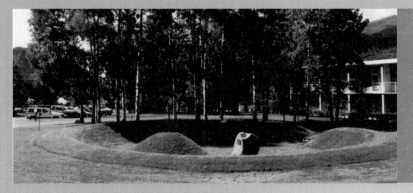

Herbert Bayer, *grass mound*, 1955
Aspen Art Institute, Colorado
(Photo Credit: Center for Land Use Interpretation, 2001)

Herbert Bayer's *grass mound* (1955), a 40 foot diameter mound at the Aspen Art Institute in Colorado, is considered the first example of contemporary environmental art. "It offered a balanced community where livelihood, sports, culture and art could be pursued amidst the beauty of nature."[18]

The Center for Land Use Interpretation included this work in its 2001 survey of the current status of Earthworks.

spaces," as opposed to particular natural environments, such as along a river, amidst a field, or in an urban setting. As the **Center for Land Use Interpretation's** *Formations of Erasure: Earthworks and Entropy* (2001) exploration of the current status of Earthworks demonstrates, several Earthworks have become victims of neglect, vandalism and degradation, not unlike the abandoned industrial sites that dot the landscape. As Roberta Smith noted "most are returning inexorably to the earth whence they came, despite the unchanging nature of the widely reproduced photographs by which nearly everyone knows them."[17]

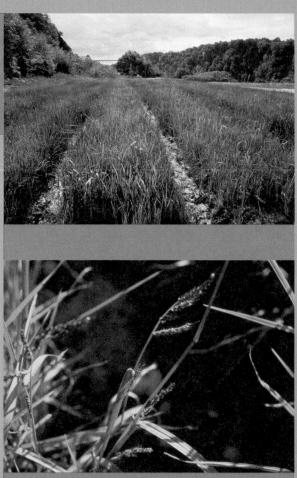

Agnes Denes, *Rice/Tree/Burial "ricefield,"* 1977-1979
Artpark, Lewiston, New York (Photo Credit: Agnes Denes)

After planting white *Rice/Tree/Burial*, a second version of her 1968 ritualistic performance, in Artpark, Denes was surprised to discover red rice growing, which led her to detect the high level of toxicity in Artpark's soil. Knowing now what we do about phytoremediation, planting Rice/Tree/Burial may have revitalized the spoiled soil, though it was obviously never tested.

Environmental art, like **Meg Webster's** works or **Agnes Denes'** ritualistic endeavor *Rice/Tree/Burial* (1977-1979) (a second version of Denes' 1968 performance), is generally less monumental and tends to employ nature as a medium, so as to enhance the viewer's awareness of nature's forces, processes and phenomena, or to demonstrate an indigenous culture's awareness of nature's sway. Denes' rice field, meant to explore the life cycle's process of regeneration, evolved into an ecological work, when her planting of ordinary Louisiana white rice seeds eventually

Agnes Denes *Rice/Tree/Burial "red rice"* detail
(photo credit: Agnes Denes)

produced rice resembling a variety of Chinese red rice that's technically impossible to grow in New York. This led her to detect nearby Love Canal's long-term impact on the toxicity of Artpark's soil. Smithson's *Spiral Jetty*, a breakwater that forms a lagoon, might now be considered an ecovention, given its function and placement near a disused oil-drilling operation. The artist expressed an interest in "the origin of life as well as the devastating forces of entropy and the irreversibility of the loss of energy."[18] However, the environmental hazards associated with Smithson's sculpture make it an unlikely precursor for ecological art.

One of Smithson's last proposals, which entailed reclaiming a strip mine, enabled him to mediate "between ecology and industry by reclaiming the land in terms of art,"[19] and might have been one of the first ecological works – if not an ecovention – had it been built. Certainly, his *Spiral Hill/Broken Circle* (1971), a reclaimed open sand pit in Emmen, Holland, stands as an early example of eco-art. As the section "Valuing Anew" will demonstrate, Smithson, like Morris, thought artists shouldn't clean up or decorate industry's messes, so his notion of reclamation meant re-evaluating a site's ugliness or appreciating its problematic condition for what it is. Ecological artists consider issues of sustainability, adaptability, interdependence, renewable resources, and biodiversity, but they don't necessarily attempt to transform the local ecology. Not all ecological artists employ inventive strategies, nor do they necessarily aim to restore natural resources, stabilize local environments, value anew, or alert people to potentially confrontational conditions, which is why not all eco-artists create ecoventions. Even artists who actually make ecoventions create other kinds of art, too.

Given the variety of artists who have worked in this fashion since the late 1950s, it is truly amazing that so many built projects remain so invisible. Unlike a typical work of art that can move from one community to another, or is part of a body of work that can be discussed as a whole, most of these projects have impacted local communities in rather particular ways and therefore

have remained local. Of course, all of the artists cited have participated in gallery and museum exhibitions, and some have catalogs and articles to support their work, but the majority of their projects are still little known among the art world cognoscenti.

The fact that so many ecoventions have either been folded into public works (sewage and waste-water treatment plants, public gardens, public landfills) or have been initiated by artists locally (brownfields, surface mines) further contributes to their invisibility. Finally, the difficulty of exhibiting, let alone explicating, ecoventions indoors, coupled with their resistance to collecting, has minimized a need to discuss them in mainstream art magazines and books. Even the recent monograph *Transplant* presented primarily indoor examples, despite the reality that plants typically reside outdoors. Baile Oakes' indispensible *Sculpting with the Environment*, featuring thirty-three artists' descriptions of their practice, is the single book devoted to working with nature outdoors.

The *Nation's* architecture critic Jane Holtz Kay similarly laments the absence of any discussion of buildings' environmental aspects in key journals such as *Architecture* and *Architectural Record*, despite *International Design* magazine's recent recognition of eighteen architects for their ecological designs and the American Institute of Architects' (AIA) granting of 2001 Honor Award to the 48-story Condé Nast Building (4 Times Square), designed by Fox and Fowle, for its "elements of new thinking and constructing."[20] She comments further that an article dedicated to the use of materials in *Boston Architecture* failed to discuss the materials' sustainability. And *Architectural Record's* "Material Affairs" interview with Tod Williams and Billie Tsien, architects of the American Craft Museum on 53rd Street, acclaimed by some critics as New York City's most important building since Frank Lloyd Wright's Guggenheim Museum, failed to discuss the building materials' ecological content or impact.

According to Holtz Kay, only *Landscape Architecture* has addressed ecological concerns, leaving the "would-be earth guardians isolated, only a whit more powerful than [they were] in less ecological times."[21] On the other hand, **Patricia Johanson** argues that, unlike ordinary art that depends on a body of art history or critical interpretation, an ecovention can be grasped directly — whatever one thinks about it is valid.[22] Well it's really not that simple, because the question "Why is it art and not science?" or "not a public garden?" or "not a sewage treatment plant?" still remains. By contrast, one wouldn't enter a green building and doubt whether it's architecture, though one might wonder whether it's finished, as many do with the "earthships" of Taos-based architect Michael Reynold.

Image of an Earthship's interior, video still image

Passive solar buildings made from natural and recycled materials, including used automobile tires and soda cans, earthships are totally "off the grid." Such homes produce electricity and water and use wetlands to treat their own waste water. Since moving to Taos in 1969, University of Cincinnati-graduate Michael Reynolds has developed several sub-divisions of earthships there. Others have been built around the world.

Certainly, art historical figures like **Joseph Beuys**, Mel Chin, Agnes Denes, Helen and Newton Harrison, **Ocean Earth**, Robert Smithson, Alan Sonfist, and Mierle Laderman Ukeles are known and collected, yet too few in the art world realize the role ecoventions have played in convincing local city planners, landscape architects, civil engineers, and watershed managers to rethink their practices. When one considers the number of projects that some of these artists have realized, it's truly alarming that none has had an exhibition that specifically focuses on their realized projects. There have been several important group exhibitions, such as "Earth Art" (1969) at Cornell University, "Elements of Art: Earth, Air and Fire" (1971) at Boston's Museum of Fine Arts, "Earthworks: Land Reclamation as Sculpture" (1979) at the Seattle Art Museum, and "Fragile Ecologies" (1992), curated by Barbara Matilsky, the first exhibition to focus exclusively on ecological art, at the Queens Museum of Art. However, the Seattle Art Museum exhibition, initiated by the King County Arts Commission and the Department of Public Works of Washington, which presented proposals for sites slated for reclamation (gravel pits, flood-control sites, surface mines, and landfills) by **Iain Baxter**, Herbert Bayer, **Richard Fleischner**, **Lawrence Hanson**, **Mary Miss**, Robert Morris, Dennis Oppenheim, and **Beverly Pepper**, did lead to the realization of proposals by Morris and Bayer.

Rather than provide a definitive summary of every artist-initiated ecological project to date, *Ecovention* seeks to open a door onto this field and to introduce many of the active participants. Rather than focus on historical works, *Ecovention* seeks to expose the large number of ecoventions that have just been completed or will come to fruition within the year. It is hoped that other institutions will build on the research that went into *Ecovention*, just as *Ecovention* has benefited from what came before.

For explanatory ease, ecoventions have been sub-divided into five categories: 1) activism to publicize ecological issues/monitoring ecological problems, 2) valuing anew/living with brownfields, 3) biodiversity/accommodating species/studying species depletion, 4) urban infrastructure /environmental justice, and 5) reclamation and restoration aesthetics. Of course, these categories are hardly fixed, in that artists who create ecoventions are ready activists who incidentally champion environmental justice. For example, Patricia Johanson's projects function as infrastructure for modern cities and employ inventive reclamation schemes, but her nourishing, life-sustaining habitats are featured in the "Biodiversity" section because her work serves as the benchmark for this particular specialty. Similarly, the Harrisons could be classified in either the "Valuing Anew" or "Biodiversity" sections, but they are included in the "Activism" section since they view their process as a "conversational drift" surrounding discourses of nature.

Such categories should enable newcomers to draw distinctions between artists' intentions and practices. This catalog seeks to flesh out each artist's philosophical perspectives and methodologies. Such divergent practices yield works with quite different focuses. The competing beliefs and attitudes among artists make for a lively field. The following on-line chat among several members of the on-line eco-art dialogue (hosted by Ohio State University) took place January 18-26, 2001, and demonstrates the wide-ranging beliefs and attitudes that influence how one might initiate an ecovention in a city like Cincinnati.

Author	Topic:

Lynne Hull

Posted on January 18, 2001 01:46 PM

Hi Group, since Aviva asked for more philosophical dialog, I'll throw this one out 5 ecoartists are invited to do a site visit at a large rust belt city near the confluence of several rivers. Some of the possible sites to work on are industrially trashed, creeks partly channelized and industrialized, some areas in riparian corridor, others in mowed lawns, serious problems with sewage overflows, leaking storm sewers, etc. A large restoration project is beginning. Some areas are still in pretty good shape- mature trees, reasonably clean water. Preservation as a wildlife corridor/greenbelt has been suggested but is not yet in place. There are a couple of totally destroyed sites right in the high-rise downtown as well- empty lots or big holes in the ground. Where should the artist choose to work? Are there ethical questions involved? One of the artists suggests "Work in the creek, where restoration is beginning- it needs help the most." But a biologist not involved in the project suggests "Go for the preservation project- protect the biodiversity you have left and stabilize it." Another says: "Take the downtown hole. It's the highest profile, to reach the audience you won't reach on an eco-art project." Any other thoughts? best, Lynne.

IP: Logged

Aviva Rahmani

Posted on January 20, 2002 06:43 PM

Lynne asked how we say our responsibility to a site. I suppose my question back is whether ethics are part of our tool bag or whether some of us consider that extra baggage? I have a bias towards ethics... Maybe this is skirting the issue, but my feeling is that when I look at a site, my first job is to gather all the info I can and then go with my instincts. Research always turns up something unexpected. I do think that we have an obligation in our practice to be clear about why we have taken the choices, paths we have. Perhaps that's why many of us were disturbed by Kac... either he wasn't clear or we disagreed strongly with his choice. This is thinking out loud a bit but I know I take my ethics with me wherever I go and they inform my practice but don't predetermine it... I think whether or not we have made correct choices can only emerge in retrospect by seeing the consequences and our own sense of ease or unease. Honestly, I could be repelled by the idea of moving in a direction with my work only because of the audience impact, an injunction from a scientist about what they want illustrated or the most obvious starting place...tho I understand that for many, the educational impact would be pre-eminent, for others scientists lead the way, etc. For me that would be dodging my responsibility: to make a coherent analysis of the situation out of my responsibility: to make a coherent analysis of the situation out of my own informed intelligence, commit myself to means and then knock myself out to make it as effective & beautiful as I can.

IP: Logged

Author	Topic:

Deirdre Elmansoumi

Posted on January 21, 2002 02:35 AM

Thank-you Aviva. Although I had never thought of the ideas you put forth in quite that way, they sounded very comforting to me. I especially appreciate your highest regard for gathering information before proceeding with action. I wish to work interactively with nature; gathering information, taking some small steps of action, and then closely observing the effects of what I've done. As I see it, working interactively, with nature requires patience, time, and utter curiosity. It seems to me that it would be impossible to work this way with a formula. You words have freed me from feeling like I have to defend my ethics.

IP: Logged

Mo Dawley

Posted on January 22, 2002 05:40 AM

Aviva, Bravo, Well said. The idea of informed instinct appeals greatly to me. Although a sense of ethics requires us to be aware, communicate and investigate ourselves and our environment and can be a pain in the butt, it is necessary "baggage" as far as I'm concerned. Some might say that a sense of ethics might compromise an individual's creative process or flow, but in the long view, I imagine somehow an individual taking that path would be squelched eventually down the road since we are all connected. Ethics is tough because it is far-sighted and a rough road. It's always so much simpler to give up and go for the throat or sensationalism or what have you. Thich Nhat Hah says "Our only true possessions are our actions" Alice Walker says "...violence is not radical enough. Love is more radical."

IP: Logged

Helen Harrison

Posted on January 23, 2002 09:15 AM

Good for you! I agree about an informed intuition and about ethical thinking being part of all decisions, not only about art. Thanks for saving me from having to think through an answer. Best of everything to you.

IP: Logged

Susan Steinman

Posted on January 24, 2002 12:22 PM

I assume that for all (99%) of us, ethics is a major given part of our chosen life's work. Therefore I think Lynne's real question may have gone unanswered. The very real pressure is that work is needed on many fronts at once, given that we have only x amount of time, money, energy, etc. , where can we be most effective when we are invited to do our "guest projects." This requires different considerations than projects in which we are long-term residents or have multiple-year financial support. Where we begin, or choose to work, is often a "King Solomon's decision." Something is gained; other intangibles lost. Perfection is neither a reasonable nor healthy goal. Research is critical, of course, but it is impossible to cover all the variables

Author	Topic:

Susan Steinman Cont.

in any one project. Restoration, conservation and community building & audience education/participation are equally critical areas to work in.

In Lynne's alternatives, I'd say any place was a good place to start, but most of us gravitate toward where our individual skills and heart lead us. Thank goodness for the myriad skills and interest we all bring to the table. We need each other, and more. Best always, Susan.

Joyce Cutler-Shaw

Posted on January 25, 2001 12:52 PM

Aviva as usual sums up a position so usefully. I believe also, there is not a single formulaic response possible. The very reason why various disciplines are of value, to inform us about a site, because of the different focus of attention each brings. As an artist, aware of ecological concerns and environmental protection for the long run, I am faced with various projects with conditions in place that make an ecological use of the site- often meaning "do nothing to disturb"- impossible in an aggressive commercial culture. In that case, the artwork becomes an homage to what is lost, or (without being didactic) an illumination of alternatives not taken, and to push for strategies for the most environmentally conservative process of development within the scope of the project as a member of the design team.

Tim Collins

Posted on January 26, 2002 08:27 PM

You lay out three questions. The first two have overt environmental texts (devoid of the word art), the third subverts the environmental and elevates both art and the audience. The location of each effort is defined in value-laden terms as CREEK, BIODIVERSITY, HOLE. When beginning a discourse on ethics, I would think you would want to lay out the issues in a cohesive and equitable manner. You have begun the discussion with an explicit bias. Art-Audience VS Restoration and Preservation. (This bias, may be intentional, in which case I apologize for rambling!)

To balance the bias:

Ecologically, the issues are actually defined by preservation (conservation) (2), restoration (1), and rehabilitation (3). So the "downtown hole" recently freed of human infrastructure becomes a disturbed earth site for ecological rehabilitation. The issues of audience can also be equally distributed amongst all three, if that is an issue you think implicit to the moral question you are asking.

I guess I'm asking how do you present each site semi-objectively so that the language doesn't value or devalue the natural/social issues upon which ecoart draws some of its strength, and upon which we might begin to consider ethical questions. Out of the gate, you have manipulated our perception simply by the choice of words. I think we can adjust your ethical conundrum for balance without being politically correct. This would help us see the potential "sites" of intervention with clarity, then let each of us consider the ethical points of consideration. You could tune it as a continuum.

1. Preservation based biodiversity (wilderness) site / virtually inaccessible.
 Human use minimal
 Ecosystem form and function intact
 Hydrological function intact
 Soil intact

2. Restoration based exurban-suburban creek site / accessible with effort
 Human use regular
 Ecosystem form and function debilitated
 Hydrological function semi-intact
 Soil semi disturbed

3. Rehabilitation based urban center site / prominently visible
 Human use regular and crowded
 Ecosystem form residual and function residual or lost
 Hydrological function disturbed
 Soil disturbed

With each site, the current human use ecological, hydrological and soil conditions are given. There are points of intervention or change in all three, as well as a range of symbolic/semiotic opportunities for artistic inquiry. To return to your question, is there an ethical question involved here? Personally, I would argue no. Each site has its own set of issues and the value of an eco-artist's effort in any of the three is of equal import and is ethically balanced IMHO. The issue is not in the selection of context/site, but rather a personal question of ethical RESPONSE. A secondary point of moral/ethical consideration occurs after. After the work is in place, it becomes a public issue of PRODUCT IN SITU for the audience to consider (and potentially publicly debate) on ethical grounds. [23]

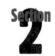

activism to publicize ecological

This section explores the variety of artists' strategies designed to make communities aware of particular ecological problems and potential solutions. In most cases presented here, activism eventually led to measurable change.

direct engagement

"We are storytellers. Our art is about direct engagement."

—Newton Harrison[1]

This section focuses on artists whose work has challenged people to consider problems and solutions that defy conventional thought and practice. Although several of the works included here have not been realized, per se, these artists disclose problems and often suggest solutions, so their works stand as a means to an end, unlike poetic practices that offer ritualistic acts of healing or consciousness raising and are conceived as ends in themselves. As suggested in the "Introduction," activism is a broad category, especially since any work of art that introduces an unfamiliar idea or alternative plan is indeed subversive, and therefore activist. This affirms the view that art is essentially political, precisely because interesting art challenges preconceptions and incidentally fulfills an activist role. By contrast, artists presented here have created intentionally activist works that often weave their way into the fabric of society to intervene in situations in unexpected ways.

Such interventionist schemes demonstrate the artist **Joseph Beuys'** (1921-1986) notion of "infiltration," which he likened to an oil stain spreading across a filter. "This is the other side of the filter: a new refined essence, the spreading of ideas to the different forcefields of human ability, a kind of inspiration that takes effect through a physical process of capillary absorption: psychological infiltration, or even the infiltration of institutions."[2] While Beuys' oeuvre was wide-ranging, covering

installation, performance, sculpture, drawing, lecturing, and political organizing, he was one of the first artists to employ performance art to articulate both the interconnection between human life and nature, and art's capacity to render radical social change.

EARLY ON, JOSEPH BEUYS CELEBRATED THE SIGNIFICANCE OF BOGS, NATURAL ENVIRONMENTS KNOWN AS WETLANDS, THAT CLEANSE AND ABSORB WATER.

To demonstrate his concern for bogs, Europe's most endangered eco-system, he carried out *Eine Aktion im Moor (Bog Action)* (1971), in which he jogged through a bog, bathed in the mud, and eventually swam through this swampy pit. Bogs were under threat of being drained to form low-lying land masses known as polders. Beuys described his interest in bogs as follows:

> Bogs are the liveliest elements in the European landscape, not just from the point of view of flora, fauna, birds and animals, but as storing places of life, mystery and chemical change, preservers of ancient history. They are essential to the whole eco-system for water regulation, humidity, ground water and climate in general.[3]

Geographically, Europe ends with these regions, which is why Beuys believed Eurasia begins in Ostend, Belgium.

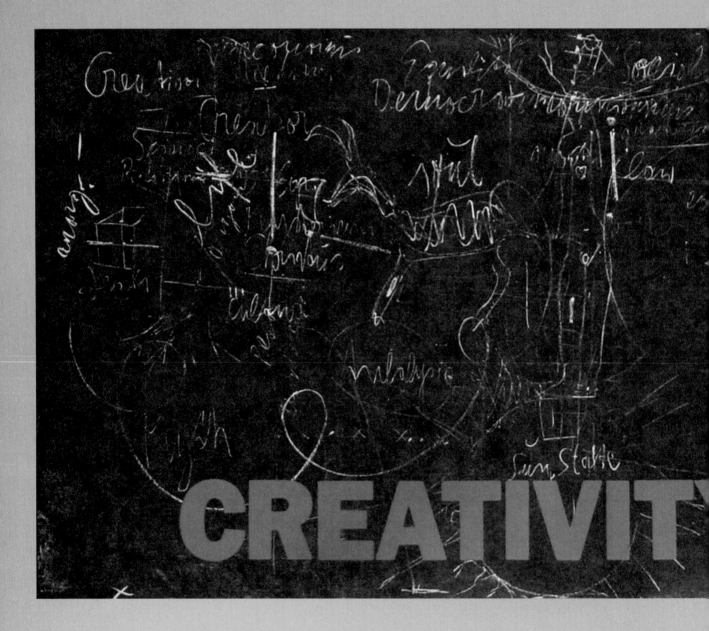

CREATIVIT

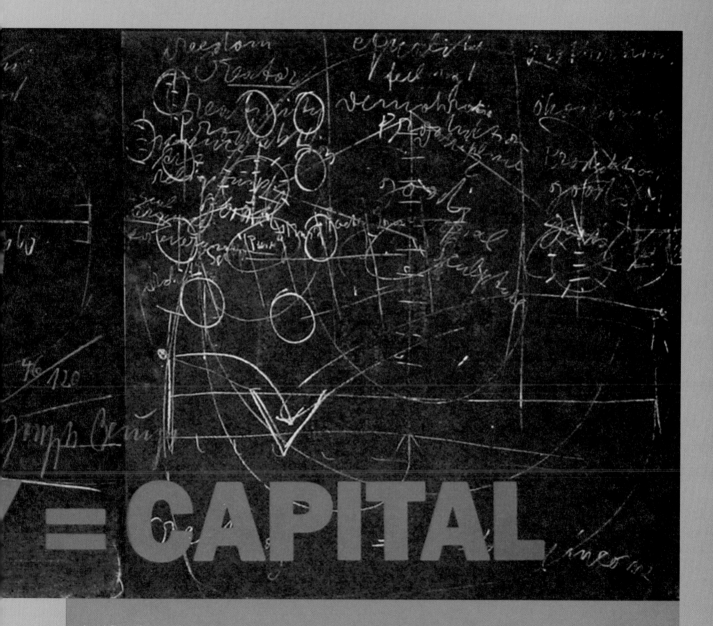

Joseph Beuys, *Creativity=Capital,* 1983, silkscreen, lithograph, 11" x 27.75", Edition 120

This poster encapsulates the main point of Beuys' blackboard lectures and his aesthetic motto, "Creativity= Capital." He proposed an alternative economic system, a society in which all citizens are free to explore and develop their creative potential to reap the greatest economic gains.

Even his mythologized *Coyote. I Like America and America Likes Me* (1974), for which he spent several weeks penned up with a coyote, explored ecological concerns. The unusually intelligent coyote, historically maligned by cattlemen who have viewed them as threats to livestock, symbolizes both its own endangerment and the extermination of native Americans, who consider it sacred.[4] Best known for his lively blackboard lectures, Beuys traveled the United States articulating his *Energy Plan for Western Man* (New York, Chicago and Minneapolis, 1974), which introduced Americans to his theories about creativity's potential, man's relationship to nature, and his own mystical world view. During these performances, Beuys would draw, erase, and redraw throughout the event, diagramming his theory of social sculpture — art's political, evolutionary and revolutionary power to free humankind from all oppression. These talks culminated in lively discussions, during which he invited audience members onstage to debate him. His vision of radical democracy required every person's participation in determining his or her own destiny, which necessitates thinking, feeling, willing, and protecting creative freedom.[5]

**Joseph Beuys, *7000 Eichen (7000 Oaks)*
Installed posthumously
New York City, New York
(Photo Credit: Theresa Hackett)**

In 1988, New York City's Dia Center for the Arts, which owns a number of Beuys' works, posthumously paired five columnar basalt stones (shipped from a quarry 30km outside Kassel), with trees (gingko, linden, Bradford pear, sycamore, and oak) in front of its building at 548 West 22nd Street. Beuys' vision to extend *7000 Oaks* beyond Kassel was further expanded in 1996, when Dia installed 32 more pairs along the entire length of 22nd Street.[6]

Concerned by Germany's rapid deforestation, Beuys first conducted a forest action in Düsseldorf in 1971 to call attention to the need for a progressive urban ecology. His contribution to the international art exhibition "Documenta 7"

(1982), a plan to reforest Kassel, Germany with 7000 oaks, revisited this 1971 action. The oaks symbolize life's fragility and the mutually beneficial relationship between nature and humans. Anyone could participate by sponsoring a tree for $210. In return, each sponsor received a signed certificate stating "small oak trees grow and life continues."[8] Students from the Free International University helped plant the trees.

Placed aside four-foot-tall, locally-quarried basalt columns, the relational proportions constantly change. Each stone marker's stasis contrasts with the living tree, growing beside it. In actuality, fifteen different types of trees were used and only 60% were oaks. When Beuys died in 1986, only 5500 trees had been planted, so his son, Wenzel, carried forth the plan and planted the 7000th tree at the opening of "Documenta 8."[9]

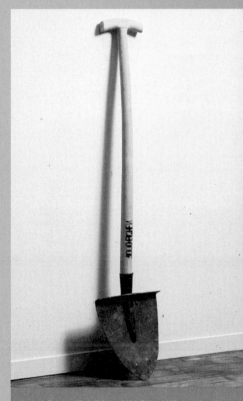

Joseph Beuys, "Pala" from *7000 Oaks*, 1983, metal and wood. 53" x 11.5", Edition 35.

This shovel symbolizes Beuys' call for the re-forestation of Kassel, Germany, with 7000 oak trees. Not only do trees absorb rainwater and airborne pollutants, and produce fresh oxygen, but their shade cools nearby buildings and the ground below, preventing the rapid evaporation of water from the soil. Well-planned landscaping can reduce the costs of heating and cooling a home by as much as 30%.[10] Consult your local Extension Service for advice on appropriate plants.

In 1981, Beuys declared *An Appeal for an Alternative*, which he directed to all people belonging to the European cultural sphere and civilization. It was reprinted in the "Documenta 7" catalog. He named the ecological crisis as one of four symptoms of the crisis in late-capitalism. He wrote:

> Our relationship to nature is characterized by its having become thoroughly disturbed. There is the threat of total destruction of our fundamental natural basis. We are doing exactly what it takes to destroy the basis by putting into action an economic system which consists in unscrupulous exploitation of this natural basis...Between the mine and the garbage dump extends the one-way street of the modern industrial civilization to whose expansive growth more and more lifelines and life cycles of the ecological systems are sacrificed.[11]

Best known for conceptual works that expose current social injustices and inequitable power relationships, **Hans Haacke** is an activist whose strategies have played an instrumental role in the history of eco-art. For Cornell University's 1969 "Earth Art" exhibition, Haacke grew grass without any pesticides on an indoor mound of soil. *Grass Grows* grew out of his 1965 manifesto, which called for a changing, indeterminate, living-in-time, non-stable work of art that the viewer could handle. It would also react to its environment, temperature changes, and light.[12] Not only were dirt and seeds little-known art materials back then, but the work's changing nature introduced an artistic interest in time-based materials.

Hans Haacke, *Bowery Seeds (Bowery Samen)*, 1970
New York City, New York, © VGBild-Kunst

For Bowery Seeds, Haacke carved out a small circular area of earth, enabling airborne seeds to take root.

Grass Grows focused the audience's attention on an event that one typically takes for granted, while offering each viewer incredibly different experiences. For those who revisited the exhibition, watching winter rye grass grow became a memorable experience that undoubtedly changed their awareness of this everyday event.

YOKO ONO'S PAINTING FOR THE WIND, FROM SUMMER 1961, INSTRUCTED VIEWERS: "CUT A HOLE IN A BAG FILLED WITH SEEDS OF ANY KIND AND PLACE THE BAG WHERE THERE IS WIND."

Working with several architects on a 1968 plan for Brooklyn's Fort Greene Park, Haacke proposed to leave a portion of the park totally uncultivated. With *Bowery Seeds* (1970), he actually achieved this, as a small circular area of earth lay open awaiting airborne seeds. By leaving this area uncultivated, so that embedded and airborne seeds could vegetate wildly, this work resembled the spirit of **Yoko Ono**'s proposition, *Painting for the Wind* (1961).

When Bonn's Federal Ministries invited him to propose a work for a new Ministries of Education, Science, and Justice building complex, Haacke proposed *Vorschlag "Niemandsland" (Proposal "No Man's Land")* (1973-1974). Though its form may have been similar to *Bowery Seeds*, its process, effect, and meaning would have been quite different given its location. Haacke proposed that a circular site, 25 meters in diameter, be carved into the pavement. A conveyor belt placed over the site would randomly deposit the soil on it. Unlike Ono's *Painting for the Wind*, Haacke's indeterminate project was not meant as a recipe, event-score, or proposition, but as a fluid alternative to the political system's rigid structure. He even requested the German government sign an internationally binding treaty that relinquished all rights in and to this territory, thus pledging to grant everyone access to this no-man's land.

Although this proposal was later rejected, it paved the way for the equally radical *Der Bevölkerung (To the Population)* (2000), whose process is very different, though similar in meaning and effect. Twenty-five years later, Haacke was once again invited to propose a public work for a German government building. Following the reunification of Germany, the capital moved from Bonn back to Berlin and the controversial Reichstag was chosen to house the Bundestag (German Parliament). His title *Der Bevölkerung (To The Population)* improves upon *Dem Deutschen Volkes (To The German People)*, inscribed on the Reichstag's western portal in 1916. Haacke first noticed this troubling inscription in 1984. In order to express the sovereignty of German soil, as opposed to German blood, which could represent the population, Haacke requested each of the 639 Members of Parliament (MPs) to carry

Hans Haacke, *Der Bevölkerung*, 2000
the Reichstag, Berlin, Germany, © VGBild-Kunst

Invited by a committee of twelve parliament members to propose a work for Sir Norman Foster's renovated Reichstag, Haacke proposed a work that would both critique the building's 1915 inscription and require parliament members to deposit two 25-kilogram bags of soil from their region onto a plot in the northern courtyard. Despite efforts by a coalition of Christian Democratic Union and the Christian Social Union to defeat his proposal, the measure passed by a narrow margin of 260 to 258.

two 25-kilogram bags of soil from their home region. The soil was then spread around four-foot neon letters, which typographically match the original inscription's font, placed in a 21 foot x 68 foot trough in the Reichstag's northern courtyard.

Newly elected MPs contribute new soil, and when an MP's term expires, a portion of the soil, commensurate with his/her contribution, is removed. Plaques bearing all the names of the MPs and their respective districts are installed wherever Der Bevölkerung is visible. This new ecosystem mirrors the population's inherent diversity, while nature's tug-of-war symbolizes the democratic process. As Haacke observes:

> In an extremely controlled building, the ecosystem of imported seeds in the Parliament's courtyard constitutes an enclave of unpredictable and free development. It is an unregulated place, exempt from the demands of planning everything. It is dedicated TO THE POPULATION.[13]

By displaying samples of water released from the Krefeld sewage plant in large glass bottles in the local museum, Haacke's *Rhinewater Purification Plant* (1972) increased public awareness of the Rhine River's deterioration. For this work, contaminated water was "pumped into a container where it was filtered and purified before entering a large rectangular basin housing goldfish... The presence of a large fish bowl and the picture-window view into the wooded landscape served as a point of contrast between a life-supporting ecosystem and one on the verge of collapse."[14] Any surplus water was discharged into the garden behind the museum. When one considers the number of artists working in water reclamation today, one can see why this stands as Haacke's most influential work.

1998	Bundestag initiates Art in Public Buildings project.
November 2, 1999	The Kunstbeirat, the committee of twelve Members of Parliament (MPs) who invited and chose the proposals, accepts Haacke's proposal by a vote of 9 to 1. Secretary of the Christian Democratic Union, the lone dissenter, moves his party and its sister party, the Christian Social Union, to block its realization. With the goal of defeating the project, 150 MPs brought it to a full House debate.
April 5, 2000	After one debate among MPs, the proposal slides by (260 to 258, with 31 abstentions), even though all but two CDU/CSU members reject it.
September 12, 2000	Speaker of the Bundestag sets the project into action by delivering two 25-kilogram bags of soil from a Jewish Cemetery in Berlin.
Summer of 2001	More than 200 MPs have participated.

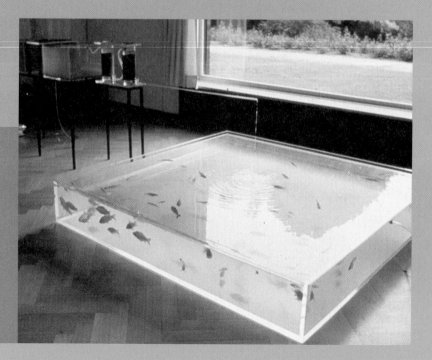

**Hans Haacke, *Rhinewater Purification Plant*, 1972
Museum Haus Lange, Krefeld, Germany
© VGBild-Kunst**

Haacke's *Rhinewater Purification Plant* stands as the historical precedent for artists like Betty Beaumont, Jackie Brookner, Tim Collins, Betsy Damon, Reiko Goto, Basia Irland, Stacy Levy, Ocean Earth, Aviva Rahmani, and Buster Simpson, whose art concerns water quality. By displaying the Krefeld Sewage Plant's murky discharge, officially treated enough to return to the Rhine River, Haacke brought attention to the plant's role in degrading the river. By pumping the water through an additional filtration system and using the surplus water to water the museum's garden, he introduced gray-water reclamation.

breaking out of the box of culture onto the stage of history[15]

Although projects proposed by the collaborative duo **Helen Mayer** (b. 1929) and **Newton Harrison** (b. 1932) have rarely been realized as proposed their influence can be measured by evaluating a particular project's implemented plan minus their proposed solution. They describe their working process and related contribution as a "conversational drift," since discussion is the starting point for many of their ideas, which are circulated by word of mouth.

> We understand the universe as a vast possibly infinite conversation taking place simultaneously in trillions of voices and billions of languages, most of which we could not conceive of even if we knew they existed. Of those voices whose existence has impinged upon our own to the degree that we can become aware of them, we realize that our own understanding is imperfect at best.[16]

The Harrisons often engage journalists, mayors, public officials, government planners, business people, artists, farmers, and videographers in a public discussion to discover an appropriate solution that optimizes twin components: biodiversity, which depends upon the continuity and connectivity of living organisms; and cultural diversity, which requires framing and distinction between communities.

> Our work begins when we perceive an anomaly in the environment that is the result of opposing beliefs or contradictory metaphors. Moments when reality no longer appears seamless and the cost of belief has become outrageous offer the opportunity to create new spaces – first in the mind and thereafter in everyday life.[17]

Their proposed solutions for invigorating watersheds and renewing urban and rural environments take the form of large-scale installations of cartographic imagery, poetic texts, collaged photographs, and video, which offer deconstructivist or fragmented narratives, that entail shifting metaphors. One aspect that differentiates the approach of the **Harrison Studio** (formed in

1993 to include architectural designers **Gabriel Harrison** and **Vera Westergaard**) from those of other eco-artists is that they examine several conditions, including cultural, economic, and ecological concerns, ranging in scale from a museum installation to a peninsula, such as *Peninsula Europe*.

Thirty years ago, however, their scale was much smaller. With *Making Earth* (1970), Newton romped in mud one year before Beuys' *Bog Action*. He gathered different kinds of manure, sewage sludge, sawdust, vegetable matter, clay, and sand to create seven piles of earth that he watered and worked until they smelled so rich that he could put the soil in his mouth. Invited to participate in the Los Angeles County Museum of Art's landmark exhibition "Art and Technology" (1971), Newton worked with Jet Propulsion Laboratory's Richard Feynman to create *Encapsulated Aurora*. First exhibited in a darkened room in the American Pavilion at Expo'70 in Osaka, Japan, *Encapsulated Aurora* presented the glow discharge phenomenon associated with the Northern Lights in 12-foot tall, 18-inch diameter plastic tubes. This project became *Survival Piece #1* and led to Newton's second project, *Notations on the Ecosystem of the Western Salt Works (with the inclusion of Brine Shrimp)*, which was exhibited with *Encapsulated Aurora* in "Art & Technology." This led to the Harrisons' *Survival Series* (1970-1973), which introduced self-sufficient harvesting techniques. They thus transformed public exhibition spaces into portable fish farms, orchards, and fields. Catfish, pigs, berries, beans, cucumbers, oranges, and avocados were then harvested, prepared, and served to museum visitors in Fullerton, Brussels, London, Houston, and Boston.

Once they realized that farming under lights was too energy-expensive, they "began to think more directly about reclamation and restitution at whatever scale opportunity offered."[18] *First Lagoon* (1972), a small simulated aquatic ecosystem, featured hardy creatures that could live under museum conditions. The Scripps Institute of Oceanography awarded them a grant and they created six more lagoons between 1972 and 1979. The original 360-foot *Lagoon Cycle* is in the National Museum of Modern Art at the Pompidou Center in Paris, France.

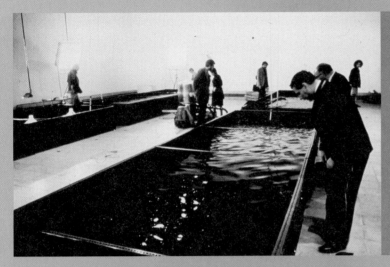

Several works from the 1980s led to environmental changes, though the Harrisons continued to emphasize conversational drift over direct action. Their *Barrier Islands Drama: The Mangrove and the Pine (1982)* project for the Ringling Museum in Sarasota, Florida, was partly responsible for the banning of the so-called Australian pine from South Florida. Their proposal to restore a tributary of the Los Angeles River, the *Arroyo Seco Release* (1985) for California Institute of Technology's Baxter Gallery, was completed by others almost fifteen years later.

In anticipation of people needing 600,000 new homes by 2010, the Cultural Council of Southern Holland invited artists, architects, and urban planners to propose solutions for a vast tract of farmland at the center of a ring of cities. The pilot who founded KLM named it "the green heart of Holland" when he flew over it in the mid-1930s. While about thirty other participants' proposals were exhibited in the

What have the Harrisons taught us about lagoons?
The properties of estuarial lagoons, where salt and fresh water meet and mix offer a metaphor for culture. Unlike a river, a lake or an ocean, whose water volume provides consistency, lagoons are volatile ecologies, whose properties respond to temperature fluctuations, forest fires, and rain. "Life in the lagoons is tough and very rich. It breeds quickly. Like all of us, it must improvise its existence very creatively with the materials at hand. But the materials keep changing, only the improvisation remains constant."[19]

Architecture Museum in Rotterdam, the Harrison Studio's proposal, *A Vision for the Green Heart of Holland* (1995), was exhibited in a small chapel in Gouda. Nonetheless, most of the issues the Harrison Studio raised and the strategies they proposed were included in the Minister of the Environment's formal presentation eight months later. The Harrisons were successful, in part, because several Dutch ecologists and landscape architects were involved in its conception. The Cultural Council of Southern Holland sent out 3000 posters and organized several public discussions, including a television program. Their Gouda exhibition traveled to Delft and Zoetemeer.

The inventive feature of their proposal is its Bio-Diversity Ring, a multi-use park with housing on its perimeter that encircles the existing farmland and polders to form a protective eco-urban edge for the "Green Heart" and Randstat, a group of culturally diverse cities including Amsterdam, Rotterdam, Utrecht, Den Haag, Haarlem, and Delft. The Harrisons value it as "the first Bio-Diversity Ring to be invented."[20] If new homes could be built outside this one-to two- kilometer wide, 140-kilometer long Bio-Diversity Ring and its outreaching arms, then the Green Heart would both be preserved and the economic influx of ƒ120 billion to build 600,000 homes would flow to the communities outside the ring, rather than be concentrated on the giant new city or cities within it.

**Harrison Studio, *A Vision for the Green Heart of Holland*
Map illustrating the Bio-Diversity Ring, 1995**

This map demonstrates the Bio-Diversity Ring's particular advantages. Since each city has defined edges, its cultural diversity is protected. New communities can be developed in time amidst its perimeter.

Furthermore, a Bio-Diversity Ring could absorb 5,000 tons of carbon dioxide and make about 25,000,000 cubic meters of clean water available, thus eliminating the need to use polluted Rhine water in summer. Finally, its gradual implementation would shelter it from a sudden economic downturn or a decline in migration. The Harrison Studio's vision for Holland, the first "continuous corridor for bio-diversity in Continental Europe," exemplifies the balanced ecological-economic design that they have promoted for decades, echoing their earlier idea to create an eco-security system by taxing the gross national product 1%.[21]

Between 1977 and 1978, the Harrisons worked as community organizers to create *Spoil's Pile*. Three thousand dump trucks full of earth were dumped to transform one corner of Artpark's spoiled land into a twenty-acre meadow. This paved the way for *Future Garden, Part 1: The Endangered Meadows of Europe* (1996-1998), a continuously changing, living, 3600-square meter color field atop Bonn's Kunst-und Ausstellungshalle der Bundesrepublik Deutschland.

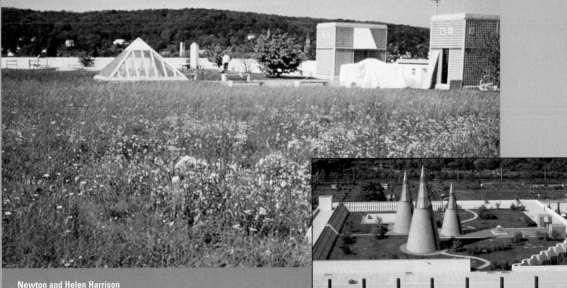

Newton and Helen Harrison
Future Garden, Part 1: The Endangered Meadows of Europe, 1996-1998
Kunst-und Austellungshalle der Bundesrepublik Deutschland, Bonn, Germany
The Harrisons moved a 400-year meadow to this museum's roof, in order to create a roof garden and to conserve this ecosystem.

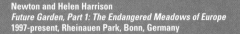

Newton and Helen Harrison
Future Garden, Part 1: The Endangered Meadows of Europe
1997-present, Rheinauen Park, Bonn, Germany

Working with botanists, the Harrison Studio selected a particular site for their meadow, across the Rhine from the original site, just south of the main bridge to the city center and north of the ferry to Bad Godesberg.

By transplanting a 400-year old meadow from the Eifel region to the museum's roof, they saved a section of an eco-system that was being destroyed to make room for a housing development. A wet meadow, a dry meadow, and a stone meadow were added to create diversity. In 1997, a portion of this meadow was moved and reconstructed along the Rhine in Bonn's Rheinauen Park (a site chosen by the Harrisons and several botanists). The meadow was called a future garden because they saw it as a model for a future forest, future estuary, or future lake, as well as a biologically diverse alternative to a monocultural Europe.

Incorporated in 1980 as the **Ocean Earth Construction and Development Corporation (Ocean Earth)**, it changed its official name to Ocean Earth Development Corporation in 1994, so as to avoid confusion with the Paris-based agency OECD. Basically an artist-run, yet incorporated, research and development think tank, Ocean Earth aspires to create necessary, useable, marketable, and therefore saleable technology. It was:

What have the Harrisons taught us about meadows?
From an ecological point of view, meadows have evolved as a result of centuries of forest clearing. Maintained by livestock grazing and/or hay cutting, meadows support microscopic life, insects and invertebrates, various plants, reptiles, amphibians, mammals, avians, and the farmers whose flocks graze there. "Here the harvest preserves two systems, one cultural and the other ecological, each helpful to the other's well-being."[22]

chartered to produce "architectural components" and "media services." Both lines of production are directed towards changes in the perception, organization and management of habitat—ranging from immediate environs of the body to the entire planet. Principles come from the classic books on architecture of Leon Battista Alberti, in which four responsibilities are defined. They are, for a given city to assure 1) clean air, 2) clean water, 3) circulatory space, and 4) defense. Ocean Earth works in these four sectors, separately and in combination.[23]

Ocean Earth's product brands fall under four categories: 1) Cycle Power: the development of non-polluting energy production using water bodies; 2) Earth Works: systems designed to restore large numbers of keystone animals necessary for plentiful, good water; 3) City Bild: consumer goods such as urban mega-structure components and Exoware-brand bodywear; and 4) Space Force: civil-satellite monitoring of global hot spots with policy, news-media and diplomatic intent. Its membership at any particular time reflects each project's technical needs. Over the past twenty years, numerous individuals and groups have worked with Ocean Earth, including artists **Christina Cobb**, **Bill Dolson**, **Peter Fend**, **Julia Fischer**, **Colleen Fitzgibbon**, **Ingo Günther**, **Heather Josephine Jansen**, **Win Knowlton**, **William Meyer**, **Dennis Oppenheim**, **Paul Sharits**, **Taro Suzuki**, **Wolfgang Staehle**, **Glenn Steigelman**, **Eve Vaterlaus**, **Sophie Vieille**, and **Joan Waltemath**; naval architect Marc Lombard; architect Kevin Gannon; and scientists from IFREMER oceanographic institutes (France), Cal Tech, Institute of Gas Technology, SUNY Stony Brook, Danish Meteorological Institute, the Japan Ocean Industries Association, and NASA.[24]

While several eco-artists regularly use satellite imagery to gain a bigger picture of the destruction or of nature to study the interrelationships of topographical forms, Ocean Earth was the first to use them as a powerful information tool. Ocean Earth

For their first exhibition, *Art of the State* (1982), they proposed a tax system, not unlike the Harrisons', whereby governments would assign baseline values for ecological health, and then charge taxes, monitored by satellite imagery, pixel by pixel for every algorithmically-measured divergence from those values. "People with property that measures healthy pay no taxes. People with black top, or highways, or noxious emissions in the atmosphere, or other forms of degradation, pay much higher tax."[25]

gained notoriety when news sources like CNN, NBC, CBS, several European television stations, and international newspapers like the *International Herald Tribune* started purchasing their Space Force group's satellite imagery, produced using Landsat civil-satellite data. Space Force could process satellite data because member Bill Dolson had worked on the software for Landsat, and they hired LogEtronics, a state-of-the-art satellite data processor. Using revenues from their television sales, Space Force purchased the data from satellite ground stations, so they controlled the the data's application and owned the related images. Space Force's specialty was selecting the site/date and frame of the data.[26]

According to Ocean Earth's résumé, their satellite survey maps of basins and sub-basins were instrumental in anticipating, providing evidence for or explaining many news-breaking stories during the 1980s. Ocean Earth imagery provided crucial information about attack routes in the Falklands (1982) and Beirut (1982), explanations for Chernobyl's melt-down (1986), the motivations behind Swedish prime minister Olof Palme's assassination (1986), Russian submarine bases (1986), Pakistan's nuclear facility (1987), and Iraq's invasion of Kuwait. At the same time, they provided news services ecologically-sensitive information, but there were far fewer media outlets for eco-related stories. Nonetheless, they sold a story about the Amazon basin and its impact on the Caribbean Sea to Turner Broadcasting and the Cousteau Society (1983).[27]

What is most significant is the way Ocean Earth's ecologically-driven pursuits have incidentally identified sensitive military maneuvers of global import. For example, their 1984 decision to study Iraq's Basra marsh frame, rather than its Majnun marsh, revealed that the Russians had dug twenty narrow, paral-

OCEAN EARTH FIRST GAINED ATTENTION WHEN NEWS SOURCES LIKE CNN, NBC, CBS, SEVERAL EUROPEAN TELEVISION STATIONS, AND NEWSPAPERS LIKE THE INTERNATIONAL HERALD TRIBUNE STARTED PURCHASING THEIR SPACE FORCE GROUP'S SATELLITE IMAGERY, PRODUCED USING LANDSAT CIVIL-SATELLITE DATA.

lel channels to penetrate Iran's Karun River with enough force to divert about 100 miles of the Tigris River (hence, the epithet "River Rifle"), potentially altering Iran's boundaries. Artist Peter Fend's familiarity with artist **Dennis Oppenheim**'s never-built *Dead Furrow* (1968), channels designed to alter a river's flow, enabled this veteran Ocean Earth participant to identify the purpose of these channels, which incidentally also provide ecological advantages for water-stressed regions.[28] In the end, a UN contact secretly transferred Ocean Earth-collected photographs, charts, maps and video-tapes to Iranian officials, who used the information to locate and destroy Iraq's "River Rifle."

As if to remedy this misuse of Ocean Earth's findings and to prove the group's apolitical position, Fend met with Iraqi officials in their Paris embassy in 1990. Fend proposed that Iraq rebuild the destroyed Earthworks, whose positive environmental applications include de-desertification and river-restoration.[29] In 1988, Ocean Earth had developed a massive de-desertification plan to green the deserts of Iran, Iraq, Syria, Kuwait, Jordan, Turkey, Saudi Arabia, and various emirates, which they later hoped the military forces of Desert Storm would construct. That same year, the

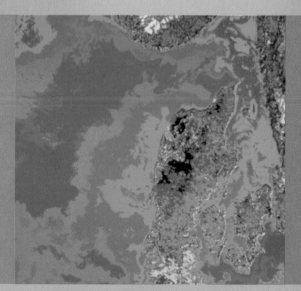

Ocean Earth
Satellite imagery of Algal
Bloom, 1988, Denmark

This one-kilometer resolution satellite image proved that an algal bloom had spread over night to the entire ocean body surrounding Denmark.

precocious Ocean Earth group released a one-kilometer resolution satellite overview to Danish, German, and Swedish media. This image indicated a toxic algal bloom in the North Sea that had spread from a small area near Sweden to the entire ocean body around Denmark in just one day. In 1985, the Algerian ambassador to France had asked how Ocean Earth could help the Algerian army restore Algeria's desert to savannah. Inspired by this query, Ocean Earth finally answered him with a proposal for a bird path extending from the Algerian mountains to the Black Sea basin. Exhibited in 1994 for "Startbahn Österreich" at Galerie Metropol, Vienna, Austria, their proposal called for migratory species like birds and insects to provide nutrients that enable vegetation to take hold and spread, creating an appropriate habitat for larger mammals.[30]

Ocean Earth, *Methane Fire*, Spacex 2, Exeter United Kingdom, 2001

This "soil rig," first introduced at the 1993 "Venice Biennale," was designed to grow green algae vertically in the ocean. The algae is harvested and converted to a valuable non-polluting energy resource. While scientists attempting such research have been routinely blocked, Ocean Earth managed to demonstrate the practicality of this process in 2001, using a horizontal rig to grow green algae in England's Exe River within the Lyme Bay basin. The algae was then fermented and burned as methane gas, hence *Methane Fire*. Ocean Earth accomplished this with additional contributions from Dr. Samantha Lavender, University of Plymouth and Dr. Stephen Hughes, University of Exeter.

While much of Ocean Earth's early work has centered on saltwater basin mapping and providing "Motile-Media Site Monitoring," their most ecologically relevant projects involve their "architectural components," such as GAS-CAR (Green Algae System-Clean Air Rig/Carbon Absorption Rig/Cities Architecture Rudiment). This giant algae system rig was first introduced in 1993 at the "Venice Biennale Aperto Exhibition" and traveled throughout France from 1993 to 1996. GASCAR, a structure that is submersed up to 40 meters, facilitates the growth and harvesting of marine or freshwater algae (plants like hyacinths, or fuel-rich microorganisms that grow on the water's surface). Other Ocean Earth-designed non-polluting, energy-harvesting structures include Large Algae Systems, Medium Algae Systems, Wateroogster (Freshwater Algae Harvester) and the OUW (Ocean Earth Undershot Water Wheel). Ocean Earth is currently dedicated to creating a highly efficient water wheel, inspired by Poncelet's theories and named for this 19th Century French inventor. [32]

16 Foot Poncelet Water Wheel
8 Section 40 Bucket Model
42 inch Cord for a 6 Ft Head

Water Raceway

Gate Valve

Copyright 2002 Waterwheel Factory

Ocean Earth, sketch of *Poncelet Undershot Water Wheel*, 2000, 19"x24"
Water Wheel Factory, C.A.D. design of Poncelet Water Wheel, 2002

Ocean Earth plans to adapt a highly efficient water wheel, based on the innovative theories of Poncelet for use in deep rivers. The Water Wheel Factory produced this manufacture-ready C.A.D. design based on Ocean Earth's specifications for an undershot water wheel. Ocean Earth's *Poncelet Undershot Water Wheel* assures nutrient flows to the sea. Their research shows that wrongful fishing methods offshore and large river modifications upland, like dams, are the chief causes of the fish population decline.

research centers

Although the **Center for Land Use Interpretation (CLUI)** is a non-profit organization, it resembles Ocean Earth, since its endeavors are often associated with a key individual, yet they really involve team members' efforts. Since its 1994 inception, CLUI's "corps" has included **John Alvarez**, **Lisa Boulanger**, **Eric Carver**, **Ellen Coolidge**, **Matthew Coolidge**, **Miles Coolidge**, **Walter Cotton**, **Kelly Coyne**, **Mark Curtin**, **Diana Drake**, **Damon Farragut**, **John Fitchen**, **Jennifer Gabrys**, **Jon Hartzog**, **Sebastian Hassinger**, **Chris Kahle**, **Michael Kassner**, **Camille Kirk**, **Erik Knutzen**, **Carrie Lincourt**, **Angela Loughry**, **Lucy Lin**, **Suzanna Mast**, **Sabrina Merlo**, **Lize Mogel**, **Steve Parker**, **Rex Ravanelle**, **John Reed**, **Shelby Roberts**, **Steve Rowell**, **Amy Russell**, **Sarah Simons**, **Melinda Stone**, **Dave Vamos**, **Igor Vamos**, and **Diana Wilson**, among others.

CLUI's website declares its dedication "to the increase and diffusion of information about how the world's lands are apportioned, utilized, and perceived."[33] One could say that "anthropo-geomorphology," the study of land forms created by man, is CLUI's primary field of inquiry. In this respect, CLUI has inherited Robert Smithson's fascination with post-industrial sites, but its purview is much broader than his, and even includes classic Earthworks such as his *Spiral Jetty*. Despite its resemblance to a dry government manual, *The Nevada Test Site: A Guide to America's Nuclear Proving Ground*, which was CLUI's first publication, introduced mostly original research and created an instant buzz, targeted as it was to a general audience.

Wildly prolific, CLUI maintains an on-line database of "unusual and exemplary land-use sites;" manages a research center in Los Angeles, California (facilitates processing, archiving, and exhibiting information); sponsors the Land Use Museum Complex (encompasses CLUI-identified land forms, Wendover Exhibit Hall in Wendover, Utah, and other, often temporary, multimedia activities); operates the Desert Research Center in Hinkley, California; regularly exhibits in other

museums; organizes and distributes its exhibition catalogs; leads site visits and bus tours (led by CLUI guides and accompanied by onboard videos), and publishes the quarterly *Lay of the Land* newsletter

.

The website alone is an incredibly useful tool. A visitor can index a site by entering a key word, state, site name, or land-use category, such as cultural, industrial, military, mining, nuclear/radioactive, research and development, transportation, waste, and water. She or he can even explore sites of interest by cross-matching a category and a locale. For each entry, the visitor can access the site's description, its brief history (recounting its evolution from a natural state to its present form), current status and future plans. In several cases, photographs and site maps are available.[34]

To CLUI's credit, most projects proposed in their September 1996 Site Extrapolation Projects pamphlet actually came to fruition. Its Site Extrapolation Division examines the particulars of specific landscapes and sites, using photography, video, and sculpture to "enhance the legibility of the site and the issues it raises."[35] Like Ocean Earth, CLUI has experienced a greater demand for information of military and industrial consequence. When asked whether this reflects a particular CLUI fascination, Matt Coolidge explains:

> [S]ome people seem to interpret an apparent emphasis on our part on military or industrial sites, but I think what that's really indicative of is a lack of a public perception about the magnitude and extent of alteration and transformation through those branches of human endeavor. The

The hinterlands are very much related to the cities. They're the other side of the coin. Things in the city would be very different if it weren't for the nuclear proving ground.[36]

Ironically, most sites of CLUI interest support urban centers. Sites like mega-landfills, nuclear test sites, military training facilities, borate mines, and magnesium plants are nonetheless almost invisible to the urban populace, though they affect city life in ways both positive and negative. In response to the concern that CLUI doesn't take a political stance, Brendan Bernhard concludes:

[I]t may be more effective to put up a Suggested Photo Spot sign in front of a landfill than it would be to write an essay about why it (and other places like it) shouldn't be there in the first place — or why their presence is unavoidable, or why they're out in the middle of nowhere because it's better than having them in the cities, or why... Well, it does get complicated.[37]

Just as Ocean Earth has worked hard to avoid identification with any one political agenda, CLUI attempts a neutral approach, which evidently frustrates many people, who consider CLUI too informed not to take action. As Igor Vamos remarks, "our goal is to help people by providing information, and we will try to provide information for people who have political agendas."[38]

Most CLUI museum exhibitions are accompanied by bus tours to nearby sites of interest. These enable all sorts of people to experience first-hand dozens of "unusual and exemplary" man-made landforms. Once the local exhibitions or tours are over, interested viewers can take a

Center for Land Use Interpretation, image of people on a tour

To date, CLUI has led dozens of all-day excursions to "unusual and exemplary" man-made land forms found in exurban Southern California, the Puget Sound, the San Francisco Bay, and the Southern California desert. Dozens of CLUI guide books enable anyone to conduct a self-guided tour. Their *Lay of the Land* newsletter details such events as they occur.

self-guided tour using information provided by CLUI's detailed exhibition catalogs or tour vicariously through the *Lay of the Land* newsletter and their fascinating website. Several popular guidebooks like *Route 58*, *5th Avenue Peninsula Tour* (Oakland), *Points of Interest in the California Desert Region*, *Around Wendover*, and *Subterranean Renovations: The Unique Architectural Spaces of Show Caves* were created without an accompanying museum exhibition.

Being There: a short history of popular CLUI-led bus tours and site visits

1997- Three different ten-hour tours, *Hinterland*, Los Angeles Contemporary Exhibition, California.

1999- Three separate all-day tours, *100 Places in Washington*, Center on Contemporary Art, Seattle, Washington. Five-hour tour, *Extrapolations on the Commonwealth of Technology*, Massachusetts Institute of Technology. Two-day tour of Southern California desert, Linz Department of Experimental Visual Design.

2000- Four-Day Field Session in desert for Otis College of Art environmental art students, California. Day-long tour to film location and aerospace sites near Antelope Valley, California.

2001- Two all-day tours, "Lines of Flight: A Voyage along High Desert Vectors," *Flight Patterns: Picturing the Pacific Rim*, Museum of Contemporary Art, Los Angeles, California. "Bay Tours by Land and Sea," *Back to the Bay: An Exploration of the Margins of the San Francisco Bay Region*, Yerba Buena Center for the Arts, San Francisco, California.

In 1996, Bern-based artist **George Steinmann** initiated the Forum for Sustainability, a research center in the Priluzsky region of Komi Republic, Russia. This center has a mission similar to CLUI's Wendover Camp and Desert Research Center. Located on the western slope of the Ural Mountains in Russia's extreme northeast Komi Republic, the boreal Taiga forest is significant because it is one of Europe's last remaining pristine, uncultivated forests. It demonstrates what the forests of Western Europe and Canada's northern territories were like 1000 years ago. Rich in mushrooms, berries, and medicinal plants, this forest is nevertheless at risk of environmental degradation, because it is rich in exploitable natural resources. Russia's second largest energy reserves are located in Komi, which is also Russia's prime resource for metals like bauxite, titanium, chromium, manganese, and barium. The dominant industries in the region are coal mining, petroleum and natural gas, timber, pulp, and paper industries.[39]

Addressed to and involving the people in Komi, the forum's activities will "especially through the infrastructures of the international art world, create attention to the issues of pristine forest conservation."[40] By educating the local people about their environment's ecological significance, Steinmann hopes that *Voj-Vozh* (a growing sculpture) can be preserved as a place to study boreal forest conservation, sustainable forest management, and biodiversity. Recent research has already unearthed very interesting scientific data regarding lichens. Of particular interest is the Komi healers' knowledge of medicinal plants. Steinmann is working with a pharmacist to prepare the essences of plants, berries, and herbs for future use as phytotherapeuticals.

"Growing step-by-step, *Voj-Vozh* [Komi language for "in the North/in the forest"] is a trans-disciplinary network, a model for sustainability through art."[41] Steinmann is responsible for developing *Voj-Vozh* (a growing sculpture) in its entirety. Specific advisers are the people of the Prilusky region (including foresters, guides, shamans, and healers); The Swiss Federal Forest Agency, Bern, Switzerland; Professor Dr. Yrjö Haila, Department of Environmental Policy, the University of Tampere, Finland; and The Institute of Biology, Komi Scientific Center, Ural branch of the Russian Academy of Science.

A wooden building designed by acclaimed Helsinki-based Heikkinen-Komonen Architects, the Forum for Sustainability facility accommodates ten to twelve people and offers a room for studies and education, a community room with cooking facilities, and a banja (sauna). Design priority was given to ecological sustainability, environmental protection, and the use of local materials. Future forums will assemble local and foreign students, scientists, foresters, ecologists, and artists, in order to build "positive energy and through that, create help for self-help."[42] Falling under the auspices of the Komi branch of the World Wildlife Foundation (WWF) International, a nongovernmental agency under mandate of the Swiss Agency for Development and Cooperation, the forum is run by the Administration of the Municipal Union for the Priluzsky region.

Drawing for *Voj-Vozh*, Forum for Sustainability, Priluzsky model forest area, Komi, Russia

Acclaimed Helsinki-based Heikkinen-Komonen Architects worked with George Steinmann to design a building that considers ecological sustainability, environmental protection, and use of local materials.

community action

Like other artists in this section, **Basia Irland** makes interdisciplinary and participatory works, so their influence extends well beyond the art world. She gained a lot of attention for *A Gathering of Waters: Rio Grande, Source to Sea* (1995-2000), a participatory performance staged along the world's third most endangered river, the 1885-mile Rio Grande/Río Bravo basin, which rises in Colorado, passes through New Mexico, extends along the Mexican border, and flows into the Gulf of Mexico. Hundreds of artists, government agencies, private water users, farmers, ranchers, Native American leaders, and ordinary people collected small river water samples in a canteen and logged their experiences in a field book. The canteen and log book, which were voluntarily passed hand-to-hand, community-to-community, traveled by "boat, raft, canoe, hot-air balloon, car, van, horseback, truck, bicycle, mail, and by foot,"[43] tying diverse communities to a common interest. In 1999, Irland completed a documentary on this extraordinary event, that only she could imagine wouldn't result in losing the lone canteen. This grass-roots activity explored the rich diversity of the upper and lower river basins and contributed to the public's awareness of the river's relationship to the cultural and environmental issues of its adjacent communities.[44]

BETWEEN 1995 AND 2000, HUNDREDS OF ARTISTS, GOVERNMENT AGENCIES, PRIVATE WATER USERS, FARMERS, RANCHERS, NATIVE AMERICAN LEADERS, AND ORDINARY PEOPLE COLLECTED WATER SAMPLES, FROM THE 1885-MILE RIO GRANDE, IN A CANTEEN AND LOGGED-IN THEIR EXPERIENCE. THE CANTEEN AND LOG BOOK WERE VOLUNTARILY PASSED HAND-TO-HAND AND TRAVELED BY BOAT, RAFT, CANOE, HOT-AIR BALLOON, CAR, VAN, HORSEBACK, TRUCK, BICYCLE, MAIL, AND BY FOOT, ON THEIR WAY TO THE GULF OF MEXICO.

With one recent group of portable sculptures, Irland juxtaposed "the human impulse to chart —whether U.S. Geological Survey Maps, aerial photographs, or archeoastronomy drawings from ancient cultures— with the power of water to inscribe itself on the rocks beneath a glacier or in the marks of the tide."[45] Poetic trip kits like *Kit for Paddling through Stars Floating on a Lake* (2000) or *Of Pelicans and Palapas* (1999) hold maps, charts, photographs, books, objects, and videos, providing both the necessities for a water journey and repositories for a record of the trip.

When invited to create a fountain for the Albuquerque Museum, Irland took advantage of an opportunity to enlighten people about the preciousness of water in the Albuquerque desert environment. Like a desert arroyo, *Desert Fountain* depends on the harvesting of rain or snow. When full, its 50-gallon storage tank enables the fountain to flow for 30 hours over three pair of bronze arms with etched, cupped hands. In the summer of

1999, she was rewarded for her thoughtfulness when a severe drought forced the state to temporarily turn off all public fountains. An unexpected shower made *Desert Fountain* the only flowing fountain in the state, and created the public stir necessary to raise awareness about this arid region's need for water conservation.

Dedicated to archiving the use and abuse of water sources, Irland is the founder and director of the International Water Institute and is often the only artist to address international conferences on

water and environmental policies. Her recognized expertise in harvesting precipitation has led to her involvement in massive rainwater collection and recirculation schemes. In 1998, the California Polytechnic University, San Luis Obispo invited her to discuss the possibility of harvesting and recirculating rainwater to make its campus self-sufficient. Irland is currently constructing two rainwater harvesting demonstration projects, one for the University of New Mexico and another for Pueblo of Isleta, New Mexico.

Kathryn Miller, *Seed Bombing the Landscape,* 1992, Santa Barbara, California

Using soil and seeds of plants native to Santa Barbara, California, Miller randomly re-vegetates degraded, physically abused, or barren landscapes.

Since 1992, **Kathryn Miller** (b. 1953), an artist also educated as a biologist, has distributed *Seed Bombs* (1992-2001) to re-vegetate degraded, physically abused or barren landscapes with native plants. When local seed bombs are exhibited as part of a museum exhibition, museum visitors may take one and toss it locally, wherever they feel native plants are needed. Similar in concept and impact to Ono's *Painting for the Wind* (1961), Haacke's *Bowery Seeds* (1970), **Sonfist**'s *Seed Catcher* (1973), and conceptualist **Rob Pruitt**'s *Art Idea No. 20: Slash Open a Bag of Potting Soil, Sprinkle Plant Seeds in the Wound and Watch them Grow* (1999), Miller's *Seed Bombing the Landscape* is less a proposal and more a call for real action, which results in plants randomly sprouting wherever seeds take root. A work entitled *Subdivision* (1992-present) entailed building small soil houses as containers for sprouting plants. The plants in turn provide nectar for butterfly

EACH SIX-SQUARE FOOT PATCH OF LOS ANGELES LAWN REQUIRES MORE THAN 220 GALLONS OF WATER ANNUALLY. LAWNS CONSUME 60% OF ALL LOS ANGELES DRINKING-GRADE WATER, WHOSE SOURCE IS UP TO 400 MILES AWAY.[46]

whose disappearance reflected food shortages. Meant to draw attention to the way subdivisions replace local ecologies with buildings, asphalt, concrete, and non-native plantings, Miller's soil and seed homes dissolved over time to become part of a neglected Isla Vista Park's landscape.

Like Irland and Ocean Earth, Miller is particularly concerned by the region's aridity. In collaboration with **Michael Honer**, Miller began the *Desert Lawn* series in 1994. Dressed in scrubs like doctors from the tele-drama *ER*, they raced between deserts, chemical plants, and rivers with a plot of grass on a gurney, hooked up to an intravenous drip. For *Lawns in the Desert* (1995), they displayed related photo-text panels and *Desert Lawn*'s props next to 35 eight-gallon bottles of water — the amount of water this small plot consumes annually — to illuminate the absurdity of artificially sustained lawns. Like CLUI, Miller's ecologically sensitive discoveries have been compiled into nine artist's books to date.

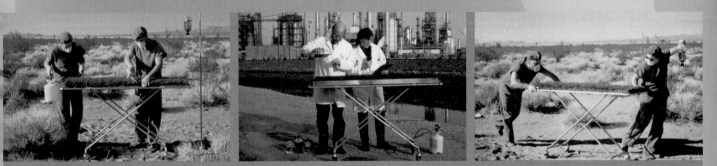

Kathryn Miller and Michael Honer, *Desert Lawn* actions, 1994

Resembling a scene from *ER*, Honer and Miller race through the desert with a plot of lawn splayed out on a gurney attached to an intravenous drip. This absurdist performance stresses the emergency caused by the lawn's pathological state of dehydration and its dependence on deadly chemicals.

Section 3

valuing anew / living with

This section presents an overview of artists who have altered views of particular sites and objects that most people consider degraded, dirty, contaminated, or useless. Artists have done so not by salvaging sites, per se, but by challenging the value judgements underlying words such as irreparable, impure, or trash. They thus provoke us to see anew, as our perceptions, which are tied to our values, change.

sites and nonsites

The Nine Mile River team would argue that art is about shifting values. The artists are interested in the place itself as the object and subject of inquiry and manipulation. We have the chance to reconsider the forces that created post-industrial brownfield properties and how we can better integrate production goals with environmental health and quality. ...We have the opportunity to reconsider the split between nature and culture, and public and private. ... New images, symbols and ideas must be embraced and creative thinking (by both children and adults) must be welcomed in post-industrial dialogue and community planning.[1]

-Tim Collins

The world needs coal and highways, but we do not need the results of strip-mining or highway trusts. Economics, when abstracted from the world, is blind to natural processes. Art can become a resource, that mediates between the ecologist and the industrialist. Ecology and art are not one-way streets, rather they should be crossroads.[2]

-Robert Smithson

As discussed in the "Introduction," **Robert Smithson** (1938-1973) was highly critical of art that sought to reclaim degraded land. He preferred to demonstrate industry's role in molding new land forms. Due to his untimely death, he realized only one ecological work of art in an open sand pit in Emmen, Holland. Even so, his controversial anti-reclamation philosophy continues to shift people's perceptions and values. Smithson consciously chose already degraded sites, yet he routinely encountered criticism that his earth works were environmentally "insensitive." *Spiral Jetty* (1970) had lagoon potential but it's in a salt lake adjacent to abandoned oil rigs that had already polluted the surrounding waters. His *Island of the Broken Glass* (1969), for which he wanted to shatter 100 tons of green-tinted glass, was slated for a "remote, undisturbed, barren rock off Vancouver

Island."[3] Wanting to protect migratory birds who perch on this rock, environmentalists put a halt to Smithson's plan to visualize the process of erosion that naturally shaves glass into sand over centuries.

Smithson even approached several mining companies with the hope that they might find his services of interest. He didn't offer to create works that would rejuvenate the land, since he believed that such works "cosmetically camouflage the abuse."[4] "In accepting the reality of the site, Smithson ensured that the damage from industry would remain visible."[5] Under government and public pressure to "clean up" degraded lands, mining company executives probably ignored his provocative proposals for Earthworks because they didn't seem effective enough. As Barbara Matilsky has observed, Smithson's plan for *Bingham Copper Mining Pit-Utah Reclamation Project* (1973) made no attempt to ameliorate the blight caused by strip mining. Rather, he proposed to add four small curving lines at the very bottom of the world's largest open-pit mine, in order to transform a three-mile trench into a gorgeous gorge.[6]

> Could one say that art degenerates as it approaches gardening?[7]
> -Robert Smithson

Floating Island: To Travel Around Manhattan (1970), an isle of flora on a barge that Smithson proposed be tugged around New York City, once seemed like just a frivolous fantasy. It's unknown whether he considered its ecological benefit to the river, or whether he just wanted to provide additional green space. Nonetheless, this was the era when floating islands floated into artists' imaginations. One of **Patricia Johanson**'s 1969 drawings detailed floating "islands" and

Robert Smithson, *A Nonsite (Franklin, New Jersey)*, 1968, painted wooden bins, limestone, gelatin silver prints and typescript on paper with graphite and transfer letters, mounted on mat board, bins installed: 16.5 x 82.25 x 103 inches, board: 40 x 30 inches, Collection Museum of Contemporary Art, Chicago, Gift of Susan and Lewis Manilow, 1979.2.a-g, photo © MCA, Chicago

Art © Estate of Robert Smithson/Licensed by VAGA, New York, NY.

"walkways" that extended the land area of a narrow beach and provide protected swimming.[8] **Gordon Matta-Clark** produced a series of related drawings titled *Islands Parked on the Hudson* (1970-1971). To date, large-scale floating islands have yet to be realized in the United States. Since 1989, **Lynne Hull** (b. 1944) has placed small-scale floating islands in ponds, marshes, and swimming pools to sustain ducks, geese, turtles, heron, and aquatic insects. She wants to install a large-scale *Bird Barge/Biodiversity Life Raft* at the confluence of the Ohio River and Cincinnati's Mill Creek.

Smithson introduced the notion of the "nonsite," natural elements presented in an unnatural setting like a gallery or museum, as differentiated from the "site" —the actual work. This side bar clarifies how Smithson distinguished sites from nonsites.

	Site	**Nonsite**[9]
1.	open limits	closed limits
2.	a series of points	an array of matter
3.	outer coordinates	inner coordinates
4.	subtraction	addition
5.	indeterminate certainty	determinate uncertainty
6.	scattered information	continuous information
7.	reflection	mirror
8.	edge	center
9.	some place (physical)	no place (abstract)
10.	many	one

itinerant nature

> [A]n important criterion of most of my projects is to invite the site's community to collaborate. If they work on it, ownership resides within the community, where it belongs. When I begin work in a new community, it's critical to publicly acknowledge my itinerant nature, seek permission and invite real participation. This way of working led to my being hired by the City of Oakland Community and Economic Development Agency...neighbors told me what they liked and didn't like about the park. We prioritized desired solutions.[10]
> -Susan Leibovitz Steinman

In 1989, **Susan Leibovitz Steinman**, then a graduate student at Oakland's California College of Arts and Crafts, enrolled in noted performance artist **Suzanne Lacy's** course City Sites. Based on Lacy's lecture series, for which ten internationally known artists presented their socially engaging work, City Sites students teamed up with other artists to create site-specific projects in places like a drug rehabilitation center, an AIDS shelter, and a recycling plant. Leibovitz Steinman and **Roberta Fudim** worked in a retirement home. The rest is history. Leibovitz Steinman, who does have a studio practice and often exhibits on her own, is best known for facilitating massive public projects, which have involved her collaborating with a range of folks from volunteer Caltrans workers to winners of a "What California Means in Three Words or Less" contest, amateur landscape designers, San Francisco League of Urban Gardeners (SLUG), East Bay Urban Gardeners, professional landscape architect Laurel Kelly, master gardener Kathi Kinney, West Oakland Neighbors, artist **Janice Clement**, Merritt College's Horticultural Landscape Department, high school students, the Museum of Children's Arts' after-school program, homeless people already inhabiting sites, seasoned activists, and unwitting bystanders.

> We were afraid it would look like a pile of junk.
> - Hugh Lau, Marketing Director for a neighboring business
> (his initial response to *Mandela Artscape*)

Leibovitz Steinman's public works are ecoventions not just because they inspire ownership, assemble diverse teams, or offer unforeseen economic opportunities, but because she discovers

unexpected resources, tackles unlikely sites, and regularly changes the function of even an ordinary site, like a pedestrian walkway in Palo Alto, California. How does she do it? Imagination, persistence and team building are key ingredients. Who else would describe Caltrans' Oakland salvage yard as a candy store? Or see the potential in a Caltrans transit corridor hidden under a freeway overpass? Or seek to alter narrow nothings like median strips into engaging artscapes? In the spirit of Smithson's revealing rather than concealing a degraded site, she and artist **Andrée Singer Thompson** opted to spend the $5000 it would have cost to break apart and haul away an ugly blockish cement bench near some Oakland tennis courts on enlisting area elementary school children to paint tiles on its front and back.

Under the auspices of Appalshop Community Gallery, in Whitesburg, Kentucky, Leibovitz Steinman, Suzanne Lacy, and **Yutaka Kobayashi** (an artist from Okinawa currently visiting University of California, Berkeley, and California College of Arts and Crafts) have been invited to transform Elkhorn City, Kentucky, a scarred ex-mining town, into an eco-tourist destination for naturalists, whitewater rafters, and kayakers. Nearby Breaks Interstate Park, which straddles Kentucky's West Virginia border, contains the 250-million-year-old Breaks Canyon, considered to be the "Grand Canyon of the South." The Kentucky side of Breaks Interstate Park is currently under threat of natural gas drilling, and Elkhorn City's enlightened officials realize that eco-tourist dollars will benefit their community more than natural gas drilling, whose income stream is short lived. Their proposal entails restoring a waterfront; designing an interpretive park with mini-wetlands, where storm water runoff from a gas station hits the river; creating riverfront performances in conjunction with a theater artist from Antioch; and collecting "river and land stories" that will air on Appalshop radio station and be used in some visual, archival way to preserve the oral history of the river and land.[11]

Those unwilling to mix it up need not explore her public works. Despite the fact that *Mandela Artscape* (1998-1999) was originally slated as a temporary visual gateway to West Oakland, the "Green City," it remains Leibovitz Steinman's most ambitious and imaginative endeavor to date. Within a few weeks, a two-acre median strip along the Mandela Parkway, where 42 people died when the Cypress Freeway collapsed during the 1989 Loma Prieta earthquake, not only memorialized the dead, but reconnected West Oakland, which was cut off when the freeway sprung up 30 years ago. Caltrans not only let her select objects from its salvage yard, but it lent cranes, forklifts, dump trucks, and experienced workers, who moved giant mounds of soil and heavy pieces of equipment around the site. Metal frames that typically hold freeway signs became trellises and gorgeous salvaged blue water pipes lined a native grass patch like a river. Crushed recycled freeway concrete formed a path that intersected the "river" midstream, creating a bridge symbolic of the reunification of the neighborhood since the freeway's demise.

The *Mandela Artscape* also infused the community with paid jobs, new skills, and free training. Leibovitz Steinman patched together four separate environmental art grants to raise the necessary $32,000. The garden's 3000 plants (California poppies, redwood and cypress trees, grasses, passion vines, and morning glories) were maintained by a crew of volunteer gardeners, who graduated

from a free ten-week landscape gardening course offered by Meritt College's horticulture department. Some graduates went on to work on other community landscape projects. Once the project ended, the plants were replanted in other West Oakland parks.

> I think people compartmentalize their lives. They think apple trees
> belong in the country and apples in the store.
> -Susan Leibovitz Steinman[12]

Several other of her temporary projects have offered economic, psychological, and social benefits for community gardeners, proving once again that apples can appear almost anywhere! In the spirit of the **Harrison's** *Survival Series* (1970-1973), Leibovitz Steinman facilitated *Gardens to Go* (2001), an organic "demonstration" garden featuring pumpkins thriving in antique cast iron bathtubs, spinach sprouting in raised beds, and a dwarf citrus tree growing in a planter made from old wooden doors and shutters. The West Oakland Neighbors encouraged her to create this portable garden, which was temporarily located at the intersection of Peralta, Union, and 32nd Streets, adjacent to the Poplar Community Recreation Center. By reinvigorating the lead-ridden urban site with fresh soil protected by inventive, raised planters, this demonstration garden "shows that anyone can get some containers together and have a site at home," notes area resident and volunteer gardener, Susanna DeAngelo.[13] The group of neigh-borhood volunteers, including

Susan Liebovitz Steinman, *Gardens to Go*, 2001
Peralta, Union and 32nd Streets, West Oakland, CA

About 50 people worked on this abandoned intersection to demonstrate how gardens can sprout anywhere, despite the prevalence of lead pollution, typical of older neighborhoods. In partnership with West Oakland Neighbors (WON), she spent more than one and a half years organizing and lobbying to realize WON's dream of having a community garden to grow food for local needs. Community gardeners earn the fruits of their labors.

about 20 local youths who earned a stipend, planted corn, watermelon, basil, strawberries, Meyer lemons, and beds of flowers in painted retired tires and outdated toilet tank tops, for which they exchange their labor. "Leftover food (no one can eat all of those zucchini alone!) was donated to the center for their free lunch program."[14]

In 1994, Leibovitz Steinman helped to organize *Food for Thought: Urban Apple Orchard*, a six-month experiment on a blighted Caltrans lot, at the corner of Octavia and Market streets, under San Francisco's elevated U.S. 101 freeway. This mini-orchard featured a dozen trees, representing eight varieties of "antique" apples, planted in salvaged tires painted in shades of green. Truly forbidden fruits, "antique" apples are neither on the City's official tree list nor are they readily available, since they're not considered commercially viable. Without such projects, there is a reduction in both the apple gene pool, and the types that can be tasted by the average urban dweller.[15]

As San Francisco's Norcal recycling and waste transfer facility's artist-in-residence, Leibovitz Steinman worked with 75 San Francisco high school students to create *River of Hopes and Dreams* (1992), a 3-acre sculpture garden, whose mountain of earthquake rubble has since been reclaimed by nature.

> I love to do art that people might not even recognize as art, but they
> find it when they're going to the grocery store or to work.[16]
> -Susan Leibovitz Steinman

For *California Avenue/California Native* (1997), Leibovitz Steinman engraved winning phrases from the "What California Means" contest, in sets of three, onto about half of the terra cotta bricks used to form two herringbone-patterned paths. Native wildflowers and the grasses that local Indians once wove into baskets were interspersed between the paths. Salvaged Sierra granite "sitting stones" provide resting spots for musing upon these philosophical/poetic bits of whimsy. Seven banners containing the names of species, whose Latin name contains the word "California" like Lepus Californicus (California Jack Rabbit), rim this Palo Alto median strip.

agents of perceptual change

> The process of restoration, begins with a walk—an intimate sensual experience—seeing the site with the eyes of an artist, a biologist, or an engineer begins the cultural process of restoration. Restoration will not occur in any landscape without care.[17]
>
> -Tim Collins

One of the now defunct **Nine Mile Run Greenway Project** (**NMR-GP**)(1997-2000) team's stated cultural goals was to reclaim for public use urban rivers, streams, and estuaries colonized by private industry during the industrial revolution.[18] Like the itinerant teams that Leibovitz Steinman, Ocean Earth, and the Harrison Studio assemble, three artists (**Bob Bingham**, **Tim Collins** (b. 1956), and **Reiko Goto** (b.1955)) plus attorney **John Stephen** directed university and industry professionals in interdisciplinary research. Building upon the Harrison Studio's model of conversational drift, the **NMR-GP** team engaged the public in meaningful conversations about public opportunities available at the 100-acre Nine Mile Run Greenway, a remnant stream adjacent to an abandoned ten-story slag heap in Pittsburgh, Pennsylvania. Though the NMR-GP team partnered with local government, its members retained autonomy by providing their own funding.

Like Leibovitz Steinman's model for community ownership, NMR-GP provided interested volunteers the training necessary to participate as stakeholders, both in terms of decision-making and labor skills. Like CLUI, NMR-GP tours elucidated the site's central features. Unlike CLUI or Ocean Earth, they didn't aim for amorality (good=consensus), though NMR-GP sought objective decision-making tools. Like Smithson, they value post-industrial public spaces that reveal both the legacy of industrialism and the ecological processes at work.[19] As Mel Chin did, NMR-GP relinquished their authorship, and passed the baton to committed citizen stakeholders.

> Our audience was a diverse group of municipal officials, artists, architects, hikers, bikers, dog walkers, botanists, birders, planners, environmentalists, community representatives and other stakeholders.[20]

After three years of NMR-GP-initiated workshops, site tours, panel discussions, lectures, and exhibitions, community participants generated alternative design guidelines that introduced a socially acceptable solution, that was also economical, aesthetically rich, and ecologically sound. Opting not to restore the brownfield to its original condition (where would the slag go?), they created an integrated ecosystem restoration indicative of nature's complex goals.[21] After careful scrutiny, the artists and biologists realized that slag heaps offer more biodiversity than typical lawns or city parks! So in 1999, the NMR-GP team started the recuperation process by spraying a mulch containing a mixture of nutrients and grass seeds to grow grass on the hard, gray, and otherwise porous slag heap. NMR-GP-related activities eventually altered everybody's cultural, aesthetic, economic, and ecological values. "Recognizing that the Greenway serves both the human and biological communities of the watershed, the Guidelines reflect the range of functions that the Greenway currently serves or may serve in the future."[22]

Background. In 1910, Frederick Olmsted Jr. identified the Nine Mile Run's flood plain as a site for a new city park. By 1922, the Duquesne Steel Company had purchased the land, which it used until 1972 to illegally dump millions of tons of slag, a hard, gray, porous, steel-industry by-product.
The Pittsburgh City Planning Department's 1993 plan for houses and open space on this industrial mound required burying the remnant stream in culverts under 150 feet of slag. The city's proposal to bury the stream first brought the NMR-GP team together.

Model Planning

Model Planning is about talk, argument and shaping attention. - Tim Collins

Year One (1997)	**Ample Opportunity: *The Community Dialogue***
	• Offer on-site workshops on four topics: a) History, Context and Public Policy, b) Urban Stream Remediation, c) Soil Slag and Habitat, and d) Sustainable Open Space.
	• Plan workshops that include a) background documents, b) one to two hour walking tours, c) expert overviews of the issues and alternative approaches, and d)integrated professional/citizen break-out sessions.
	• Place a team facilitator at each break-out session to maximize each stakeholder's involvement. Break-out sessions entail groups of 10-20 people discussing different aspects of that day's topic. Record and analyze all citizen/institutional comments.
	• Identify specific values and opportunities that begin to emerge through this process.
	• Prepare and distribute a final report of issues and values identified during dialogues.
Year Two (1998)	**Ample Opportunity: *The Ecology of a Brownfield***
	• Prepare exhaustive biological and landscape studies to serve as baseline measures.
	• Invite more specialists to engage in interdisciplinary study based on needs set by the community the prior year. Experts generate a set of design alternatives.
	• Continue public programs- mini-dialogues, experts detail latest findings and conclusions, community members weight the values of topics, sub-topics and issues. Citizen comments are integrated into prior year's report of issues and values.
	• Community helps to set goals and guiding principles for final year's work.
Year Three (1999)	**Ample Opportunity: *The Brownfield Transformation***
	• Consult new experts- urban planner, public policy specialist, non-profit administrator, and landscape architect- to advise on realistic institutional and economic plan.
	• Develop effective communication tools (images, texts and events) to build consensus that fosters inertia and support to follow through with plan.
	• Weight the program with recognition and support from local community and decision makers, as well as regulatory and institutional interests.
	• Surround audience in results by choosing a site that facilitates interest/discussion.
	• Invite decision makers to breakfast briefings, tours, and community workshops.
	• Build a transition team.
	• Identify responsible parties and implementation scheme.[23]

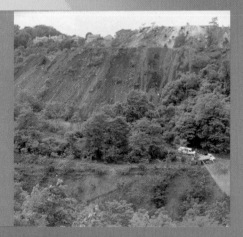

**Nine Mile Run Greenway Project
Slag Mountain**

The left image depicts NMR-GP's project statement overlaying the image of the massive slag mountain. Over a period of 50 years, the Duquesne Steel Company illegally dumped millions of tons of slag, a by-product of the steel industry, onto this site to create this ten-story-high mountain of hard, porous slag. By later spraying a mulch containing a mixture of nutrients and grass seeds onto this man-made landform, the NMR-GP team demonstrated how to transform this gray mountain into a slaggarden.

The outcome of three years of intense discussion, the adjacent guidelines provide parameters that safeguard the Nine Mile Run as a natural site, rich in ecological and cultural benefits. They also demonstrate the community's heightened awareness of the significance of watersheds and biodiversity. How did the NMR-GP team achieve this level of social engagement and commitment to progress? Just as the Harrisons' *A Vision for the Green Heart of Holland* touring exhibition contributed to its wider acceptance, NMR-GP's efforts culminated with *Conversations in the Rust Belt: Brownfields into Greenways* (1999), an exhibition in a Pittsburgh gallery. This site served to facilitate further interest and discussion, as viewers were surrounded by NMR-GP's community generated solutions. The gallery setting enabled them to continue the discussion with breakfast briefings, tours, and community workshops.

Design Guidelines for The Nine Mile Run (December 1999).
The Greenway:

- carries storm water from the entire watershed to the Monongahela River.
- is the route of sewer pipes as well as combined sewer overflow.
- has the potential of serving as a model for ecological restoration and transformation of an urban brownfield.
- can serve as a place for enjoyment of a natural environment as well as a significant recreation, research, and educational resource.
- can provide content for a range of disciplines including ecology, biology, and public policy.
- provides Pittsburgh's East End with an important transportation linkage, eventually enabling a stream and riverside bicycle commute to downtown Pittsburgh.[24]

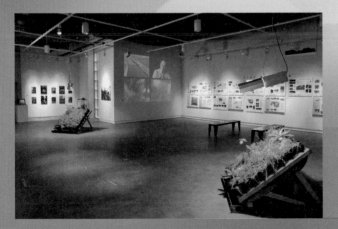

Nine Mile Run Greenway Project, *Conversations in the Rust Belt: Brownfields into Greenways*, 1999, Miller Gallery, Pittsburgh, Pennsylvania

This installation shot features EPA-funded soil/slag test plots plus the kinds of images and texts NMR-GP gathered to facilitate further public tours, meetings, and discussions.

biodiversity / accommodating

A number of artists are completely dedicated to studying species depletion and preserving biodiversity. Diversity is consequential, especially since cultural diversity can be directly correlated with biodiversity. Some artists consider animals to be their ultimate audience. Others have even converted their studios and museum exhibitions into mini-biology laboratories.

habitat architecture

BIODIVERSITY IS DIRECTLY PROPORTIONAL TO CULTURAL DIVERSITY. OF THE NINE COUNTRIES WHERE 60% OF THE WORLD'S REMAINING 6500 LANGUAGES ARE SPOKEN, SIX (MEXICO, BRAZIL, INDONESIA, INDIA, ZAIRE, AND AUSTRALIA) ARE ALSO CENTERS OF MEGA-DIVERSITY FOR FLORA AND FAUNA.[1]

Patricia Johanson (b. 1940) first gained attention in 1968 for *Stephen Long*, a strip of color running 1600 feet along an abandoned railroad track that responded to changes in natural light. This first environmental sculpture of its kind led to a *Vogue* article, as well as a garden commission for *House and Garden* (*H&G*) magazine. The commission never came to fruition, mostly because *H&G* expected Johanson to design estate gardens, while she was more interested to close the gap between thriving habitats and human design.

I saw that by using the line as a compositional basis you could incorporate nature intact, without displacing or annihilating anything else. So the line became a strategy for creating non-intrusive, interwoven structures that could be as large as you wished, but wouldn't be imposing. I later built *Cyrus Field* in this manner.- Patricia Johanson[2]

Although the commission fell through, related research inspired this artist, who later took a degree in architecture, to write a series of essays and design hundreds of inventive sketches for environmental projects. In 1969, she originated plans for water gardens (made from flood basins, dams, reservoirs, and drainage systems), ecology gardens, ocean-water gardens, dew ponds, municipal water-garden lakes, and highway gardens, even though she had no particular clients in mind. "My idea was to take things that are engineered and built, and transform them into fountains and gardens."[3] This thinking paved the way for an entirely new approach to integrating nature and the urban infrastructure.

Moreover, some of the ideas that Johanson developed during this period influenced her organization of *Cyrus Field* (1970), which linked a geometric marble path to a redwood maze configuration to a concrete pattern. Created in the woods near her Buskirk, New York home, the forest's irregularity disrupted this work. Like **Haacke**'s *Grass Grows* (1969) or **Sonfist**'s *Time Landscape* (1965/1978-present), *Cyrus Field* inspired visitors to focus on ecology. Twenty years later, she discovered that several places were moss-covered and the redwood had buckled, as trees grew larger. "The traditional art object is based on the idea of perfection...*Cyrus Field* is alive. The piece grows and changes; it is in the process of becoming other things."[4]

In 1978, Harry Parker, then director of the Dallas Museum of Fine Arts, got the idea to invite her to restore Leonhardt Lagoon, after seeing her *Plant Drawings for Projects* exhibition at the Rosa Esman Gallery. Parker hoped that an art museum exhibition would garner the publicity necessary to raise the funds to carry out Johanson's awe-inspiring design to remediate the lagoon he had loved since his youth. Working in tandem with the Dallas Museum of Natural History, she set out researching what various animals eat, since she wanted to create an ecosystem for a wide range of native plants and animals. The lagoon had died because its food web was out of balance. Aquatic insects, snails, some crustacean, and other middle food-web species were not present, largely due to the absence of a littoral zone, which is composed of vegetation and supports 75% of a pond's life.[5] Her practical and aesthetic proposal, which sought to reshape a functioning aquatic community, was implemented in two phases, first ecological and then sculptural.

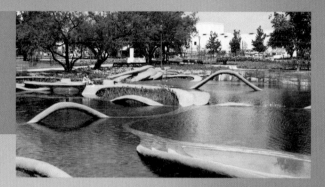

Patricia Johanson, *Fair Park Lagoon*, 1985, Dallas, Texas

Not only did she totally reconstruct this lagoon's food web, but she placed sculptures in the lagoon, elaborate entangled walkable paths with bridges and arches. Her massive paths reference two native Texas plants: 1) a 225-foot by 112- foot by 12-foot sprawling causeway in the form of a "Pteris Multifada" fern and 2) a 235-foot by 175-foot by 12-foot entangled mass of pathways reminiscent of the "Saggitaria Platyphylla" (known locally as the "Delta Duck-potato").

Her 1981 design, which seems like common practice today, was totally experimental back then. To reduce turbidity (clear up the water) and stabilize the shoreline, she suggested planting native emergent vegetation at selected points around the lagoon to act as a mat on top of the silt and to provide a buffer between water and shore. This also helped to eliminate the overpopulation of floating algae. She recommended they trap the problematic Asiatic Ducks and remove them to another location, and also stop fertilizing the strips of grass around the lagoon. Fortunately, this more "ecological" approach both reduced maintenance costs and provided a "living exhibit" for the Natural History Museum.[6]

Johanson even provided the park a complete list of recommended species for the restored ecosystem including: 1) fifteen bank and emergent plant species, 2) four kinds of floating plants, 3) three different submerged plants, 4) eleven fish species, 5) five types of turtles, and 6) several kinds of ducks. To reduce the number of sunfish, she suggested officials encourage fishing with the stipulation that the fisherman not throw the fish back![7]

While this was her first large-scale project, she has since begun or completed dozens of all-encompassing environments in San Francisco, Nairobi, Seoul, Salina, and Petaluma. San Francisco's Sunnydale Facilities, a pump station and holding tank for water and sewage used primarily during heavy rains, hosts *Endangered Garden* (1987-1996). This sewer facility as life-

Patricia Johanson, *Endangered Garden*, 1987-1996
Sunnydale Pump Station, San Francisco, California

Endangered Garden provides food and habitat for butterflies, shellfish, waterfowl, and small mammals, as well as human access to beaches, marshes, and the longshore barrier spit.[8]

supporting work of art increases food and habitat for wildlife, while providing maximum access to San Francisco Bay.[9] This garden's central feature is the giant twisting *San Francisco Garter Snake*, a half-mile-long baywalk winding its way through the park to anchor individual habitat gardens, such as butterfly habitats, bird baths, tide pools/tidal steps, and marshes.

An 1869 U.S. Coastal map shows the presence of sheltered coves, lagoons, tidal marshes, and longshore barrier spits along San Francisco Bay's shoreline—all restored by Johanson. Like Alan Sonfist's use of pre-colonial flora, Johanson opts for local landforms that pre-date modern man's influence. When the tide rises twice daily, the marshes are flooded and various images appear or disappear, so this time-based work constantly changes with nature's ebb and flow.

ONE SEPTEMBER DAY, THE CO-FOUNDER OF THE COMMUNITY GARDENS FOR BUTTERFLIES RECORDED MORE BUTTERFLIES AT JOHANSON'S ENDANGERED GARDEN THAN ANY OTHER PLACE IN SAN FRANCISCO. SHE DOCUMENTED ANISE SWALLOWTAILS, WEST COAST LADIES, CHECKERED SKIPPERS, UMBER AND FIERY SKIPPERS, PAINTED LADIES, A CALIFORNIA RINGELT, A MONARCH, PLENTY OF BUTTERFLY EGGS, AND CATERPILLARS. [10]

THREE BILLION PEOPLE WORLDWIDE LACK CLEAN, SAFE DRINKING WATER, AND NEARLY FOUR MILLION CHILDREN DIE EVERY YEAR FROM RELATED DISEASES.[11]

Just before Johanson got involved in the Nairobi River Park, newly introduced, Japanese-constructed sewage treatment lagoons had mysteriously dried up Lake Nakura, eliminating its world famous wildlife. For *Survival Sculpture (Water Purification)* (1995-present) in the Nairobi River Park, she worked with local workers to reclaim a public resource (previously polluted by human/animal waste and industrial effluents) that also sustains wildlife, urban food plots, and safe water. By diverting a 4000-foot-long meandering channel of river water through wetlands of thickly planted aquatic vegetation and micro-organisms, which decompose pollutants, the river is affordably cleansed before re-entering the main source. This improved habitat attracts birds, butterflies, waterfowl, baboons, and monkeys, providing a wildlife core so central to Nairobi's eco-tourist trade.[12]

> When water was worshipped in Korea as the sacred sustainer of life, water pollution was not a problem. Perhaps by reintegrating nature and culture within public landscapes, we can ensure the transmission of both ancestral truths and the preservation of the gene pool that ceaselessly provides new forms, meanings and products.[13]
> -Patricia Johanson

For Seoul's 912-acre *Ulsan Park* (1996-2002), Johanson preserved important cultural icons by including those animals, insects, and plants found in Korean "Minhwa" paintings in gardens that actually support these species. In this respect, *Ulsan Park* not only reflects cultural history, but protects and transmits genetic information to the future. "Haitai" and dragons (both mythical figures) are depicted in imagery, while carp, grasshoppers, forests, and tigers are present in abundance. The "haitai" are mythological guardians that ward off evil. To teach children about biodiversity and sustainability, children can experiment with pumps, waterwheels, and sluices; experience tigers first hand in the Tiger Valley; and learn about the tiger's extinction in the Sanshin-Dang (shrine building), due to deforestation and habitat loss.[14]

Ulsan Park is not Johanson's only project for Seoul. In 1999, the Seoul Development Institute assembled a team of international experts to design a blueprint for the sustainable development of Nanjido, a dump site, adjacent to the 2002 World Cup Soccer Stadium, slated to become *Millennium Park* (1999-present). Sited on Nanji Island over the Nanji Stream in the middle of the Han River, Nanjido opened in 1978, but was closed off in 1990 when the dump reached nearly 300 feet high. It is also located on Seoul's major growth access, along the major highway between Kimpo International Airport and City Hall. The care of this site is particularly urgent, given its prime location and the fact that during heavy rainfalls industrial pollutants leach into the already-polluted Nanji Stream and Han River.

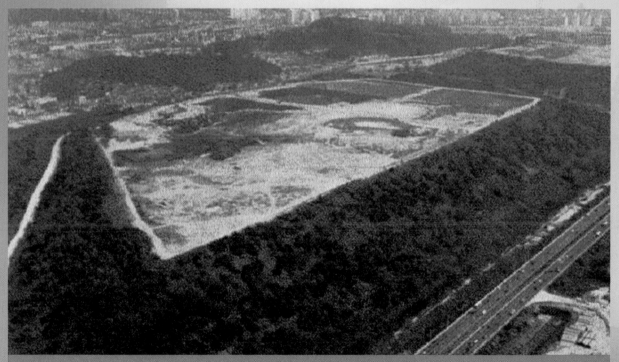

Patricia Johanson, *Millennium Park* under construction, 1999-present, Seoul, Korea

Johanson is transforming a 300-foot dump site into a park whose central feature is the mound of trash terraced to resemble Korea's mythological guardian, the "haitai," which encourages smaller microhabitats and provides hiking trails, overlooks, and vehicular access to the twin summits.

The "haitai" mythological guardian, whose patterning resembles rice-paddy farming, is also used in *Millennium Park* to ward off evil. To stabilize this ominous man-made landform, its slopes have been terraced like the historical "haitai" form to encourage smaller microhabitats and provide hiking trails, overlooks, and vehicular access to the twin summits. "Its reclamation offers the possibility of both serving the public, and re-establishing and protecting native plants and animals within the urban landscape."[15]

Johanson is also designing *Enhancement Wetlands* and *Treatment Wetlands*, public facilities in a 170-acre water recycling facility (formerly called sewage treatment plants) for the City of Petaluma, California (2000-present). Johanson notes that this ecologically innovative sewer treatment plant's proximity to a Sheraton Hotel, marina, and major park offers "an unparalleled opportunity for recreation and education within the context of urban infrastructure, environmental stewardship, and economic benefit."[16]

The restored habitats will attract birds, Western Pond Turtles, Black Rails, the Salt-Marsh Harvest Mouse, and California Red-Legged Frogs. The vehicular access road offers close-up views of various wetland ecosystems (littoral zone, storage ponds for recycled water, habitat islands, tidal marsh, and mudflat). An interpretive center places the treatment center within the larger context of the Petaluma watershed. One trail provides close-up views of river traffic and reveals the intricacies of the tidal cycle.

Johanson's latest project transforms three miles of drainage medians along U.S. 81 in Salina, Kansas (2001-present) into "a public landscape, art, [and] habitat, adding recreational trails and biodiversity to the drainage infrastructure and Wal-Mart."[17]

ocean habitats

Betty Beaumont's experience testing equipment for James Bond movies, as a diver for the Underwater Motion Picture Society, inspired her "fascination with the ocean, its physical beauty and the dream state it induces."[18] While a graduate student in environmental design at the University of California, Berkeley, Beaumont documented the use of high-pressure hoses that eject steam to remove oil from the shore (since proven to cause even more ecological damage), during the clean up of the 1969 Santa Barbara oil spill, the worst in U.S. history. As Barbara Matilsky has observed, her images of this ecological devastation "transcend their status as documentation of a specific oil spill and serve to remind us of the continued assault on ocean life around the world."[19]

Betty Beaumont, *Santa Barbara Steam Cleaning the Santa Barbara Shore in California,* 1969

In 1969, the United States' worst oil spill occurred off the coast of California. Betty Beaumont documented the clean-up process, which has since been proven to cause more ecological damage.

Beaumont has since inserted five environmental works into the landscape, one of which, *Cable Piece* (1977), also provided an ecological benefit. She used 4000 feet of iron cable, which she obtained from a military surplus list, to create a 100-foot diameter ring by looping the cable twelve times. This iron ring, which hastens grass growth, is sited on a Macomb, Illinois farm, and references the circular neutron-accelerator track of the nearby Fermi Laboratories.

Inspired by a team of marine scientists, who had been experimenting to stabilize fly ash, a coal by-product, in water, Beaumont proposed to merge their findings with a type of reef building used in Japanese fish harvesting. In 1978, she initiated *Ocean Landmark*, an artificial coral reef for fish formed from thousands of fly-ash blocks submerged 70 feet beneath the ocean's surface, three miles off the

Betty Beaumont, *Cable Piece*, 1977, Macomb, Illinois

This 100-foot-diameter iron cable ring was left on a farm to bury slowly into the ground. In the years since, infra-red aerial photography has shown that this ring made from 4000 feet of iron cable, looped twelve times, hastens grass growth much like iron spurs human growth. Inspired by the Midwest's Native American burial mounds and nearby Fermi Laboratories, a neutron-accelerator testing facility, this work poetically merged technology and ritual to achieve an ecological advantage.

coast of Fire Island. This reef was intended to counter the damage caused by overfishing, waste dumping, and the destruction of coastal wetlands (see **Aviva Rahmani**'s research in this area). Of equal relevance, her *Ocean Landmark* could help to revitalize the Long Island fishing industry by providing a spawning habitat for fish. Not only did she raise $3 million for the project, she also studied a test site for a year, and researched possible block sizes and scales. To simplify casting, she chose the dimensions of a typical cinder block. After years of preparation, 17,000 8 x 8 x 16-inch blocks, fabricated from 500 tons of recycled fly ash were slowly and selectively dumped along the Atlantic Continental Shelf to construct the artificial coral reef.[20]

This enormous endeavor entailed collaborating with scuba divers, biologists, chemists, oceanographers, and engineers from the State University of New York at Stony Brook, Columbia University, and New Jersey's Bell Laboratories. Her past filmmaking experience came in handy for this massive undertaking, which required years of "pre-production" — researching details, writing proposals, raising funds, scouting locations, and meeting with her collaborators.[21] All of this effort culminated in a one-day installation event. While installing it, she was careful to record underwater sounds using a special hydrophone system. During the launch, technicians in a separate boat obtained echogram images of the installation on the ocean floor and sonic recordings of the fish. These sounds have been used to measure the ecosystem's growth, which is monitored every five years.

> Fundamental to the original concept of the work was the belief that its integrity resided in its invisibility— it could only be imagined.
>
> - Betty Beaumont[22]

Although Beaumont likes the idea of an invisible sculpture, which one grasps either by imagining it or by studying the fish population, she recently received another grant to model the process of dropping blocks to create the reef by using VRML software.

Betty Beaumont, *Ocean Landmark VRML World,* **2000**

From 1978 to 1980, Beaumont collaborated with scientists to create *Ocean Landmark*, an artificial reef three miles off the coast of Fire Island. Wanting to demonstrate this artificial reef's formation, which entailed dropping 17,000 8 x 8 x 16-inch fly-ash blocks, she recently applied VRML technology to simulate this process, which is not documentable with standard photography.

Beaumont, who regularly reads Environmental Protection Agency (EPA) reports, discovered a report describing dozens of examples of fish exhibiting mutations as a result of the presence of radioactive World War II waste stored in drums deep beneath the ocean's surface. She later realized that another branch of the EPA had designated this same site as the best place to dump New York City sludge, a slushy remnant of sewer treatment. Fortunately, the same man who lent her a helicopter for *Ocean Landmark* still worked at the EPA. She contacted him to tell him of this egregious error. Although he was unaware of the EPA's fish report, her intervention prevented this site from becoming even more contaminated. Ocean dumping has since become illegal.

Using research gathered a decade earlier, she created *Fish Tales* (1991), a series of flash cards illustrating the dozens of species mutated by their exposure to nuclear waste. Beaumont's image and text flash cards are based on information gathered by scientists working at the National Oceanic and Atmospheric Administration. Created as an edition to be sold to the general public, such cards warn of the horrific evolutionary changes that human beings are triggering.[23]

trans-species art

"I may as well be making art for antelope"

- Lynne Hull[24]

Lynne Hull, *Turtle Island,* **1997, Lincoln Memorial Gardens, Springfield, Illinois**

During its first summer, *Turtle Island* (1997) hosted geese, ducks, green heron, cormorants, songbirds, swallows, frogs, aquatic insects, and three species of turtles. Once Hull's works are installed, biologists monitor them to determine their effectiveness. She has erected similar works for sites in England, Kenya, Mexico, Northern Ireland, and the United States.

Since 1985, **Lynne Hull**, the inventor of trans-species art (art created for animals), has worked with state wildlife departments, the Forest Service, the Bureau of Land Management, and the National Parks Service to place over thirty ecologically beneficial works throughout Colorado, Florida, Kansas, Massachusetts, New York, Ohio, Oregon, Texas, Utah, Virginia, and Wyoming. She has implemented similar projects in England, Kenya, Mexico, and Northern Ireland. She collaborates with wildlife specialists, environmental interpreters, landscape architects, and local community members to create sculptures and installations that "provide shelter, food, water or space for wildlife, as eco-atonement for their loss of habitat to human encroachment."[26]

HULL'S CLIENT LIST INCLUDES HAWKS, EAGLES, PINE MARTENS, OSPREY, OWLS, SONGBIRDS, WATERFOWL, BATS, SPIDER MONKEYS, BEAVER, OTTER, SALMON, FROGS, TOADS, NEWTS, BUTTERFLIES, BEES, OTHER COUNTLESS INVERTEBRATES, AND OCCASIONAL HUMANS.[25]

Trans-species art doesn't alter the environment. It often foregrounds its location, but it must also fit in with the surrounding ecology. Some trans-species works withstand the elements to make lasting contributions to the lives of the animals they support. Some last only as long as it takes for restoration to begin and for nature to take over again.[27] Others enter the natural cycle rather quickly. Once works are installed, Hull depends on wildlife biologists and zoologists to evaluate their impact. Five summers in a row, a specialist observed young Ferruginous hawks, a threatened species, nesting in Hull's *Lightning Raptor Roost* (1990) (see accompanying case study). This led him to deem the project a success on scientific terms.

> Where early site-specific sculpture was in a sense a parasite of nature, absorbing surrounding beauty but contributing little to its continuity, Hull's work functions within that environment, exchanging beauty with that of the surroundings.
>
> - Lucy Lippard.[28]

For *Hydroglyph 1* (1983), Hull carved spiral hydroglyphs into rocks, so that rain or snow could be caught and stored for desert wildlife in Wyoming. She considers *Hydroglyph 1* the first example of trans-species art. It is the inverse of Smithson's *Spiral Jetty*, in that water resides in stones, rather than stones occupy water. By contrast, *Stones for Salmon* (1993) entailed placing etched boulders in Northern Ireland's Colin Glen River to provide spawning pools for salmon. Hull has built marten havens, enabling pine martens, which depend on old growth forests, to survive in younger forests or on the edges of clearcuts.[29] *The Raptor Roosts*, for which Hull first became known, offer eagles and hawks of the high plains an alternative to perching and nesting on potentially deadly utility poles. As she learns about different eco-zones, she explores the needs of local wildlife in order to devise appropriate structures. Most of her works are designed with "biofeedback loops," which is to say that the support of one species leads to the support of another species, and this leads to greater biodiversity.[30]

Lightning Raptor Roosts, 1990, Red Desert, WY[31]

1. Hull receives New Forms: Regional Initiatives Grant from the Colorado Dance Festival and the Helena Society; and a re-grant from NEA, Rockefeller Foundation, and Apache Corporation funds.

2. Wyoming's "Wildlife Worth Watching" program and the Bureau for Land Management (BLM) help her select a site adjacent to a small parking pull-out, in a bare, windy section of the Red Desert.

3. Pacific Power and Light (PP&L) agrees to donate poles and install the sculptures.

4. With the help of carpenter Mark Ritchie, Hull designs and roughs out large sculptures in a BLM garage in Rawlins.

5. In November, they move the pieces to the site. The BLM raptor specialist adjusts the wire mesh on the nesting platform to make sure bird claws couldn't get caught. Game and Fish personnel observe, photograph, and videotape the installation. The PP&L crew, with their massive line truck and crane, drill the hole and hoist the roosts.

6. Another roost is installed close enough to the parking lot that travelers can observe hawks and eagles perch.

7. During a break, the PP&L crew discuss the problem of eagles nesting on power poles.

Lynne Hull, raising the *Windmill to Raptor Roost*, 2000, Lubbock, Texas (Photo Credit: Kippra Hopper)

Working with students from Texas Tech University, Lynne Hull raises a raptor roost made from reworked windmills.

Texas Text (2000), an environmental sculpture in a playa lake on the grounds of the Texas Tech Research Farm in New Deal, Texas, attempts to restore declining species native to the Texas Panhandle and migratory birds passing through. This sculpture could assist recent arrivals, species whose presence the human-revised landscape makes possible. Working in collaboration with established groups such as university scientists, the Bureau of Land Management, and the Pacific Power and Light may not sound subversive, but the fact that Hull works with non-art agencies, personnel, resources, and equipment to create art to support wildlife, makes her smile inside.

Lynne Hull *Puente Monos (treetop monkey bridge),* 1998, Punta Laguna, Quintana Roo, Mexico

Working with Mayans living in a Yucatan forest, Hull designed this bridge to enable spider monkeys in a natural preserve to cross a road without being frightened by cars, people, and dogs. Using machetes, the Mayans swiftly cut the lightest, but strongest tree branches with shapes Hull admired. They then used nylon cord to tie the branches together and suspended them like a hammock. The monkeys' preservation is crucial both to sustain biodiversity and to attract eco-tourist income. Unfortunately, the biologist originally committed to this project abandoned it. Hull speculates that the reason the monkeys don't use this bridge is because they may not trust the structure. This project might have worked better had the biologist remained involved.[32]

> HULL'S ADVICE TO ARTISTS WHO WANT TO WORK INTERNATIONALLY IS TO BE CROSS-CULTURALLY AWARE OF HOW THINGS ARE DONE IN THE PLACE YOU'RE IN, BUT YOU MIGHT AS WELL BE TECHNOLOGICALLY AWARE TOO. THEY PROBABLY KNOW WAY MORE THAN YOU DO ABOUT THEIR PLACE. THEY KNOW HOW TO MAKE THINGS WORK IN THEIR ENVIRONMENT. [33]

Like **Leibovitz Steinman's** massive public works, some of Hull's smaller scale projects offer economic benefits in addition to ecological ones. They often provide short-term jobs, teach new skills, or build the infrastructure by creating eco-tourist attractions, thereby warding off undesirable industries. For instance, she used a U.S.-Mexico Fund for Culture grant to work with ProNatura, a Mexican environmentalist group, and local Mayans to build four art projects that benefited both the people and animals. By constructing a playground in the Moxviquil Reserve, San Cristobal de las Casas, in the state of Chiapas, they provided children a safe play area. The playground's design mimics animal habitats, leading children to play-act at animal behavior, thus creating an awareness of the presence of local fauna. They created houses in the Huitapec Reserve (also in San Cristobal de las Casas) for cavity-nesting owls, whose nests have been threatened by illegal woodcutting. In Punta Laguna, in the state of Quintano Roo, they suspended a bridge to help resident spider monkeys, living in a community nature preserve, cross the road without being frightened by cars, people, and dogs. Using tree branches, they marked out a canoe trail in the Punta Laguna, where an abundance of turtles, waterfowl, and other tropical species make it a popular eco-tourist attraction. All the workers were paid a sum on a sliding scale reflecting the job's potential danger, such as climbing a tree to hang the monkey bridge. Owls and monkeys not only optimize biodiversity, but they attract tourists, whose presence can ultimately prevent further deforestation.[34°]

spying for nature

By proposing a new mode of inter-species socialization that is fundamentally constructed, fictive and imperfect, Håkansson defers from offering pragmatic solutions, or the next paradigm model. Instead, his practice asks to be understood as an allegory that illuminates the complex circumstances of species estrangement in general.[35]

-Joshua Decter

Henrik Håkansson first gained international attention with *Z.O.N.E. (Zoological Optimized Nocturnal Ecstasy) for Frogs* (1996), included in the landmark exhibition NOWHERE, at Denmark's Louisiana Museum. This was his second work to feature the musical talents of frogs. Håkansson and percussionist and DJ Jean Louis Huhta played techno and trance music to inspire a polyrhythmic croaking chorus. His *Monsters of Rock Tour* (1996) carried the sound of thousands of live crickets chirping together across a public address system. *Wall of Voodoo's* rather prescient 1996 title forecast an ominous curse. The survival of a colony of Peruvian fern stick insects depended upon their man-made ecosystem's computer-controlled heat, light, and moisture levels. Some insects died from eating pesticide-coated plants and then the wall structure accidentally collapsed. The bio-techno zone's creator's absence raised some eyebrows. But, this was not his first brush with moral turpitude: for *Growing Up in Public* (1994), Congo beetles depended on viewers to provide them their daily supply of bananas and water.

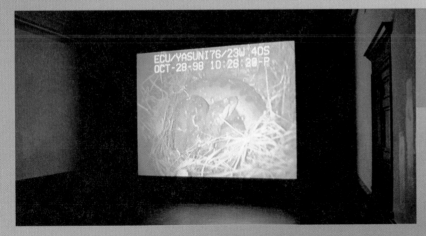

Henrik Håkansson, *Sleep (Eunectes murinus)*, 1998, projected video, Yasuni Park, Ecuador

Tipping his hat to Andy Warhol's video *Sleep*, Håkansson taped a sleeping anaconda until the camcorder's batteries expired after three hours.

At some level there is an abiding interest in the urban cult of surveillance cameras, the possibility, as Håkansson describes, of "action everywhere," that may or may not be used as evidence. But for every low-profile, pen-size camera, there is a moment during which the artist is obtrusively stumbling, waving the directional mike around, a high-tech parody of the butterfly collector's swooping, retinal activities.[36]

-Andrew Gellatly

Like Johanson's habitats or **Beuys**' *Coyote* performance, most of Henrik Håkansson's current work places nature's secrets center stage. To do so, he opts to penetrate them with a camcorder's lens. Håkansson's parasitic works focus on nature, but they rarely address biodiversity or contribute to conservation, though they thrive on it. Because animals make his works, he depends on biodiversity for the continued health of his artistic project, almost as much as his "non-sites" require galleries and museums. For this reason, this provocative artist is one of today's most exhibited eco-artists. In the absence of diversity and unpredictability, his works wouldn't hold interest for long.

Håkansson's point is nearly this simple. Real feelings for nature require the right equipment to discern its intricacy. By fanning the flame with supposedly dispassionate instruments, viewers spy on nature's behalf. While too many artists display live animals to capture their audiences' immediate attention, Håkansson pairs living things with live-feed video versions to reveal a splitting, as viewers glean more from the screen than the real thing. Recent works like *Untitled (Production Set)* and *Prototype*

Henrik Håkansson, *Nightingale- Love Two Times*, 2001, 35 rpm record

Håkansson recorded both a Swedish and an Italian nightingale, one on each side of the same record. When played simultaneously, the nightingales perform a duet of sorts, lending cultural diversity to biodiversity. Like Felix Gonzalez-Torres' stacks of printed paper sheets, the records are available as take-away works of art.

(Funnel Trap) (both 2000) are actually high-tech stage sets designed to lure insects and to record their activities from multiple perspectives. These sets facilitated two intimate filmic encounters, *Lure* and *The Tunnel* (both 2000), respectively. Accompanied by sound tracks reflecting each trap's distorting echos, they were broadcast larger than life on gallery walls.

By contrast, projects like *Out of the Black Into the Blue* (1997), *Park Life (Birdhouse Project no. 3)*(2000), and *A Thousand Leaves* (2000) affirm biodiversity's significance. For *Out of the Black Into the Blue*, Håkannson built an open-air sanctuary for butterflies and moths (once indigenous to Italy, but now extinct) in the Nordic Pavilion at the "Venice Biennale." Audiences witnessed moths and butterflies undergo metamorphosis either firsthand or on monitors. Feeding was an especially popular event.

For *A Thousand Leaves*, pen-size cameras were focused on aspects of a 90-foot-long meadow, built along an excavated property adjacent to a beach. Visitors observed the plants' and insects' real-time progress on flat screens attached to the meadow's fence. In contrast to other eco-artists' literature, this reconstructed meadow's content is never discussed. As it turns out, the meadow contained a European flower known as the thrift, which is endangered in Finland due to habitat

Henrik Håkansson, *A Thousand Leaves,* 2000, Helsinki, Finland

Håkansson dug a 90-foot trench adjacent to a beach and planted a temporary meadow in soil mixed with beach sand. Flat-screen monitors suspended on the fence enclosing the meadow displayed images of insects and growing thrifts captured by pen-size cameras. Part of it still exists thanks to those who still care for it.

loss. The site was selected for its proximity to a section of Helsinki where the exhibition's other projects were sited. Basically dismantled after the exhibition ended, a fraction of the meadow remains, since some of the local people who helped create it still look after it.[37]

Given the role of video in monitoring animal behavior, Håkansson's fascination with surveillance isn't so far off base. Håkansson's project explores this odd relationship further. "Scientific observation can create order and focus. But what sort of order? Focus on what?"[38] Despite the issues of control associated with surveillance, Håkansson's use of surveillance liberates nature from neglect.

For *Tomorrow and Tonight* (1999) at Kunsthalle Basel, video images of an outdoor roof garden's activities were interrupted by surprise images of spectators experiencing the exhibition, enabling the now objectified/subjugated /violated/spied-upon spectator to momentarily exchange roles with nature. The roof garden was built in collaboration with the University of Basel's Institute of Geography's Urban Ecology Research Group. The experimental roof garden, where the drama actually unfolds would ordinarily be the focus of a typical eco-artist's work, but here it plays second fiddle to the power and seduction of images obtained via surveillance.

Henrik Håkansson, Zeewolde Field Library, 2001, Zeewolde, the Netherlands

Like CLUI's Desert Research Center and Steinmann's Forum for Sustainability, Håkansson has inserted a field observatory into a field. This trailer features mostly field guides for Dutch flora and fauna. Despite his having conducted field research in an Ecuadorian rain forest, Trinidad's Arima Valley, a Finnish roadside meadow, a Swedish wetland, and a Basel roof-top garden, Håkansson's research tends to yield quirky videos and sound recordings, leaving underlying specimens unaffected.

species reclamation

Since 1995, **Brandon Ballengée** (b. 1974) has been researching amphibian deformity and population decline. To this end, he has contacted and interviewed numerous scientists conducting related studies. In 1999, he began breeding and experimenting with live Hymenochirus family frogs to explore aspects of their recent development that might explain their declining populations. Describing his process as species reclamation, Ballengée's studio practice entails recreating the nearly obsolete Hymenochirus curtipes model frog, a frog that was once abundant in the Democratic Republic of the Congo (formerly Zaire). By controlled pairing of related species, he literally breeds the species backwards. The Congo's biodiversity has been threatened by the "slash and burn" clearing of forests to meet the logging demand. Unfortunately, civil strife and political chaos over the past decade have made conducting biological studies there incredibly difficult.[39]

Ballengée has either instigated or participated in numerous wetland surveys throughout North America. Since 1996, he has worked with biologist Dr. Stanley Sessions of Hartwick College to develop and test various hypotheses that explain the recent increase in the population of malformed frogs. A November 1999 survey in Franklin County, Ohio, revealed a deformity rate of 1% at some sites, but a June 2001 survey of 1000 individual specimens in the same region yielded a deformity rate of greater than 5%.[40]

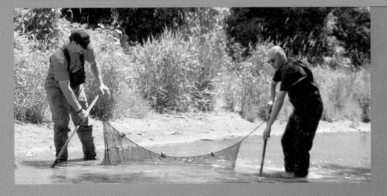

Dr. James Barron and Brandon Ballengée, *Surveying a Wetland at State Run Park*, Franklin County, Ohio, June 2001 (Photo Credit: Dr. Mac Albin, Franklin County Wildlife Research Division)

As field observers for the United States Geological Survey's North American Reporting Center for Amphibian Malformations (NARCAM), Ballengée and Dr. James Barron of Ohio State University, Lancaster, conduct a six-week joint survey of amphibian populations in Fairfield County (central Ohio). Since June 1998, Ballengée has worked with biologists to conduct deformed amphibian surveys for NARCAM in Ohio, Florida, Pennsylvania, New Jersey, New York, and Tennessee.

The Malformed Amphibian Project (1995-present)[41]

Background. Fossil records indicate the presence of frogs and salamanders as far back as 250 million years ago, long before dinosaurs. By continued adaption and variation, they have survived large-scale environmental shifts. Reports of amphibian deformity date back several centuries, but in the past few decades this phenomenon has exploded on a global scale.

1989	International herpetology conference identifies the global population decline and rise of developmental abnormalities among frogs, salamanders, and other members of their class.
1990	Noted expert on amphibian deformity, Stanley Sessions co-authors article in *The Journal of Experimental Zoology* that outlines his hypothesis explaining this phenomenon. His theory that abnormal limb growth is caused by parasites of the trematoda class - goes largely unnoticed.
1995	Minnesota school kids' discovery of dozens of malformed frogs becomes a highly publicized news story, leading to a firestorm of similar stories in North America, South America, and Asia. Scientists report the rate of malformation of frogs in ponds and lakes to be as high as 80% in Minnesota and Quebec, versus 8% in Vermont.
1996	Brandon Ballengée begins working with scientists to study amphibian population decline and deformities.
1999-2001	Ballengée works with biologists to survey amphibians in New York, New Jersey, Pennsylvania, Florida, Ohio, and Tennessee for the United States Geological Survey's North American Reporting Center for Amphibian Malformations (NARCAM).
2001	Ballengée and Dr. James Barron of Ohio State University, Lancaster, conduct a six-week joint survey of amphibian populations in Franklin County (central Ohio), which shows a rise from 1% amphibian deformity in 1999 to greater than 5%.

Brandon Ballengée and Dr. Stanley K. Sessions
Cleared and Stained Deformed Hyla Regilla, Pacific Treefrog, 2001

Malformation caused by the trematode Ribeiroia. Imaging by Brandon Ballengée in collaboration with Dr. Stanley K. Sessions. 8000 dpi scan courtesy the Institute for Electronic Arts, School of Art and Design, New York State College of Ceramics at Alfred University, Alfred, New York.

At first glance, Ballengée's recent project, *The Ever Changing Tide: The Ecological Dynamics of the Earth's Oceans as Exemplified through the Biodiversity of the Queens Seafood Markets* (2000-2001), resembles artist **Mark Dion's** 1992 effort to identify and log the varieties of fish found in New York City's Canal Street fish stands. By contrast, Ballengée visited various fish markets in Flushing, New York, over a period of a year to amass around 450-500 species of seafood from all over the world. Taking the act of collecting and the process of identifying one step further, Ballengée conducted a phylogenic examination–preserving, photographing, and digitally recording each specimen. Todd Gardiner of Hofstra University's Marine Biology

Department and Peter Warny, Associate Researcher at the New York State Museum, helped him preserve and identify each sample's precise taxonomic placement. He worked with Mercedes Lee of the National Audubon Society's Living Ocean Program to discern each species' ecological status. Classified and sorted according to family, genus, and class, (some remain unidentified), the collection of Iris prints are arranged to form a large geometric wall installation that visualizes their evolutionary interrelationships. Finally, the actual specimens entered the ichthyology study collections of the American Natural History Museum, The New York State Museum, and the Peabody Museum at Yale University.[43]

Scientists have narrowed the cause of red bloom or brown tide to four hypotheses: increased levels of nitrogen due to fertilizers flowing through the watershed to the ocean, water temperature fluctuation due to global climate changes, the introduction of exotic species via international

The BIG Question?
Why are there fewer amphibians? [42]

Hypotheses tested by scientists Stanley Sessions and Jim Barron, and artist Brandon Ballengée.

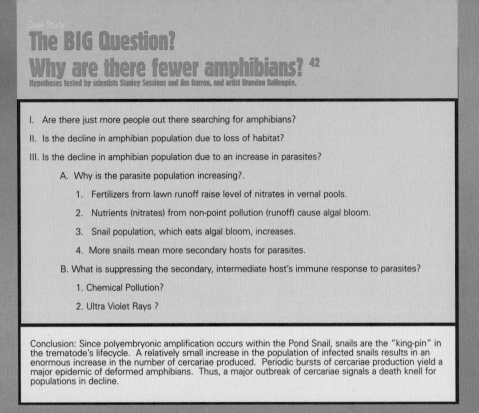

I. Are there just more people out there searching for amphibians?

II. Is the decline in amphibian population due to loss of habitat?

III. Is the decline in amphibian population due to an increase in parasites?

 A. Why is the parasite population increasing?.

 1. Fertilizers from lawn runoff raise level of nitrates in vernal pools.

 2. Nutrients (nitrates) from non-point pollution (runoff) cause algal bloom.

 3. Snail population, which eats algal bloom, increases.

 4. More snails mean more secondary hosts for parasites.

 B. What is suppressing the secondary, intermediate host's immune response to parasites?

 1. Chemical Pollution?

 2. Ultra Violet Rays ?

Conclusion: Since polyembryonic amplification occurs within the Pond Snail, snails are the "king-pin" in the trematode's lifecycle. A relatively small increase in the population of infected snails results in an enormous increase in the number of cercariae produced. Periodic bursts of cercariae production yield a major epidemic of deformed amphibians. Thus, a major outbreak of cercariae signals a death knell for populations in decline.

shipping, and decreased exchanges with ocean water. In 2000, Ballengée began to culture red and brown algae, and field collect a variety of harmful and innocuous microscopic algae, from fresh and marine sources throughout the United States. He then photo-documented all of these specimens and others sent by Harmful Algal Bloom researchers stationed at Woods Hole Oceanographic Institution. Some images include cyanobacteria (formerly known as blue-green algae), unidentified bacteria, and a fungi that contaminated a number of his earlier cultures. Ballengée's *The Red Bloom and Brown Tide: A Visual Survey of Toxic Microalgae* was exhibited at the Hillwood Art Museum, Long Island University's C. W. Post Campus in Brookville, New York.

When is algae problematic?
In the past two decades, patches of microscopic, single-cell algae—as opposed to beneficial blue-green or green algae—have grown so fast that they alter marine habitats by blocking out light and killing water life. Known as red bloom or brown tide, such overgrowths are responsible for upwards of $1 billion in losses, including human illness and death. This problem became newsworthy in 1985, when an immense bloom of tiny microalga Aureococcus anophagefferens occurred concurrently in Long Island and nearby mid-Atlantic coastal bays, reducing New York's commercial scallop and hard clam harvest by 80%.[44]

Like Brandon Ballengée's project to regenerate a nearly obsolete species, **Tera Galanti** (b.1960) has been breeding flightless silkmoths backwards since 1997 to create flying silkmoths. Immobilized by man, silkmoths have been bred so that their bodies are disproportionately larger than their wings. Wild moths fly away upon emerging from their cocoons, but weak-winged silkmoths remain close to their cocoons, awaiting human help. In silk production, silkmoths never emerge from the cocoon, since they're steamed to death during the process.

By chance, Galanti noticed some silkmoths attempting flight, and chose to explore whether it was possible to breed them to fly, thereby facilitating their return to a wild state of being. Silkworm farmers only allow weak-winged silkworms to reproduce. Galanti's project reverses this strategy by favoring strong-winged silkmoths. Male silkmoths are more likely to fly since their wings are proportionately larger.

Galanti's interest in silkworms developed from a childhood fear of flying moths and an adult fascination with the concept of domesticating animals. Her devotion to their well-being ultimately overcame her original fear. She links her childhood fear of flying moths to the more general fear of "wild" things, provoked by humankind's loss of control over the environment. The need to control nature underlies most of society's civilizing solutions, such as re-orienting rivers, culverting creeks, or eliminating pests. By forcing order to perfect their world, humans have thwarted biodiversity, wreaking havoc on nature.[45]

Beautiful Moths (Fly) Project Plan
2002, graphite and digital media
8 1/2"x11"

Beautiful Moths (Fly), 2002, 50 inches x 72 inches x 72 inches
Silkmoths, cocoons, fabric, foam, wood, wire, paper and plastic ties

Since 1997, Tera Galanti has bred silkmoths backwards in order to cultivate silkmoths that fly. This particular sculpture demarcates the best fliers, who mate as they fly to higher and higher levels, thus improving their offspring's ability to fly.

urban infrastructure

Some artists are predominantly involved with urban infrastructure, inevitably exploring issues of environmental justice. A city's compacted scale often makes it ecologically efficient, but pollution is rarely distributed equally. As a result, the need for more greenspace, economic opportunities, clean energy, clean water, and clean air are especially pressing concerns.

urban forests

Ten years before landscape architect George Hargreaves began to transform the University of Cincinnati into a verdant wonderland, Sonfist proposed *Cincinnati Castle of Refuge* for this same institution. His open-sky castle made from refuse would have protected over 400 indigenous species of trees, shrubs, and wildflowers. Some of the plants selected included bellworts, wild ginger, Jack-in-the-pulpit, snow trillium, and bluebells. Viewers would then spy on venerable species through portholes in the debris.[1]

While artists like **Michael Heizer** and **Smithson** were "bulldozing tons of earth and rocks in remote parts of the western United States to create monumental Earthworks, **Alan Sonfist** (b. 1946) chose to situate his most significant work within the city itself."[2] In contrast to Earthwork builders, Sonfist pledged not to destroy a natural environment in order to create a work of art. In fact, he remained deeply committed to urban environments, particularly because he grew up near the Bronx River Park. After a river drowning led authorities to brand his beloved forest dangerous, the park's trees were cut down and their roots were encased in concrete. For almost 40 years, Sonfist has dedicated his work to linking city-dwellers and suburbanites to a nature that civilization has destroyed, with the hope that a greater appreciation of nature would encourage them to protect its future.[3] Eleanor Heartney notes that once eco-art emerged, artists began to focus on the reclamation and restoration of ecological systems severely stressed by industry and urbanization. Sonfist's work was separated from this group, though "he is certainly one of the originators of this way of thinking."[4]

In 1969, Sonfist monitored the air quality of four popular New York City intersections (57th Street and Fifth Avenue, 42nd Street and Broadway, West Broadway and Houston Street, and Rector Street and Broadway) and posted the results to alert passersby.[5] In 1973, Sonfist drew

Seed Catcher, whose concept parallels **Ono**'s 1961 *Painting for the Wind* and **Haacke**'s 1970 *Bowery Seeds* (both are detailed in the "Activism" section). *Seed Catcher* described its own conditions: "pool of virgin earth to collect the seeds of nearby forests through wind and animal migration."[5] Later realized as *Pool of Earth* (1975) at Artpark in Lewiston, New York, it occupied a 25-foot-diameter, six-foot-deep hole in land that was tainted by chemicals leached from nearby Love Canal. Sonfist laid a clay-based, sealed environment (the pool of untainted earth) over the wasteland to collect the seeds.[6]

In addition to the New York Parks Department's folding Sonfist's *Time Landscape* into its *Greenstreets* program, several new ecoventions by Sonfist are on the horizon. For *Secret Garden* (2001), sited in the Walker Botanical Garden in St. Catherines, Ontario, Sonfist elected to replace a section near the garden's entrance with 100,000 tons of rocks and boulders, and to plant the seeds of 800-year-old cedars. The boulders are piled into a ten-foot-high tower of stone, 34-feet in diameter, and the slabs are arranged according to their geological history from the ice age back into time.

"Conceived as a circular configuration of monumental stones within which endangered tree and plant species will grow in perpetuity,"

Alan Sonfist, *Secret Garden*, 2001, Walker Botanical Garden, Rodman Hall
St. Catherines, Ontario

Wanting to draw attention to the cavalier way most parks still use pesticides and fertilizers on flora, Sonfist built a large rock garden near this park's entrance that included seeds planted from ancient cedars. Using rocks eliminates the need for chemicals.

Sonfist's *Secret Garden* has openings or windows in the stone walls, enabling visitors a partial view of the life growing within.[7] The openings between the rocks correspond with shadows cast to highlight the forest during the summer and winter solstice. By offering a natural alternative to the typical garden, Sonfist wants *Secret Garden* to challenge public parks and botanical gardens that continue to spray harmful pesticides and fertilizers.

Pesticides that spread throughout the watershed during watering are some of the most pestilent pollutants. "Wildlife scientists have uncovered persuasive evidence that artificial pesticides and industrial chemicals are infiltrating wombs and eggs, where they send false signals imitating or blocking hormones, which control sexuality. Although the parents are unharmed, their embryo's sexual development is disrupted, and some male offspring are left chemically castrated and females become sterile."[8] Timothy Kubiak believes that this could have significant biological repercussions among species and populations around the globe. Forty-five chemicals used to kill insects and weeds either mimic estrogen or inhibit testosterone.

Another project on the horizon was initiated 20 years ago. In 1982, Harry Parker, then director of the Dallas Museum of Art, asked Sonfist to propose an alternative to the city's official plan for a park along the river. "While the official plan recommended the creation of an artificial lake over a polluted flood plain, Sonfist suggested that a series of time landscapes [islands] could recreate the diverse ecologies which characterize the state of Texas, while simultaneously introducing a natural filtration system to purify the sewage and industrial waste that were damaging the flood plain."[9] The City of Dallas eventually altered his plan and decided to create only one island along the lines suggested by Sonfist in an effort to restore the natural edges of the river. Unfortunately, the city waited 20 years to finally build it.

Alan Sonfist, *Island of Dallas*, 1997

Fifteen years after Sonfist first proposed a series of time landscapes, he was asked to consolidate his ideas into one man-made island, slated to be built in 2002. This single island both restores the river's natural edge and filters sewage and industrial waste.

After the revolution, who's going to pick up the garbage on Monday morning?[10]

The culture confers lousy status on maintenance jobs= minimum wages, housewives= no pay[11]

To heal is not to erase.[12]

- all quotes Mierle Laderman Ukeles

Mierle Laderman Ukeles' (b. 1939) *Manifesto for Maintenance Art* (1969), which doubled as a proposal for an art exhibition entitled *Care*, anticipated how her work, and that of other ecologi-cally-minded artists, would develop over the next few decades. Her proposal's final directive, *Part Three: Earth Maintenance*, called for the contents of a sanitation truck, a container of polluted air, a container of polluted water from the Hudson River, and a container of ravaged land to be dropped off at the museum daily. Upon delivery, each container would be serviced– "purified, de-polluted, rehabilitated, recycled, and conserved" by various technical procedures. Unfortunately, this plan never came to fruition, but it set the stage for all sorts of maintenance activities that museums have housed or sponsored, such as Haacke's *Rhinewater Purification Plant*, **Chin's** *Revival Field*, **Jackie Brookner's** *Prima Lingua*, and **Meg Webster's** *Pool* (1998) (P.S. 1 Center for Contemporary Art).

In 1977, Laderman Ukeles became the unsalaried, official Artist-in-Residence for the New York City Department of Sanitation (DOS), for whom she has produced over 25 large-scale works of art.[13] After the blizzard of 1978, she performed *Touch Sanitation* (1979-81), for which she shook hands and personally thanked all 8,500 NYC sanitation workers from all 59 community districts. For *The Social Mirror* (1983), a 20-foot long mirror was hung on the side of a garbage truck, enabling people to experience their reflected image, stressing each person's role in producing garbage.

In 1983, she designed the multi-media presentation *Flow City* for the DOS Marine Transfer Station (at 59th Street on the Hudson River), whose waste flow equals that of San Francisco. While collaborating with DOS architects and engineers on the renovation of this decrepit site, she envisioned a "museum of the environment," which would enable people to climb a 248-foot long *Passage Ramp* made from ten to twelve recyclable materials, including crushed glass and shredded rubber, to view the 24,000 tons of garbage that are processed daily. Unfortunately, this never materialized.

Around the same time, she was hard at work developing a future plan for the 2200-acre Fresh Kills Landfill, Staten Island, which was set to close in 2010. In 1985, an eco-gas reclamation program was added to provide energy for 22,000 homes, making this the most sophisticated renovation of an existing landfill in the United States. Fresh Kills was expected to reach a height of 500 feet to become not only the world's largest landfill, but the world's largest man-made structure and the eastern seaboard's highest point. Tired of being considered New York City's dumping ground, this Staten Island community fought to close its local landfill.[14] Laderman Ukeles finds it amusing that a large vegetated wall obscures the view of shoppers at the Staten Island Mall, which borders Fresh Kills. She sees this as "the basis of our whole culture—buy, buy, buy, and waste, waste, waste."[15] She sees the landfill as a social sculpture, since everyone has contributed to its growth.

> Since 1977, Mierle Laderman Ukeles has been the self-declared unsalaried artist-in-residence for the NYC Department of Sanitation. As a result, she single-handedly opened up a new field for artists. In 1988, the City of Phoenix initiated the nation's first master plan incorporating artists into public works like solid and wastewater treatment plants. Artists like Patricia Johanson, Laurie Lundquist, Viet Ngo, Susan Leibovitz Steinman, and Michael Singer have since played a role in designing the infrastructure for solid waste and wastewater management.

In 1996, it was announced that Fresh Kills would close at a height of 100 feet, about one-fifth

its original capacity. It received its last official garbage barge on March 22, 2001. By September 13, 2001, the super-efficient sanitation department had mobilized 25 barges and re-opened Fresh Kills to house the World Trade Center (WTC) debris. The addition of the WTC material will only add another five feet, but it also turns Fresh Kills into a burial mound. Not only have ashes from bodies been added, but since it is the site where WTC debris is sorted, it is also home to some human remains, lending new meaning to the name Fresh Kills ("Kills" means "river" in Dutch).

When it was first closed, a design competition was held to explore possible future uses for the Fresh Kills Landfill. In December 2001, three top finalists were named and their innovative designs were exhibited both at the Staten Island Institute for Science and the Municipal Art Society in Manhattan. Given Laderman Ukeles' original role in designing Fresh Kills, she will inevitably collaborate with the winning team, which comprises artists, architects, landscape designers, and many others. Not surprisingly, all of the finalists included plans for a memorial site at Fresh Kills.

Awaiting the fate of the prematurely closed landfill, Laderman Ukeles had already entered Phase II of her design plan. She was experimenting with a variety of recyclable materials and pre-consumer waste. "These prospective landfill construction/art materials will be used on a huge scale, in ways not yet seen. The challenge is to determine whether they are permanent, durable, and safe, and whether they make sense at this scale, artistically."[16] Only time will tell whether her experiments are incorporated into the winning designs. After 30 years of public maintenance art, she is still fond of her field.

> The design of garbage should become the great public design of our age. I am talking about the whole picture: recycling facilities, transfer stations, trucks, landfills, receptacles, water treatment plants, and rivers. They will be giant clocks and thermometers of our age that will tell the time and health of the air, the earth, and the water. They will be utterly ambitious—our public cathedrals. For if we are to survive, they will be our symbols of survival. [17]
>
> -Mierle Laderman Ukeles

Laderman Ukeles' current public project *Turnaround/Surround* (1989-present), commissioned by the Cambridge Arts Council's Art Insite Program, is situated in Mayor Thomas W. Danehy Park, Cambridge, Massachusetts. This site has had several incarnations. During the Civil War, the 50-acre site was transformed from undeveloped meadows and swamps into an industrial center featuring a clay pit, a kiln, and a brick yard. In 1952, the city of Cambridge purchased the pits and dumped refuse in them until 1971. After the landfill was closed, construction of a recreational park began, and Laderman Ukeles was selected to create the public art. Cambridge is the first community in the Northeast to transform a landfill into a recreational park. Not only did the city organize a series of meetings with local citizens over a period of five years, but Laderman Ukeles visited public schools to discuss recycling and her role in the conversion process. [18]

Mierle Laderman Ukeles, *Turnaround/Surround* (detail: *The Galaxy*, an urban dancefloor made from pre-consumer waste rubber), 1989-present, Mayor Thomas W. Danehy Park, Cambridge, Massachusetts

Between April 1 and April 22, 1993, Cambridge residents dropped off ten tons of glass and mirror. The Spectrum Glass Company in Woodinville, Washington donated the balance to create 22 tons of crushed glass and mirror, which was then mixed into asphalt. This sparkling half-mile-long, wheel-chair accessible "glassphalt" path passes over a mound, a man-made hill leftover from its landfill days. The views are extraordinary from this 72 foot high hill— the highest point in Cambridge. Upon completion, the hilltop will contain over-sized thrones for a queen and king, and a colorful **urban dancefloor** made from pre-consumer waste rubber. Laderman Ukeles' use of recycled materials keeps the memory of their former lives intact.

For this project, 22 tons of recycled crushed glass and mirror, partly collected from local citizens, were mixed into asphalt to create a half-mile-long glassphalt path that traverses this 55-acre former refuse dump turned recreational park on its way to a centrally located mound. Since glassphalt had never before been used in Massachusetts, Laderman Ukeles conducted three large-scale tests in 1992 with the New York City Departments of Sanitation and

Transportation in order to gain Cambridge's confidence.[19] She collaborated with landscape architect John Kissida on a planting plan for the mound and its surrounding areas. In addition to a protective Pin Oak Allée, pine and cedar trees have been planted, along with four types of native tall grasses that the artist refers to as "wavers," because they accentuate the wind. Perennials, such as roses and herbs, like Orange Mint and Lemon-Scented Thyme, emphasize the park's prior role as a smelly dump.

 Once on top of the mound, spectators become "king or queen of the hill," as they sit in a throne to experience the mound's extraordinary views. There is also an image of a galaxy grafted onto a 20 foot-diameter disc made from colored, pre-consumer rubber waste. Working with two corporations, California Products Incorporated and Cape & Island Tennis & Track, which manufacture the rubber used in monochrome running tracks, Laderman Ukeles experimented with pre-consumer waste rubber-track surfacing during the summer of 2001. She finally figured out how to get this typically monochrome material to hold multiple pigments. A two-month-long "Handing-Over to Community" ritual—a performance created by the artist— is planned for the park's completion. Representatives of Cambridge's 56 different cultures will provide the artist memorable objects for insertion into the hilltop, thus converting the site into a public monument.

 Laderman Ukeles is also working with a closed landfill in Hiriya, Israel, that sits between Tel Aviv and Jerusalem. Colored lights dance at night, mimicking the landfill's toxicity. Laderman Ukeles was also invited by an environmental foundation to collaborate with several landscape architects on a remediation of the Ayalon River that borders Hiriya.

waste treatment

Buster Simpson (b. 1942) is best known for *Hudson Headwaters Purge* (1990), a bit of environmental agit-prop for which he placed numerous hand-carved, soft-chalk limestone tablets (24-inch diameter by 3-inch thick) in the headwaters of the Hudson River in New York's Adirondack Park. Technically, this process was meant to "sweeten" (or increase) the pH of the overly acidic Hudson River, a solution that is now standard practice with environmental agencies. He had already placed similar tablets in the Tolt Watershed (1983) and the Esopus River (1984), the drinking water sources for Seattle and New York City,

Buster Simpson , "*David*" taking on "*Global Goliath*," 1983, photo of performance

Although Simpson is most famous for placing limestone tablets in the Hudson River (part of New York City's water supply), he first placed limestone in a sling, a metaphorical attempt to knock over the World Trade Center. This image set the stage for Simpson's interest in tackling problems associated with city infrastructure. Tragically, the friend who documented the first performance died eighteen years later in the WTC attack.

Buster Simpson, *Hudson River Purge*, 1990, photo of performance

respectively. Such acts tie people to the planet, through the metaphors of acid rain and acid indigestion, a connection the media picked up on, since they termed it "River Rolaids" and "Tums for Mother Nature."[20] Few realize that Simpson's first performance with limestone discs, *"David" taking on "Global Goliath,"* a staged attempt to topple the World Trade Centers with a sling containing a limestone projectile, actually occurred in 1983 and set the stage for his interest in tackling urban problems.

In 1978, Simpson wanted to draw attention to the polluted waters surrounding Artpark in Lewiston, New York, so he placed concrete casts of picnic plates at sewage outfalls into the Niagara River. He then retrieved them and exhibited the stains created by the river's contaminants. This led to a series titled *When the Tide is Out the Table is Set,* based on a Salish Indian saying linking feasts of shellfish to low tide. While working with Kohler's Art and Industry Program in 1984, he cast plates in vitreous china. He later placed those plates in sewage outfalls in Cleveland, New York, Houston, and Seattle. Over time, they became quite stained. After firing them in a kiln, he realized that toxins caused the plates' most colorful patterns. [21]

Simpson's most inventive and enduring work is *Downspout—Plant Life Monitoring System* (1978), a cost-effective way to trap and clean stormwater runoff from public buildings before it enters the public sewer. He grew ferns in plumbing pipes attached to the side of a building housing a public clinic in Seattle's Post Alley to create "vertical landscapes."[22]

Buster Simpson, *Growing Vine Street-Vertical Landscape Downspout*, 1999, Seattle, Washington

First designed in 1978, Simpson's "vertical landscapes," ferns placed in plumbing pipes attached to the sides of buildings, offer a cost-effective way to trap and clean stormwater runoff from public buildings, before it enters the public sewer. Limestone placed in the pipes' elbows neutralizes the water's acidity.

Limestone placed in the pipes' elbows neutralizes the roof runoff's acidity. This work was monitored for a number of years. Simpson returned to this technique in 1999, when he created *Growing Vine Street-Vertical Landscape Downspout*, commissioned by two separate building owners on Vine Street in Seattle, Washington. In 1991, he collaborated with city, county, and state health departments to implement an inexpensive, ecological composting public toilet that generates fertilizer for planted trees.[23]

Buster Simpson, *Host Analog,* 1991 (top), juxtaposed against *Host Analog,* 2000 (bottom), Oregon Convention Center, Portland, Oregon

In 1991, Simpson planted Douglas Fir, Hemlock, and Western Red Cedar seeds onto an eighty-foot-long Douglas Fir nurse log. These images capture its original status and nine years of growth. It remains a public monument that celebrates the Pacific Northwest's timber heritage, despite its endangerment due to clear-cutting. [24]

Host Analog (1991), a $65,000 commission for Portland, Oregon's Convention Center, has the potential to generate a forest from one fallen 80-foot Douglas Fir called a nurse log, since it hosts sprouting seedlings as it decomposes. By creating a stainless steel misting irrigation system

and planting Western Cedar, Hemlock, and Douglas Fir seeds on the log, Simpson made it possible for a fallen tree, unsuitable for the timber industry, to nurture a new forest. A 1993 Timber Summit at the adjacent Convention Center begged the question, "Are we in balance as the host and parasites or are we eating ourselves out of house and home?."[25]

Simpson has created numerous other public works that inform the public about particular issues. For example, *Exchanger Fountain* (1993), part of a streetscape package for the Anaheim Redevelopment Agency, uses the fountain's gray water to water a native willow tree, naturally cooling the water supply line at the same time. Part of the fountain's spiraling inscription reads, "The water kissing your lips is an offering." Each drinker transfers this gift, since each user waters the willow and cools the next person's drink.[26]

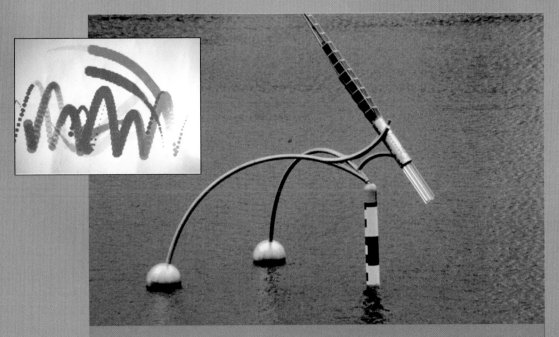

Buster Simpson *Brush with Illumination*, 1998, False Creek, Vancouver, Canada

Brush with Illumination (1998), a 30-foot-high, 28-foot wide, 31-foot long sculpture set on a 30-foot high, 18-foot-diameter piling, records environmental data, which is broadcast to a website. The data-accessing sensors are powered by batteries charged by solar energy. The data is transformed into an ideogram, or drawing, that is available from the website.

In collaboration with landscape architects Sindell, Spitzer, and Hanson, Simpson developed *King Street Garden* (1993-1997), a 35,000-square-foot park in Alexandria, Virginia, which serves three related purposes. A *Topiary Garden*, in the form of a 35-foot-high tricorn hat references Colonial Virginia settlers. The *Hanging Garden* offers a public gathering spot amidst aromatic vines. The *Sunken Garden*, a reclaimed marsh, acknowledges this site's history as a landfill, while mitigating stormwater runoff.

Water Glass and Water Table (2001), Simpson's sculpture in the plaza of Seattle's Ellington Condominiums, highlights the collection and cleansing of roof runoff. An eight-foot-tall cistern collects the water, which circulates through a wetland and then passes to a water table that demonstrates rain's measurable impact.[27]

Buster Simpson, *Water Glass and Water Table*, 2001, Ellington Condominiums, Seattle, Washington

For this sculpture, harvested roofwater is deposited in an eight-foot-tall glass cistern, shaped like a drinking cup with a straw. After circulating through a small wetland, the cleansed water passes to a water table, which measures the rain's impact on Seattle.

Part bio-engineer, architect, and artist, **Viet Ngo** (b. 1952) first began designing and building wastewater treatment plants that use his patented Lemna™ System (lemna is popularly known as duckweed) in 1983. This engineer and artist is now President and CEO of Lemna International, one of the United States' best known global environmental service companies. During the Clinton Administration, he represented the U.S. environmental business sector on a trip to China with Secretary of Commerce Ronald Brown. Lemna International has since expanded into other infrastructure sectors, including solid waste management, renewable energy, water supply and irrigation, and transportation.

Rather than use mechanical or chemical processes, Ngo's system uses small floating aquatic plants (lemna), that are grown in specially designed ponds to treat waste to a very fine degree. Lemna plants act as filters to absorb and neutralize pollutants in the water. They also help stabilize the biological reactions in the pond, "optimizing natural treatment processes by bacteria, micro- and macro-organisms, and by other physical processes."[29] Lemna plants use sulfides, methanes, and other natural gases as food sources, and they shield the pond, preventing odors from escaping into the air. Thus, this system is virtually odorless, an advantage over almost every other wastewater treatment technique. For this reason, treatment plants that employ the Lemna™ System can play a more prominent role in a community's infrastructure. Ngo tries to let the site govern the design of these plants.[30]

In 1995, Ngo's design for the Wastewater Treatment Expansion in White House, Tennessee, was awarded the prestigious "Excellence in Engineering Award" from the American Consulting Engineers Council. The award cited an initial cost savings of $500,000 and a life-cycle savings of $750,000. In 1997, Lemna International was the first U.S. company to establish a joint venture with China to build a privately funded municipal wastewater treatment plant.[31]

Lemna International's award-winning wastewater facility in White House, Tennessee, treats 800,000 gallons of water daily and consists of two aerated ponds, one Lemna pond with a nitrification reactor at its end, an ultra-violet disinfection zone, and a cascade outfall. The effluent can be used for irrigation or discharged into a small stream. The influent parameters are 200 mg/l Biochemical Oxygen Demand (BOD), 200 mg/l Total Suspended Solids (TSS) and 25mg/l ammonia. The permitted discharge limits are 10 mg/l BOD, 30mg/l TSS and 1mg/l ammonia in summer (2 mg/l in winter).

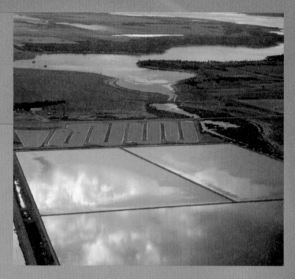

Since 1990, Lemna International has built 300 facilities in fourteen countries, half of which are in the United States. In desert countries, it is especially important to reuse every drop of waste-water. Given Ngo's art and mechanical engineering education, his designs have integrated both aesthetic and practical considerations. Design decisions like channeling water to control the hydraulic flow of the incoming water or placing floating barriers to control the lemna's growth, result in specific landscape forms that vitalize urban design.

The United States Government recently increased its standard for the allowable amount of ammonia present in the effluent, making it necessary either to add a nitrification reactor to the lemna treatment pond or to use it as tertiary treatment. But, the Lemna™ System still offers most countries, especially warm ones, an affordable natural solution for waste water treatment, especially since lemna are found throughout the world.

A final benefit of lemna plants is their high concentrations of proteins, making them a potential food source for many populations. Lemna provide reusable biomass. Harvested lemna can either be composted to form a rich fertilizer for organic farming, or, after proper testing, used as a high-protein animal feed. [33] The clear water that results from this process can be used to irrigate city parks and crops or to water golf courses.

Like Johanson, Laderman Ukeles, and Simpson, **Laurie Lundquist** (b. 1954) has participated in the design development of urban infrastructure. Early sculptures like *A System for Satisfying Needs* (1989) (water hyacinths mechanically dipping in a nutrient solution), *Skysweeper* (1989) (twelve brooms mechanized to sweep the air), and *Grass Room* (1990) (recirculating water to grow grass) stand as important examples of eco-art. One of her most beautiful installations was *Hanging Gardens* (1990). This work introduced an innovative system to support the growth of nearly 100 spruce trees suspended in burlap troughs. The water trickled down the strings suspending the burlap trough, drained through the soil and burlap into galvanized steel channels, flowed into reservoirs, and was pumped up and through the cycle again. [34] In 1990, she also created *Lying in the Desert*, a thin line of grass growing in the runoff of a bulldozed landscape.

Like Haacke's *Rhinewater Purification Plant*, Lundquist developed a system to circulate algae-dominated water from the Palace of Fine Arts lagoon through a wetland set up in the San Francisco Exploratorium (1992-1995), where she was an artist-in-residence. Plagued by an algal bloom caused by nitrogen rich bird guano, the lagoon has been sustained by routinely flushing it with city water. Since San Francisco faces a chronic water shortage, solving the lagoon's problem would both conserve valuable water and optimize the diversity of aquatic life. [35]

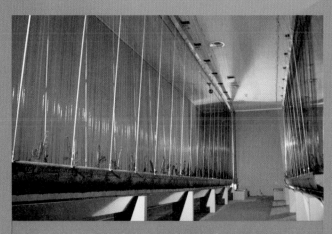

Laurie Lundquist, *Hanging Gardens*, 1990, Scottsdale Center for the Arts, Arizona

Lundquist designed and implemented an innovative watering system to support nearly 100 spruce trees growing in burlap troughs suspended from the ceiling. Water trickled down the strings to meet the troughs. Excess water was collected in steel channels below and re-circulated through the system.

In 1992, Lundquist and Dan Collins, her artist husband, founded Deep Creek, which they co-directed until 2000. Deep Creek was a learning community committed to fostering a sustained dialogue among artists of diverse backgrounds, in the Rocky Mountains near Telluride, Colorado. This summer residency offered practical and philosophical weekly

workshops and provided residents a computer lab, a ceramic shed, a darkroom, a printmaking lab, studio space, and many other amenities. In 1999, Lundquist co-led workshops on the topics of Watershed Perspective and Environmental Art: Site Dynamics. [36]

In the past decade, Lundquist has participated in the development of several ecoventions. For *Papago Arroyo Wildlife Corridor*, she designed a $120,000 water remediation scheme for the Orthologic and Sonora Quest Laboratories, funded by Sunstate Builders in compliance with the City of Tempe's Art in Private Development ordinance. In 1998, this ordinance enabled 38 projects totaling $2.5 million to be built. Lundquist's design entailed pumping water standing in an arroyo across a bridge in steel trough handrails to be returned to the pond below. To contrast the massive Central Arizona Project Water Treatment Plant (CAP), which supplies water from the Colorado river, Lundquist created an irrigation system that delivers a bare trickle of water to acacia trees planted in CAP's entry plaza. In conjunction with this project, she and Patricia Clark created *Running Water for Arizona* (1999), a 24-minute art-in-education video featuring CAP's role in providing reliable drinking water.

Laurie Lundquist, *Sweet Acacia Project*, 1999, entry plaza of Central Arizona Project, Scottsdale, Arizona

In contrast to the massive amount of water the Central Arizona Project distributes, Lundquist's irrigation system delivers barely a trickle to the acacia trees planted in the entry plaza of the Central Arizona Project. This $30,000 project was commissioned by the City of Scottsdale's Public Art Program.

As part of Arizona State University Art Museum's "Sites Around the City" exhibition, orchestrated by Heather Lineberry, Lundquist created *Algae Garden* (2000). Using water circulated from the museum's interior fountains, she grew algae on a series of concrete scuppers, placed in the center of the staircase leading to the museum, enabling the water to flow down the staircase to the nymphaeum pond below.

sustainable 'hoods

Since 1996, **Superflex**, whose members include **Bjørnstjerne Christiansen**, **Jakob Fenger**, and **Rasmus Nielsen**, have been developing applications for their two-chamber biogas unit, which converts human waste, dung, and agricultural waste into energy (biogas) and fertilizer (slurry). They worked with African and Danish engineers, including Freddy Bruzelius and Jan Mallan, to construct their simple, portable biogas unit. Hardly "eco-artists," only a fraction of Superflex's work addresses ecological concerns, though all of their work engages communities in social issues. Superflex Music, their own record company, produces and distributes small-issue CDs.[37] Superflex focus on the relationship between objects, tools, and products. Superflex see everything as tools that can be used on different levels – aesthetically, theoretically, and economically. This is the focus of their 2002 exhibition at the Rooseum in Malmö, Sweden.

When organic materials rot in airless tanks at 20-40°C, anaerobic digestion occurs, and bacteria convert organic matter into combustible biogas (methane, carbon dioxide) and fertilizer (ammonia). In co-operation with the African organization, Sustainable Rural Development (SURUDE), Superflex first tested their biogas system in August 1997 on a small farm in central Tanzania. The daily dung from two to three cattle produce about three cubic meters of gas per day, enough energy to run a lamp at night and to meet the cooking needs for a family of eight to ten. One cubic meter of biogas corresponds to .6 liters of diesel fuel.

The biogas chamber's use is expected to reduce deforestation and the burning of charcoal for fuel purposes. In Central Africa, women who spend many hours collecting firewood are targeted as the ideal consumers of their biogas systems, which are expected to cost $250 each. Burning firewood produces a lot of smoke, which pollutes the air, and causes problems with lungs, eyes, etc. Energy generated by the biogas system can be used to run stoves, lamps, and motors, to produce electric power, or pump water.[38] Superflex has collaborated with the Thai company,

CMS engineering, to use the biogas system for small pig farms in Thailand. In 2001, they tested a biogas system in collaboration with the University of Tropical Agriculture in Cambodia. Superflex has applied to the Danish Patent Board to patent their innovative two chamber biogas system.

Like Ocean Earth, Superflex Ltd., is organized as a for-profit company brand with shareholders.

Their sponsors are more like investors in joint ventures than collectors. Rather than depend upon Danish government controlled development aid, they initiated their own foundation, Super Rural Development (SUPERRUDE), a sister organization to SURUDE, to handle the biogas system's further development.

Superflex, *Bio-gas Lamp*, 2002, East Asia

Since 1996, Superflex has been developing applications for their two-chamber biogas unit, a $250 sustainable system that continually produces clean energy. In 2000, they started collaborating with a Thai company to generate typical Thai lamps using Superflex's biogas system. Trial tests in Thailand and Cambodia have proven successful.

Mel Chin, who originated *Revival Field* (1990-1993), recently proposed *S.W.I.N.G.* (Sustainable Works Involving Neighborhood Groups) in Detroit, Michigan, a project which combines conceptual art with educational experimentation, and addresses ecological and economic concerns in response to specific conditions.

In 1999, Chin was invited by the International Center for Urban Ecology (ICUE) to explore the conditions facing the East Side of inner city Detroit, a neighborhood affected by the Devil's Night Burnings. In response, Chin proposed several projects that would radically transform burned and abandoned properties into surreal works of art and architecture while insisting that a sustainable productive industry augment the interventions. *S.W.I.N.G.* is still in its nascency, but if Chin can implement its directive to combine the resources of the University of Michigan, Ann Arbor, and the City of Detroit, it will provide an innovative model for the arts and an educational practice to serve specific neighborhoods.

Rather than rehabilitate or patch the neighborhood, Chin seeks to initiate another evolution to multiple sites around Detroit. "Instead of only targeting blighted areas to add culture, the challenge to artists and architects, both professionals and students, is to invent, with the peoples and communities, projects to transform the disturbing destroyed-house icon into a new-use icon."[39]

Like the artists in the "Valuing Anew" section, Chin sees the potential in a home left standing after a fire or abandonment not as an agency for fear but for creative evolution. For example, rather than restore the home to its original condition, he wants to swing the entire house on a pivot, to take advantage of its darkness for growing worms, and then access the sunlight to sort them for sales to the sport fishing industry. The resulting compost from garden clippings and recycled newspapers can be sold to rose gardeners in the affluent Grosse Pointe area or locally serve the growing urban agrarian environment of inner city Detroit. Like Beuys' slogan, "Creativity = Capital," Chin is interested in the relationship between inventive ideas and their payback. "The ideas provide the gentle push, that sends us coolly cutting through the still air of division and fears, arcs toward economic benefits and sweeps back to each new form of creative engagement."[40]

reclamation and

Several artists have developed and implemented novel strategies for reclaiming water and soil, which inadvertently improves air quality. Such artists' initiatives have contributed workable models for the fields of ecological restoration and landscape architecture.

watershed management

In 1985, **Betsy Damon** was making a cast with handmade paper to recreate a dry river bed's form when she was told that the desert water was undrinkable, despite the fact that this Castle Valley, Utah, site was far from any obvious source of pollution. At this point, she decided to devote herself to communicating the importance of safe water. In 1989, she visited China with her son, Jon Otto, a physicist who was then studying Chinese. A year later, while living in St. Paul, Minnesota, she founded Keepers of the Water, a non-profit organization geared toward water-oriented collaborations between artists, scientists, and communities. In 1995, she directed a Keepers of the Water project, which assembled twenty artists from China, Tibet, and the U.S. to create 25 public installations along the polluted Fu-Nan Rivers (two rivers that merge in Chengdu). These activities were televised nightly, further piquing the viewers' curiosity.[1] It was particularly helpful that a broadcaster for TV Shanghai reported that there needed to be something permanent. During this trip, she was introduced to Chengdu's five-year plan to clean up its rivers.

THE UNITED NATIONS ENVIRONMENTAL PROGRAM'S GEO 2000 SURVEY HAS IDENTIFIED WATER AS THE FOREMOST ENVIRONMENTAL ISSUE OF THIS CENTURY. TWO OUT OF THREE PEOPLE WILL LIVE IN WATER-STRESSED CONDITIONS BY 2025 IF THERE IS NO CHANGE IN CURRENT CONSUMPTION PATTERNS.[2]

Thirty years prior, the Fu and Nan Rivers contained 56 different species of fish and people swam in the rivers, but as Chengdu grew from two to nine million people, the rivers deteriorated, as 60,000 cubic meters of sewage were dumped into it daily. In response to middle school students writing letters about polluted waters, Chengdu's City Government initiated China's first major clean-up effort.[3] The city's plan entailed moving 100,000 citizens living in shacks along the river, building an infrastructure for waste treatment, cleaning the river, rebuilding the flood walls, and building thirty-one miles of

parks along the riverfront. Damon suggested that they construct a park to help clean the river and teach citizens about the environment. When asked whether she could do this, she answered yes, even though she had never done such a thing.

What Damon learned doing this project has reverberated throughout the world. Her concept of *The Living Water Garden*, a six-acre, multipurpose park, employs her innovative design for flow forms, whose enhanced aeration surfaces mimic water's flow down a mountain. Within nine months of completing her project for Chengdu, Damon received requests for proposals from citizens in Duluth, Minnesota; Portland, Oregon; Bellingham, Washington; and several Chinese cities. In 1998, *The Living Water Garden* received the Top Honor Award in an international competition sponsored by Washington, D.C.'s Waterfront Center. In 1999, it received an Environmental Design and Research Association award. Juror Halsband remarked, "We actually learn something from this, by following through the spaces. " Juror Francis added, "it's a wonderful example of merging ecological design with social design."[4]

Betsy Damon, *The Living Water Garden*, 1995-1998
Chengdu, Sichuan Province, China

On a 1995 trip to Chengdu, Damon was introduced to the City Government's five-year plan to clean up the Fu and Nan Rivers that merge there. Having founded Keepers of the Water, she was already devoted to communicating the significance of water. She suggested the city add a water garden to help clean the river and to educate people about water, conservation, and treatment. They asked her to coordinate this. Working with local specialists and Philadelphia-based landscape designer Margie Ruddick, she completed a conceptual design that included her innovative flow forms. *The Living Water Garden* has received several international design awards.

The Living Water Garden cleans only 250 cubic meters of water a day, not enough to affect the huge river's overall water quality. However, Damon notes that it serves as a laboratory, "a beacon of what is possible and [an] inspiration to clean up more of the water ways."[5] If one takes the view that incremental changes contribute to the whole, the long-term affects could be enormous. In fact, within three months of the building and planting of *The Living Water Garden*, restored biodiversity was evident in the form of butterflies, dragonflies, and Kingfishers.

> I pointed out that because I was there did not necessarily mean they would be acquiring a so-called Western design. I would be helping them figure out how to organize these technologies within the frame-work of their own landscape architecture, and the design develop-ment is something I think they should be very proud of.
>
> - Betsy Damon[6]

Damon didn't build this massive water park on her own. Due to the reality of global policies, Damon found it incredibly difficult to fund this particular project. After three years, she raised less than $6,000 of the park's $2.5 million budget, since each of the eighty U.S. corporations she approached had restrictions about funding projects in China. Despite this difficulty, Philadelphia-based landscape designer Margie Ruddick sketched the park's plan within three weeks during her 1996 visit to China. Its construction began in 1997, and it took fifteen months to complete.[7] Damon developed the rhythm of the park, two sets of flow forms (complex carvings that aerate flowing water), the flow of the park's path, along with sculptural elements like the living water-drop fountain and the chambered-nautilus rose marble fountain. Hydrologist Zhang Jihai, Chengdu's Project Director, risked his career to see completion of this experimental water park. Huang Shi Da, central China's only microbiologist, designed the wetlands, selecting plants and fish for the treatment ponds.[8] He even built concrete bins in his backyard to test the abilities of native species to break down pollutants. City staff designed elements like the bridges and stone walkways. Jon Otto functioned as project manager and translator. "Artists, school-aged children, young people, and volunteers, local and from abroad, embraced this project as their own."[9]

As Damon observes, the park is particularly Chinese. The 1500-foot-long park contains mostly forested areas, comprising over 100 different trees and plants, some rare, representing the biodiversity of the nearby sacred Buddhist Mt. Emei, located 256 miles from Chengdu. Given the land's natural resemblance to a fish, the designers took the elements of a fish, a symbol of good fortune and health, and developed the park's attributes around this form.

The river's flood wall was changed into steps to form a mouth. The river water is pumped via water wheels up a hill to the settling pond (the fish's eye). The iris, at the center of the pond, is a thirteen-foot-diameter green granite sculpture that shows what a water drop looks like under a microscope. The water then passes through constructed wetlands, which are planted with seven different water purifying plants, over which people stroll on boardwalks.[10]

The water then burbles through the gills, an aeration system using a series of flow forms that form a rooster, one of the twelve Chinese zodiac signs.[11] Given the prohibitive cost of purchasing patented flow forms, Damon worked with Chengdu sculptors Deng Le and Zheng Wenjen to carve 33 of her innovative designs for flow forms, both fountains and several other works. One of the flow forms is similar to the shape of a bird, evocative of water's life-giving attributes, while another resembles the shape of a gingko leaf, the city's symbol.[12] After passing through the flow forms, water travels through fish ponds shaped like scales, where the water is aerated by sand and gravel filters, until it is clean. The chambered nautilus rose-marble fountain forms the tail of the fish.[13]

1989	Betsy Damon first visits Chengdu with her son Jon Otto.
1990	Damon founds Keepers of the Water.
1995	Damon returns to Chengdu for an art event and gets involved with river project.
1996	Damon returns with Margie Ruddick, who sketches the garden's design in three weeks.
1997	Garden's construction begins, which engages Damon and Jon Otto for fifteen months.
1998	The completed garden awaits Communist Party approval for two months. The Waterfront Center awards the garden top honors.
1999	The garden wins an Environmental Design and Research Association award.
2000	Dozens of cities in China and the United States gain interest in water gardens.

Most important, visitors walking through the park can follow the purification route, which is accompanied by explanatory signs, before the water returns to the river. Not only is there a splash pond for children, but there is also an Environmental Education Center and a circular stone amphitheater in the park.

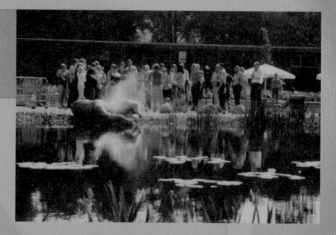

Jackie Brookner, *Gift of Water*, 2001, 3 x 5 x 8.5 feet, Grossenhain, Germany

Brookner's *Gift of Water*, moss-covered concrete hands, is the final cleansing process for pool water re-entering a pool, whose water is naturally filtered. Passing the swimming pool water through wetlands makes chemical treatment unnecessary.

While **Jackie Brookner's** (b. 1945) art has explored environmental issues for over a decade, the *Gift of Water* (2001), massive concrete hands covered in moss, is her first outdoor work. This sculpture is placed at the edge of a pool, whose water circulates through wetlands and is thus cleaned naturally. Just before the water re-enters the pool, it passes over moss-covered hands, which Brookner built in Germany. Brookner first used moss to cleanse water in 1996, when she built *Prima Lingua (First Tongue)*. The more hardy species of mosses act as biochemical and physical filters for many kinds of pollutants. In this capacity, they adsorb and absorb heavy metals (lead, copper, gold, and mercury), as well as other pollutants found in air and water. Other moss are so sensitive that they are used to measure pollution levels. Seated inside a pool of silt and agricultural runoff, *Prima Lingua* cleanses both the water and the room's air. Such a sculpture can be modified to meet many needs. On a small scale, it cleans all household wastewater, but on a larger scale it could be used to filter agricultural runoff, stormwater runoff, wastewater, and other kinds of urban pollution.

DESPITE THE FACT THAT GLOBAL CATASTROPHES HAVE ELIMINATED 99% OF ALL ANIMAL AND PLANT SPECIES THAT HAVE INHABITED THE EARTH, CERTAIN SPECIES OF MOSSES AND LIVERWORTS ARE VERY SIMILAR TO THOSE THAT EXISTED 400 MILLION YEARS AGO.[15]

Jackie Brookner, *Prima Lingua (First Tongue)*, 1996 and 2001, cement, volcanic ash, moss, plants, agricultural runoff, 64 inches x 101 inches x 80 inches

Brookner covered a giant cement tongue in volcanic rock and mosses to create *Prima Lingua*, a biochemical filter that cleanses polluted water and air. The polluted water in its trough, which circulates over the biosculpture's back, was collected from agricultural runoff. The moss, together with the fungi and many millions of bacteria growing with each plant, use the pollutants as food sources, thus gradually purifying the water. A 500 cubic foot per minute ventilation system takes one week to come in contact with an ordinary room's 70,000 cubic feet of air. By contrast, this biosculpture would absorb the vast majority of dust and pollutants from this same amount of air in a day. Snails, salamanders and other animals in the pool enhance the functioning of the whole system.[1] The image on the right shows five years of growth.

Jackie Brookner, *I'm You*, 2000, moss, volcanic lava, plants, metal, polluted water, 67 inches x 112 inches x 50 inches

Although *I'm You* resembles hands, its shape is actually based on the microscopic structure at the center of the leaves of some species of moss. A mister periodically sprays the pond's polluted water onto the moss form, which drips back into the pond. Moss growing on the lava rock covers the metal hand forms and the wetland's water plants bio-chemically filter pollutants, transforming polluted waste into invaluable nutrients.

IN DECEMBER 1999, THE ENVIRONMENTAL PROTECTION AGENCY ENACTED ITS PHASE II STORMWATER LAW, REQUIRING ALL DEVELOPED SITES TO ACTIVELY MANAGE RUNOFF. WITH THIS NEW LAW, STORMWATER MUST EITHER SEEP INTO THE GROUND OR BE ABSORBED BY PLANTS, SINCE NO MORE THAN 5% CAN LEAVE THE SITE AS RUNOFF.[7]

While the **Harrison Studio** tends to tackle large land masses, such as a coastal forest running along a 2000-mile seaboard, the European Peninsula, or the "Green Heart" of Holland, **Aviva Rahmani** operates on the principle that the environment has been lost by increments, so it can be saved by increments. This perspective, first proposed by her technical collaborator, Salem-based bioengineer Wendi Goldsmith, is hugely empowering, especially since vast, polluted sites can seem quite daunting. This novel view has initiated intriguing experiments along the lines that a little change goes a long way, opening up the possibility that reparation's effects are exponential. One of Rahmani's primary interests is the Eastern Seaboard's coastal wetlands, which have nearly been destroyed by development. She wonders whether reconstructed coastal wetlands, dotted along the Eastern Seaboard, wouldn't eventually grow to restore the entire system. Given the rapid decline in the fish supply, she may get the opportunity to test this promising thesis as the most cost-effective way to revitalize the fishing industry.

In 1991, Rahmani embarked upon her first restoration project, *Ghost Nets* (1991-2000), which transformed a 2.5 acre town dump in Vinalhaven, Maine, into an ecologically thriving salt marsh, surrounded by a successional forest, meadows, and uplands. Having moved to this fishing village only a year before she started *Ghost Nets*, Rahmani gained acceptance by immersing herself in community activities. She cultivated relationships with her neighbors by going out on fishing boats, conducting extensive interviews, and singing with the local church choir, despite her Jewish faith. Soon after she began this project, a neighbor brought Rahmani before the Vinalhaven Board of Appeals on charges that she was misusing the site under marine zoning regulations, but Rahman won the case.

In 1993, four hundred saplings were planted to restore and enhance the forest area, but 70% of the trees died due to formidable wind, climate, and soil conditions. The actual restoration, which used Goldsmith's state-of-the-art stabilization and re-vegetation techniques, required seven years of preparation, but took ten people three days to implement it. Soon after its completion, Rahmani worked with Michele Dionne of the National Estuarine Research Reserve (NERR) in Wells, Maine, to design research models extrapolating what can be learned from this site to salt-marsh systems throughout the Gulf of Maine.

IN 1987, IT WAS ESTIMATED THAT 2240 PIECES OF LOST FISHING GEAR WERE FLOATING IN THE GULF OF MAINES 2370 SQUARE MILES.[18] "GHOST FISHING" PLAYS A MAJOR ROLE IN DECLINING FISH POPULATIONS.

Ghost Nets takes its name from her discovery that invisible indestructible nets, lost by fisherman, float indefinitely in the sea "trapping fish indiscriminately and strip-mining the sea."[19] Thus, *Ghost Nets* offers a metaphor for the way destructive patterns trap and kill us all. Proving her point that a little reclamation goes a long way, this 2.5 acre salt marsh serves as a keystone, linking Narrows Island and the town park around Boothe's Quarry, thus opening up 70 acres of a class-A migratory-bird fly zone in the middle of the Gulf of Maine. Rahmani considers eco-art most successful when the artist's hand is invisible![20]

Aviva Rahmani, *Ghost Nets*, 1991-2000 salt marsh, Vinalhaven, Maine

These before and after images capture the town dump's transformation into a thriving salt marsh. After six years of preparation, ten people spent only three days installing the bioengineered design. For the first time in 100 years, freshwater flowed down a hill to meet the sea. They planted thousands of salt marsh grasses and created wave attenuation barriers out of coconut fibers. During the next spring, a deep freeze changed into a powerful thaw and the complex root systems that had taken hold, melted and slid down the hill. This further exposed the already vulnerable plantings to storm waves at high tide, so Rahmani had to design a second wave attenuation barrier that countered the wave action.[21]

If all the healing circles were re-established around the Atlantic
Ocean, would ocean degradation and the loss of clean water
be arrested?

- Aviva Rahmani[22]

Another of Rahmani's novel theories requires imagining the watersheds on either side of an ocean as a linked system, rather than as separate waterways, and then understanding the waterways as chakras with vital trigger points. She uses Geographical Information Systems (GIS), satellite, and other mapping technologies, combined with ground truthing, to identify areas of greatest degradation. These are often the richest opportunities for restoration, thus providing trigger points to stimulate the larger whole.

Designating this project *Cities and Oceans of If*, she hypothesizes that water flowing from the Gulf of Maine, arguably the world's richest fishery, enters the St. Lawrence Seaway and travels to the Great Lakes, where it feeds the rivers and watersheds of Canada, and then flows west to the Columbia River, south to St. Louis, or east to Maine via the Ohio River's tributaries. Continuing her focus on incremental change, she argues that "small, connecting corridors can have dramatic implications, that our urban-rural life has been disrupted, threatening our very survival. At the crux of this relationship is water." [23]

Since the St. Louis watershed is the third largest in the world, she has designated it one of the trigger points for healing the global body. She has also identified and proposed redesigns for Liverpool, San Francisco, Philadelphia, St. John (Canada), Mt. Desert Island, and Portland (Maine). Her analysis of biological patterns such as pre-settlement animal migrations indicates a relationship between the lost fisheries of Otterspool in Liverpool, United Kingdom (on the other side of the Atlantic Ocean) and the confluence of the three rivers meeting in the St. Louis watershed (the Missouri, Ohio, and Mississippi Rivers). By monitoring restored trigger points, she hopes to see how adjacent corridor systems can be revived for wildlife. Rahmani is currently employing this strategy as part of St. Louis' Arts in Transit program. She considers the St. Louis watershed to be a "puzzle of interrupted ecotone zones, which together contain and protect the waters and their adjacent habitat systems."[24]

Rahmani is not the only artist to base her ideas on macro-models for water systems. *Desert Flood*, **Ocean Earth's** 1991 proposal to restore the Arab world to savannah was based on similarly linked waterways, stretching from Iraq's Tigris-Euphrates rivers to an underwater delta in Kuwait to aquifers in Saudi Arabia. Just as Rahmani parallels watershed activities in Liverpool and St. Louis, Ocean Earth connects the Colorado River to the Tigris and Euphrates Rivers, linking Gulf of California natural disasters to the Persian Gulf's.[25]

Director and Founder of the Israeli Forum for Ecological Art, **Shai Zakai** (b. 1957) embarked on a wide-ranging project in 1999, which involved transforming the static Etziona Stream near her home in Central Israel. At first, she couldn't understand how the seasonal stream's flow had become frozen in concrete. She soon discovered that concrete-mixer drivers eager to return completely empty to the nearby Shafir Quarry, had illegally dumped excess concrete into the stream, clogging the watershed. Rather than simply defer to the law to end this practice, she opted for a more holistic approach that could offer a national model for watershed awareness. In fact, she won this quarry's support by stressing collaboration over fines and jail sentences.

Knesset Member Mossi Raz, chairman of the Israeli Forum for Ecological Art, remarked that the Zionist building mantra, "We shall clothe you with a cloak of concrete and cement," wasn't a call to destroy every stream and creek in the country, or to turn them in to sewage streams, as is the case with the Kishon and Yarkon rivers.[26] Rather than restore the site to its original condition, Zakai opted to preserve the disturbing memory of *Concrete Creek* by lining the revitalized stream with a three-mile avenue of 100 ten-feet-tall waving concrete flags, cut from pre-consumer (never used) concrete. There's now an official appeal to legally rename the portion of the reclaimed stream Concrete Creek. The Shafir Quarry, Israel's second largest, has since installed eco-friendly systems on site to prevent the watershed's further contamination.[27]

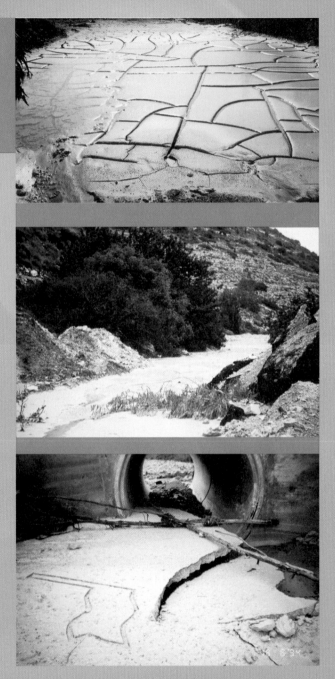

In May 2001, Zakai confronted people attending *Concrete Creek*, her exhibition at an environment fair in Tel Aviv's Exhibition Grounds, with the bewildering query, "Have you cleaned a creek today?". She documented their responses on video. Surprisingly, many people interviewed remarked that there weren't any rivers or streams in Israel. In December 2001, she organized a festival entitled *Concert for Cement Mixers* along *Concrete Creek* to inaugurate Israel's first eco-tourist site. This festival attracted a diverse group of government ministers, scientists, journalists, school children, quarry workers, artists, museum professionals, and local residents. It will be interesting to see what natural attraction Zakai takes on next.

uniting human intellect and the majesty of nature

Digging deep is what art is all about.

- Agnes Denes[28]

Since the late 1960s, **Agnes Denes** (b. 1931) has produced hundreds of gorgeously rendered drawings that visualize mathematical formulas like Pascal's Triangle, trigonometric forms like morphing pyramids, isometric models, and forces like vortices, which are often intended as studies for future buildings and environmental works. She has also used x-rays and electron micrography to reveal otherwise invisible structures. The first artist to enact eco-related performances, Denes' rituals have inspired large-scale environmental works (see the "Introduction" for images of *Rice/Tree/Burial* (1977-1979)).

During the summer of 1982, Denes' efforts captured the imagination of many New Yorkers and tourists, as they watched her plant and harvest *Wheatfield-A Confrontation*. This two-acre wheatfield was planted on top of the Battery Park Landfill, the off-shore landfill adjacent to the World Trade Center created with construction debris from the building of the Twin Towers. Only two months before she began, two hundred truckloads of dirty landfill had been dumped on this site. In May, under Denes' direction, tractors flattened this site, littered with rubble, dirt, rusty pipes, old clothing, automobile tires, and other garbage.

Eighty truck loads of fresh dirt were then dumped and spread to create the one inch of topsoil needed for planting. Denes and several volunteers cleared away rocks and garbage, and then dug 285 furrows by hand. Each furrow took two to three hours to dig. They placed the seeds by hand and covered each furrow with more soil. They maintained the field for several months. They set up an irrigation system, weeded, eliminated wheat smut (a disease that had infected wheatfields across the country), fertilized, sprayed against mildew fungus, and cleared away rocks, boulders, and wires by hand. [29]

On August 16, a hot, muggy Sunday, Denes and her volunteers harvested 1000 pounds of healthy, golden wheat from this field, surrounded by the symbols and key institutions of American commerce. Harvesting $158 worth of wheat on land valued at $4.5 billion proved a dramatic gesture, showing how the value of land in Manhattan is less a function of what it produces and more a function of the "symbolic value and global prestige it imparts to multi-national corporations."[30]

Denes had hoped that her three-month-long performance would inspire people to rethink personal values, to consider misplaced priorities, and to realize that life itself is in danger. Denes explains her strategy:

> Introduce a leisurely wheatfield into an island of achievement-craze, culture, and decadence. Confront a highly efficient, rich complex where time is money and money rules. Pit the congestion of the city of competence, sophistication, and crime against open fields and the unspoiled farmlands....The everlasting against the forever changing. Culture against grassroots....Simplicity versus shrewd knowing. What we already know against all that we have yet to learn.[31]

A universal concept, the flourishing *Wheatfield* symbolized food, energy, commerce, world trade, and economics. It was also indicative of mismanagement and hunger. From 1987-1990, the harvested grain traveled to 28 cities worldwide in "The International Art Show for the End of World Hunger", organized by the Minnesota Museum of Art. Museum visitors took *Wheatfield*s' seeds and planted them across the globe. While farming at the foot of the World Trade Center twenty years ago, Denes developed an affinity for the Twin Towers. This intimate relationship inspired her loving photographs of the clearing of the rubble, taken on several occasions since September 11, 2001.

Agnes Denes, *Wheatfield- A Confrontation*, 1982, Battery Park Landfill, New York City, New York

Wanting to encourage people to consider the relationship between world hunger and the culture of capitalism, Denes and several volunteers planted a two-acre wheatfield, which they harvested three months later. Planted on the Battery Park Landfill, this wheatfield was in the midst of both the Twin Towers and the Statue of Liberty.

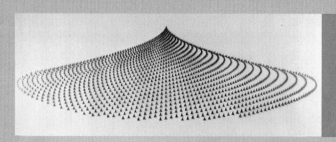

Loosely associated with the conceptual art movement of the late 1960s and early 1970s, Denes has also published several books that articulate the relevance of seemingly esoteric mathematical forms, philosophical concepts, map projections, and elementary particles like dust. For example, her monoprint *Dialectic Triangulations: A Visual Philosophy (including The Human Argument)* (1967-69) visualizes hundreds of simple segments and complex triangulating forms, and posits a list of ten "types of triangulations," mostly based on the dialectic process (adversarial discussion resulting in mutual agreement). During this period, she produced a separate text listing fifteen triangulations. Another monoprint, *Thought Complex* (1972), features dozens of chemical structures from crystallography that one might imagine also model the structure of the mind's thought processes. For Denes, such chemical and mathematical forms are the vehicles through which analytical propositions can be visualized.

Few realize that *Tree Mountain-Proposal for a Forest* (1982-1983), perhaps Denes' most popular conceptual drawing of 10,000 hand-rendered, individual trees, actually functioned as the design for a massive land reclamation project. On June 5, 1992, Earth Environment Day, the Finnish government surprised the world when it announced during the Earth Summit in Rio de Janeiro that it would build Denes' *Tree Mountain* as Finland's contribution to help alleviate the world's ecological stress.

FORESTS MITIGATE THE PROBLEM OF SEDIMENTS ENTERING THE WATERSHED DURING HEAVY RAINS. SILTING MUDDIES WATERWAYS, CAUSING COMBINED-SEWER OVERFLOW WHEN ADJACENT SEWER PIPES CLOG. EACH YEAR, RAIN RUNNING OFF AN AVERAGE FOREST DEPOSITS ONLY 50 TONS SEDIMENTS/ SQUARE MILE INTO THE WATERSHED. BUT RAIN CARRIES 1000-5000 TONS OF SEDIMENT/SQUARE MILE OFF FARMLAND AND 50,000 TONS SEDIMENT/SQUARE MILE FROM LAND UNDER CONSTRUCTION. [32]

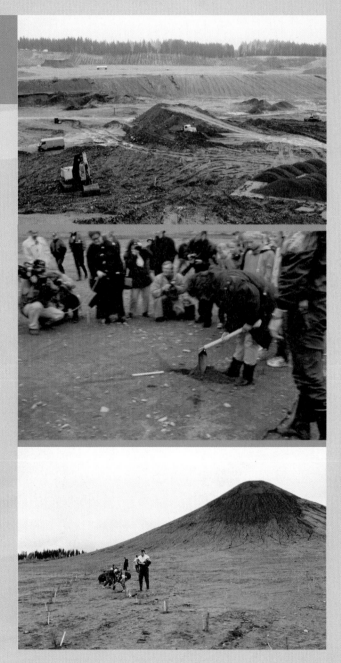

Fewer still realize that the mountain on which the trees were planted actually had to be constructed. A massive man-made mountain, elliptical in shape, measuring 460 yards long, 295 yards wide and 30 yards high, was constructed atop the Pinziö gravel pits near Ylöjärvi, Finland. While the original plan called for 10,000 Finnish Pines, this particular application of Denes' proposal required 1,000 extra trees, each planted by 11,000 people who received certificates naming them as the custodians of the trees for 400 years. Each certificate is an inheritable document, valid for twenty or more future generations.[33]

The Finnish Pine, or Silver Fir, is dying out. The mountain, formed by piling up left over soil, was so soft that the mountain kept collapsing. The little trees' roots began to strengthen the mountain, creating three times as many roots as limbs to hold it up.

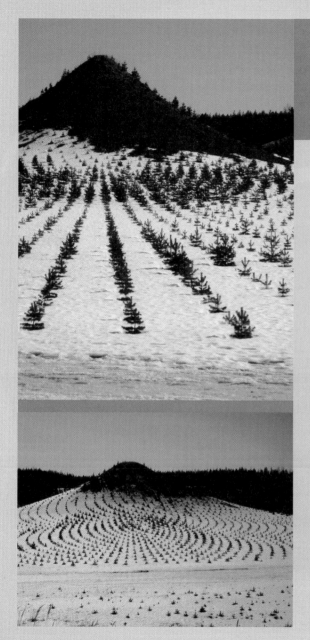

This is not Denes' only forest design that has been realized. *Forest for Australia*, Australia's first forest (1300 feet by 263 feet) was created for the Altoona Treatment plant near Melbourne. Her design entailed planting five sections of 1200 trees (River Red Gum, Paper Bark, and Eucalyptus – all dying out) of varying heights to form spiraling step pyramids. Since 2000, Denes has been working on a 25-year master plan for the 170-mile long *Waterlinie*, a 19th Century defense line in the Netherlands, consisting of 70 forts, batteries, and other fortifications.[34]

unspoiling soil

Throughout the 1980s, **Georg Dietzler** (b. 1958) worked with and exhibited unconserved botanical urban waste, such as blossoms, buds, leaves, and seeds. His work didn't begin to address particular ecological concerns until the late 1980s. When environmental factors destroyed several of **Joseph Beuys'** *7000 Oaks*, Dietzler initiated a long-term acorn conservation project. Since 1989, he has preserved 7000 acorns at -4° Fahrenheit in a freezer stored in an atomic bunker, disguised as an underground parking lot. Due to the acorn's small size, it is very difficult to freeze them for longer than eighteen months, after which the acorns are sprouted, planted, and replaced with new seeds. Detailed information concerning the collecting sites, date of deep freezing, technique for keeping seeds conserved, date of germination, number of germinated seeds, planting date, and site are carefully recorded in an accompanying notebook.[35] Dietzler awaits a new technology enabling the acorns to be stored for longer periods.

By reforesting with conserved acorns, Dietzler takes **Alan Sonfist's** *Gene Banks* (1975), sealed jars containing pieces of bark, seeds, and leaves (possible future relics of a lost forest), one step further. By ensuring unlimited germination, Dietzler's system guards against the acorn's extinction, that is until the last oak tree dies. Should the work be sold, the owner would be responsible to continue conservation. In 1993, Dietzler initiated experiments to decompose soil

Georg Dietzler, *7000 Acorns*, 1989-1990, Association of Contemporary Art, Wesel, Germany

In 1989, Dietzler developed a system to conserve acorns. By storing 7000 acorns at -4°F for eighteen months in atomic bunkers, planting those seeds, and then replacing them with new acorns, the species' survival is ensured until the last acorn tree dies.

contaminated with PCBs (polychlorinated biphenyl) using gourmet oyster mushrooms. Similar to the hyperaccumulators used in **Mel Chin**'s earlier *Revival Field*, the oyster mushroom's mycelium is able to break down the chemical structure of highly toxic PCBs into non-toxic substances without enclosing the toxins in their fruits. Oyster mushrooms generate several useful by-products. In the course of decomposing dry straw, nearly 50% of the mass is liberated as carbon dioxide, 20% is lost as water, 20% remains as "spent" compost, and 10% is converted into dry mushrooms. The remaining "spent" substrate can be used as feed for cattle, chickens, and pigs, to build composts and new soil, and to cover garbage land fills.[37]

GOURMET OYSTER MUSHROOMS OF THE GENUS PLEUROTUS ARE EITHER CULTIVATED OR FOUND IN THE WILD. THEIR AVAILABLE COLORS SPAN THE RAINBOW WHITE, PINK, GOLD, BROWN, BLUE, AND GRAY.[36]

Questions Dietzler's Oyster Mushrooms Eat Up Hazardous Waste Experiment Asks[38]
1. To what extent do PCB bonds accumulate in the "delicacy food"- the mushroom?
2. Can the mushrooms continue to be sold for consumption without hesitation, or do they have to be disposed, and to what degree must this disposal take place?
3. How does the human organism react when it consumes oyster mushrooms that have been used in soil redevelopment?
4. How can people be protected from possible misuse and poisoning?
5. Can artistically aesthetic aspects be tied into biotechnological development of industrial soil?
6. How can remaining buildings and infrastructures be used?
7. Can something like the "intervention" already described exist as an independent work of art in process?
8. Is this about "industrial design" or "scientific design" since ecological redevelopment of health-hazardous industrial sites has become a central aesthetic issue?
9. What are the connections to "art in public space" and "art in construction?"
10. Looking ahead: how can a biotechnological "soil sewage plant" be developed from this project?

Oyster mushrooms may be useful in waste management, especially agricultural waste, since such mushrooms thrive on most hardwoods, wood by-products (sawdust, paper, pulp sludge), straw, corn, corn cobs, sugar cane bagasse, coffee residues (coffee grounds, hulls, stalks, and leaves), banana fronds, cottonseed hulls, agave waste, soy pulp, and many other materials. [39]

Georg Dietzler, *Moveable Oyster Mushroom Patch*, 1996-1997, San Francisco Art Institute

While a visiting professor in the Interdisciplinary Department for Arts, Science, and Environmental Studies at the San Francisco Art Institute, Dietzler constructed a portable laboratory that was first exhibited in *Post-Waste* and later moved to campus. This portable sculpture could appear at farmers' markets, supermarkets, restaurants, and botanical parks.

What sets AMD&ART apart is the work we do is one in which artists
and every other discipline are necessary, but not sufficient.
-T. Allan Comp, Ph.D.[40]

Founded in the mid-1990s by historian **T. Allan Comp**,
AMD&ART identified several ambitious projects at the onset to
jump-start the impoverished economies of several
Southwestern Pennsylvania communities. Mined for almost
two centuries, former coal mining communities in the
Appalachian region suffer economically and environmentally
from acid-mine drainage (AMD). Groundwater running
through mines dissolves exposed minerals, such as alu-
minum, iron, sulfate, and magnesium. When the acidic,
mineral-laden groundwater reaches the surface, the
minerals react with oxygen and precipitate out of the
water, coating plant life with an orange ooze known as
acid-mine drainage. The entire ecosystem is altered due to the destruction of the base of the
food chain. Residents, businesses, and tourists are equally deterred by the lack of potable
water caused by this long-standing situation.[41]

POLLUTION CAUSED BY COAL MINING
LEAVES RESIDENTS IN ABSOLUTE POVER-
TY, SINCE SUCH COMMUNITIES ARE
UNABLE TO ATTRACT NEW BUSINESSES.
THE POVERTY RATE IN THE FIVE SMALL
TOWNS (500-4000 RESIDENTS) SELECTED
FOR AMD&ART PROJECTS RANGES
BETWEEN 54% AND 82%[42] DESPITE THE
SURROUNDING AREAS REMARKABLE NAT-
URAL BEAUTY, ATTRACTING TOURISTS
REMAINS DIFFICULT.

On October 26, 2001, after five years of work by hundreds of volunteers, including local
citizens, Americorps and VISTA volunteers, AMD&ART celebrated its first completed project, a

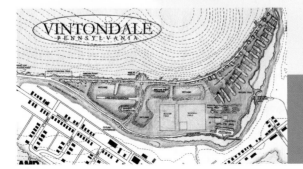

reclaimed mineland that once hosted a coking plant
and several mines in Vintondale, Pennsylvania.
After the mine closed in the early 1990s, it became

AMD&ART, Interpretive Site Plan, July 2000, Vintondale, Pennsylvania

This drawing illustrates the *Litmus Garden*, a wetland treatment system where
acid-mine drainage enters the first basin orange (upper right hand corner), but
changes to blue (clear water reflecting the sky) by the sixth basin, as it loses acid-
ity. A recreational park exists adjacent to this wetland system.

the town dump. Fourteen funding partners, including the U.S. Environmental Protection Agency, U.S. Office of Surface Mining, U.S. Forest Service, Pennsylvania Council on the Arts, and the Pennsylvania Rural Arts Alliance contributed funds toward *Vintondale*'s rejuvenation.

One of *Vintondale*'s primary features is the *Litmus Garden*, a series of seven mostly trapezoidal basins that demonstrate the restoration process, as the acid precipitate drops out and the alkalinity rises until the discharge is neutral like water. Most similar wetland treatment systems resemble switch backs shaped like intestines, but AMD&ART's innovative model enables continuous flow. The *Litmus Garden* is bordered by mountains of bony, a by-product of the coking process.

AMD&ART, Bony Pile, Vintondale, Pennsylvania

Bony, like the slag produced by the steel industry, is a useless by-product of the coal industry. The bony is often dumped to create man-made mountains.

Most novel is the way AMD&ART is financing *Vintondale*'s future. The Southern Allegheny Conservancy, responsible for maintaining Vintondale, will be created from half of the revenues earned by selling part of its basins to Pennsylvania's Department of Transportation for use as replacement wetlands.

Like Ocean Earth and CLUI, AMD&ART's design team members vary depending on the project. Artist **Stacy Levy**, landscape designer **Julie Bargmann**, and hydrologist **Bob Deason** worked with T. Allan Comp on *Vintondale*'s design. Unlike other groups, AMD&ART's philosophical approach tends to vary, depending on the project. For example, *Vintondale*'s multiple settling ponds neutralize the acid-mine drainage, while the *Hughes Bore Hole*, a project still in its nascency, will facilitate this phenomenon's monitoring without attempting to "fix" it, an approach paralleling those presented in the "Valuing Anew" section. Because of the *Hughes Bore Hole*, an excess of 8000 pounds of dissolved metals flow daily into the Little Conemaugh River from this hole in the ground. Drilled in the 1920s

Basin	Type	Color	Activity	pH
Basin 1	Acid Pool	orange	Iron oxide drops out of the acid-mine drainage and coats a bed of limestone.	2.9
Basins 2-4	Wetland Treatment Cells	less orange	cat tails clean water	3.2-4.2
Basin 5	Sequential Alkaline Producing System	pea green	mushroom soil absorbs oxygen provides anaerobic process, solution exits via 5-feet diameter pipe	6.5-6.8
Basin 6	Clarification Marsh	blue	wetlands of bulrushes, water lilies, and reeds.	6-6.2
Basin 7	Polishing Wetlands	blue	similar to Basin 6	N/A

to remove water from hundreds of interconnected coal mines, this hole was capped in the 1950s, but the cap blew off in the 1970s, worsening its impact.[44]

Another AMD&ART project geared toward changing people's attitudes is *Dark Shade Sub-Basin*, where 21 sources spew up to 2000 gallons of acid-mine drainage (pH of 3.3) each minute , loading local rivers and creeks with 30,000 pounds of sulfate, 2000 pounds of iron, and 7,000 pounds of acidity daily. *Dark Shade* is the first coal-impacted watershed to be awarded a US EPA Brownfields Assessment pilot project. AMD&ART plans to create a system of treatment areas, which double as an integrated network of recreational parks. This could serve as a model program to revitalize other river valleys in Appalachia.[45]

BECAUSE OF GASES EMITTED BY OHIO INDUSTRIES, ACID RAIN WITH A PH OF 4.6 FALLS ON WESTERN PENNSYLVANIA, DESTROYING FORESTS AND DESTABILIZING CLEAN WATER SOURCES.

AMD & ART, *Litmus Garden* basin under construction, Vintondale, Pennsylvania

This image highlights the basins' trapezoidal shape. Rather than use switchbacks, as most wetland treatment systems do, AMD&ART's innovative design facilitated a path, whose flows is continuous. This image also demonstrates the surrounding area's natural beauty.

Section 1 -"Introduction," pages 1-20
1. Caffyn Kelley, "Interview with Patricia Johanson," Art and Survival, 1992, p. 32.
2. Lucy Lippard, Patricia Johanson, 1983, p. 13.
3. Harry Parker, January 24, 1992 letter to Patricia Johanson.
4. Plato, "The Love of Beauty," Philosophies of Art & Beauty, p. 77.
5. Michael Auping, "Interview with Helen and Newton Harrison," p. 99.
6. Lynne Hull, "Environmental Arts and Collaboration Symposium," The Natural Order, Landmark Gallery, Texas Tech University, 2000, p. 30.
7. Barbara Matilsky, Fragile Ecologies, Rizzoli in collaboration with the Queens Museum of Art, 1992, p. 47.
8. Mel Chin, Sculpting with the Environment: A Natural Dialogue, ed. Baile Oakes, 1995 p. 176.
9. Andrew C. Revkin, The New York Times, March 6, 2001.
10. Anne Raver, The New York Times, November 8, 2001, p. F2.
11. Chin, p. 176.
12. Eleanor Heartney, "The Garden in the Machine: The Time Landscapes of Alan Sonfist," Alan Sonfist: History and the Landscapes, pp. 14-15.
13. Ibid., p. 15.
14. Ibid.
15. Ibid., pp. 11-12.
16. Gwen Chanzit, Herbert Bayer: Collection and Archive, Denver Art Museum, 1988, p. 9.
17. Roberta Smith, New York Times, May 25, 2001.
18. Peter Selz, "Installations, Environments and Sites," Theories and Documents of Contemporary Art, University of California Press, 1996, p. 503.
19. Ibid.
20. Jane Holtz Kay, The Nation, October 29, 2001, p. 31.
21. Ibid., p. 32.
22. Art and Survival, p. 32.
23. Eco-Dialogue on-line chat, January 18-26, 2001.

Section 2 - "Activism to Publicize Ecological Issues/Monitoring Ecological Problems," pages 21 52.
1. Newton Harrison, quote made in passing.
2. Caroline Tisdale, Joseph Beuys, The Solomon R. Guggenheim Museum, 1979, p. 148.
3. Ibid., p. 39.
4. Matilsky, pp. 53-54.
5. Joseph Beuys video footage, courtesy Ronald Feldman Gallery, 1974.
6. 7000 Oaks, DIA Center for the Arts brochure, 1996.
7. Kristine Stiles, Theories and Documents of Contemporary Art, p. 583.
8. Matilsky, p. 50.
9. Gail Enid Gelburd, Creative Solutions to Ecological Solutions, Council for Creative Projects, New York, 1993, p. 22.
10. The Homeowner's Guide, 1998, p. 20.
11. Joseph Beuys, Theories and Documents, p. 636.
12. Hans Haacke, Translplant, Barbara Nemitz, ed., Hatje

Cantz Publishers, 2000, p. 63.
13. Haacke Der Bevölkerung statement, p. 12.
14. Matilsky, p. 41.
15. Fend statement, XTRA, Volume 4, Number 2, 2001, p.15.
16. Helen Mayer Harrison and Newton Harrison, "Five Recent Works in Transaction with the Cultural Landscape," Trilogy-Art- Nature-Science, Kunsthallen Brandts Klædefabrik, Odense, 1996, p. 160.
17. Tom Sokolowski, "Nobody Told Us When to Stop Thinking," Quarterly Bulletin of Grey Art Gallery, New York University, Volume 1 #2, Spring 1987.
18. The Harrison Studio, Translplant, p. 68.
19. Michel Auping, p. 104.
20. Harrison Studio, Green Heart Vision, February 20, 1995, p. iv.
21. Helen and Newton Harrison, The Serpentine Lattice, Ronald Feldman Gallery, 1993.
22. Trilogy-Art-Nature-Science, p. 163.
23. Ocean Earth résumé.
24. Ibid.
25. Ibid.
26. Peter Fend, March 29, 2002, e-mail.
27. Ocean Earth résumé.
28. Claude Willey, X-TRA, p. 13.
29. Ocean Earth brochure, reprint of article in Issue magazine, Issue 3, 2000.
30. Ocean Earth résumé.
31. Sim Van der Ryn, Toilet Papers-- Recycling Waste and Conserving Water.
32. Ocean Earth résumé.
33. www.clui.org.
34. Land Use Database brochure, CLUI, May 1997.
35. Site Extrapolation Projects brochure, CLUI, September 1996.
36. Brendan Bernhard, LA Weekly, May 30-June 5, 1997, pp. 25-26.
37. Ibid., p. 29.
38. Ibid.
39. Steinmann, Brief Information About Komi Republic.
40. Steinmann, General Information about "Forum for Sustainability," October 2001.
41. Steinmann letter, June 22, 2001.
42. Steinmann, October 2001.
43. David Williams Bath, Navigating the Currents, interview with Basia Irland, April 2001.
44. Basia Irland, Water Library, New Mexico University Art Museum, 2001, p. 36.
45. Kathleen Stewart Howe, Ibid. p. 6.
46. Kathryn Miller and Michael Honer, Lawns in the Desert,1995.
47. Ibid.
48. Minnesota Department of Agriculture website, press release, August 18, 2000.

Section 3 - "Valuing Anew/Living with Brownfields," pages 53-64
1. Tim Collins, Interventions in the Rustbelt, statement, p. 6.

2. Smithson, The Writings of Robert Smithson, ed. Nancy Holt, New York University Press, 1979, p. 22.
3. Matilsky, p. 44.
4. Ibid.
5. Ibid.
6. Ibid.
7. Smithson, "A Sedimentation of the Mind: Earth Projects," Artforum, September 1968.
8. Patricia Johanson Public Landscapes, catalog, 1991, p. 7.
9. Smithson, "Dialectic of Site and Non-site," Gerry Schun, Land Art, Berlin, 1969.
10. Patricia Sanders, interview with Leibovitz Steinman, Artweek, December 1998, p.14.
11. Susan Leibovitz Steinman, e-mail, February 12, 2002.
12. Diana Scott, "'Food for Thought' Project Bears Fruit Under Downtown Freeway," San Francisco Examiner, July 6, 1994, p. 3.
13. Keith Jones, The Oakland Tribune, Living-1.
14. Press release, Protrero Nuevo Fund, Summer 2001.
15. Susan Kuchinskas, San Francisco Examiner, July 6, 1994, p. 3.
16. Leibovitz Steinman, San Jose Mercury News, March 31, 1997, p. 4B.
17. Tim Collins, "Conversations in the Rust Belt," From Virgin Land to Disney World: Nature and Its Discontents in the America of Yesterday and Today, Rodopi, 2002, unpaginated manuscript.
18. Ibid.
19. Kirk Savage, Ample Opportunity: A Community Dialogue, undated statement.
20. Collins, "Conversations in the Rust Belt" .
21. Ibid.
22. Ibid.
22. Ibid.
23. Ibid.
24. Ibid.

Section 4 - "Biodiversity/Accommodating Species/Studying Species Depletion," pages 65-88
1. G. P. Nabhan, "Cultures of Habitat," Our Land Our Selves, The Trust for Public Land, 1999, p.105.
2. Patricia Johanson, "The House and Garden Manuscripts," Art and Survival, 1992, p. 5.
3. Ibid., p. 6.
4. Johanson, "Cyrus Field," Ibid., p. 10.
5. Patricia Johanson, notes for Biological Restoration-Fair Park Lagoon, February 16, 1982.
6. Patricia Johanson, Notes for Phase I Proposal for Fair Park Lagoon, January 8, 1982.
7. Johanson, February 16, 1982.
8. Patricia Johanson, Public Landscapes, 1991, p. 18.
9. Ibid., p. 19.
10. Jill Manton, October 22, 2001 e-mail to Patricia Johanson.
11. Patricia Johanson, Art and Ecology: The Battle for Nairobi River, p. 30.
12. Patricia Johanson, "Preserving Biocultural Diversity in

Public Parks," N.A.P. Texts: A Literary Journal, Volume 2, Number 2, 1997.
13. Ibid.
14. Ibid.
15. Patricia Johanson, Design for Millennium Park, statement, 1999.
16. Patricia Johanson, November 19, 2001 e-mail.
17. Ibid.
18. Matilsky, p. 98.
19. Ibid.
20. Ibid.
21. Ibid., p. 99.
22. Ibid., p. 101.
23. Ibid., p. 103.
24. Simone Ellis, Public Art Review, Spring/Summer 1999, p. 28.
25. Lynne Hull, artist's statement.
26. Hull lecture notes, November 2001, San Francisco Art Institute.
27. Ibid.
28. Lucy Lippard, "Watching the Wild," The Natural Order, 2000, p. 6.
29. Hull, Sculpting with the Environment, p. 137.
30. Hull, lecture notes, 2001.
31. Hull, Sculpting with the Environment, p. 138.
32. Ellis, pp. 28-9.
33. Ibid., p. 29.
34. Ibid., p. 28.
35. Joshua Decter, Siksi, Number 2, Spring 1997, p. 73.
36. Andrew Gellatly, frieze, Issue 54, p. 103.
37. Håkansson, February 27, 2002, e-mail.
38. Yrjö Haila, Nature in Video Time, p. 50.
39. Brandon Ballengée, "Species Reclamation Via a Non-linear Genetic Timeline; an Attempted Hymenochirus Curtipes Model Induced by Controlled Breeding," 1998-2002.
40. Brandon Ballengée, "Selected Timeline of Amphibian Surveys and Related Art Activities," e-mail, February 28, 2002.
41. Brandon Ballengée, 'The Malformed Amphibian Project," 1995-2000.
42. ongoing conversation with Brandon Ballengée, 2001-2002.
43. NY Arts, November 2001, p. 17.
44. Brandon Ballengée, The Red Bloom and Brown Tide, statement, 2001.
45. Tera Galanti, February 7, 2002 e-mail.

Section 5 - "Urban Infrastructure/Environmental Justice," pages 89-108

1. Alan Sonfist, Cincinnati Castle of Refuge, project proposal.
2. Heartney, p. 7.
3. Sonfist, Sculpting with the Environment, p. 165.
4. Heartney, p. 8.
5. Allegra Raff, Alan Sonfist Studio, April 3, 2002 e-mail.
6. Raff, March 1, 2002 e-mail.
7. John Grande, Rodman Hall press release,

October 23, 2001.
8. Marla Cone, Los Angeles Times, October 2, 1994, p. A1.
9. Heartney, pp. 12-13.
10. Mierle Laderman Ukeles, "Maintenance Art Manifesto," Artforum, January 1971.
11. Ibid.
12. Mierle Laderman Ukeles, Landscape Architecture, August 2001, p. 84.
13. Laderman Ukeles, Sculpting with the Environment, p. 184.
14. Conversation with Laderman Ukeles, February 18, 2002.
15. Landscape Architecture, August 2001, p. 95.
16. Laderman Ukeles, p. 192.
17. Ibid., p. 193.
18. City of Cambridge, Transformation of a City Dump, pamphlet.
19. Ibid.
20. Buster Simpson, Hudson Headwaters Purge statement.
21. Matilsky, p. 94.
22. Ibid., p. 93.
23. Ibid., p. 95.
24. Ibid.
25. Buster Simpson, Sculpting with the Environment, p. 121.
26. Ibid., p. 124.
27. Buster Simpson, Slide Sheet, 2002.
28. Poldi Gerard, e-mail dated May 1, 2002.
29. Viet Ngo, Sculpting with the Environment, p. 179.
30. Ibid. p. 180
31. www.lemnainternational.com.
32. Ngo, p. 180.
33. Ibid., p. 183.
34. Laurie Lundquist, Description of Slides, 2001.
35. Laurie Lundquist, "Lagoon Project: San Francisco Exploratorium," Leonardo, Volume 7, Number 4, 1994, p. 367.
36. Deep Creek Arts, Summer 1999, brochure.
37. www.superflex.dk.
38. Superflex, Biogas statement.
39. Mel Chin, S.W.I.N.G. (in Detroit) proposal, August 5, 2001 e-mail.
40. Ibid.

Section 6 - "Reclamation and Restoration Aesthetics," pages 109-130

1. Betsy Damon and Anne H. Mavor, draft of The Living Garden, Chengdu Province, China, unpaginated manuscript.
2. Damon and Mavor.
3. Waterfront World Spotlight, Volume 17, No. 1, 1999, p. 5.
4. Places, Winter 2000, p. 8.
5. Damon and Mavor.
6. Places, p. 8.
7. Damon and Mavor.
8. Places, p. 8.
9. Damon and Mavor.
10. Ibid.
11. Ibid.

12. Places, p. 7.
13. Ibid.
14. Ibid.
15. Jackie Brookner, Prima Lingua statement, 1996.
16. Ibid.
17. Deborah Snoonian, P.E., "Drain It Right: Wetlands for Managing Runoff," Architectural Record, August 2001, p. 129.
18. H.A. Carr and R.A. Cooper, "Manned Submersibles Assessment of Lost Ghost Gill Nets in the GOM," 1987, Oceans '87 Proceedings, pp. 622-624.
19. Judith Bell, Ghost Nets press release, January 18, 2000.
20. Ibid.
21. Aviva Rahmani, National Wetlands Newsletter, March-April 2000, pp. 3-4.
22. Aviva Rahmani, January 22, 2001 press release.
23. Aviva Rahmani, Cities and Oceans of If press release, January 22, 2001.
24. Aviva Rahmani, December 20, 2001 e-mail.
25. Ocean Earth, Summary Statement, 1988, faxed March 31, 2002.
26. Mossi Raz, New Zionism statement, not dated.
27. Concert for Cement Mixers, press release, December 2001.
28. Agnes Denes, Agnes Denes, Cornell University, 1992, p. 118.
29. Ibid.
30. James Clark, "Food for Thought, The Art of Agnes Denes," Public Art Review, Spring/Summer 1997, p. 11.
31. Agnes Denes, Agnes Denes, p. 118.
32. Holly Utrata-Halcomb, soil conservation lecture, December 8, 2000.
33. Denes, p. 118.
34. Agnes Denes, Commissions, Environmental Sculpture, and Installations.
35. Georg Dietzler, Project Underground- 7000 acorns, undated statement.
36. Georg Dietzler, Text About Oyster Mushrooms, October 1997.
37. Ibid.
38. Georg Dietzler, Sculptural Experiments-- Biotechnological Soil Redevelopment, 1995.
39. Georg Dietzler, Text About Oyster Mushrooms.
40. phone conversation with T. Allan Comp, 2001.
41. AMD&ART tri-fold, not dated.
42. 1990 Municipal Census Profiles, Census of Population and Housing, Pennsylvania State Data Center.
43. phone conversation with Stacy Levy, May 8, 2002.
44. AMD&ART, Transforming Environmental Liabilities into Community Assets, undated brochure.
45. Ibid.

1955-	Herbert Bayer builds *grass mound* for Aspen Art Institute, Aspen, Colorado
1962-	Joseph Beuys proposes "action" to clean up Elbe River in Hamburg, Germany
1965-	Hans Haacke's manifesto calls for time-based, dynamic, natural, indeterminate art. Alan Sonfist makes original drawings for *Time Landscape*
1968-	Agnes Denes performs *Haiku Poetry Burial, Rice Planting and Tree Chaining/Exercises in Eco-Logic*, Sullivan County, New York Patricia Johanson installs light responsive 1600-foot work along railroad, Buskirk, New York
1969-	Haacke creates *Grass Grows* in response to 1965 manifesto, Ithaca, New York Sonfist publicly articulates the significance of native forests in urban centers. Sonfist monitors the air quality at 57th St & Fifth Avenue, 42nd Street & Broadway, West Broadway & Houston Street, and Rector St. & Broadway, and posts the results. Betty Beaumont documents clean-up of worst U.S. oil spill, Santa Barbara, California Mierle Laderman Ukeles writes "Manifesto for Maintenance Art" Johanson draws 100s of innovative designs for ecologically-integrated gardens for an article commissioned by *Home and Garden*, but never published.
1970-	Newton Harrison performs *Making Earth* ritual in his studio. Johanson realizes *Cyrus Field*, a path through the woods, Buskirk, New York Haacke creates *Bowery Seeds* to attract airborne seeds, New York, New York
1971-	Robert Smithson constructs *Spiral Hill/Broken Circle* in Emmen, the Netherlands Beuys performs *Bog Action* and *Forest Action*, Germany Bonnie Sherk performs *Public Lunch* with animals, the Lion House, San Francisco Zoo Laderman Ukeles publishes "Maintenance Art Manifesto," *Artforum*, January
1972-1979-	Helen and Newton Harrison realize seven projects for lagoons, California
1973-	David Tudor performs *Island Eye Island Ear*, sounds of island nature, Knavelskär, Sweden
1973-1976-	Laderman Ukeles performs 17 Maintenance Performances, United Kingdom, United States, and Israel
1973-1974-	Haacke proposes *Vorschlag Niemandsland (Proposal No Man's Land)*, Bonn, Germany Johanson links school, woods and park space, Columbus East High School, Columbus, Indiana
1974-	Beuys diagrams his *Energy Plan for Western Man*, New York, Chicago, Minneapolis.
1974-1980-	Sherk transforms barren site into local educational farm, San Francisco, California
1975-	Sonfist realizes *Pool of Earth*, a 25-foot diameter clay site to catch seeds, Artpark, Lewiston, New York Sonfist creates *Gene Banks*, a collection of relics from a virgin hemlock forest.

1977-	Denes plants half acre of white rice that "mutates" into red, Artpark, Lewiston, New York Beaumont's 100-foot diameter iron *Cable Piece* hastens grass growth, Macomb, Illinois Laderman Ukeles becomes New York Sanitation Department's Artist-in-Residence.
1977-1978-	The Harrisons' *Spoils Pile* blossoms into a meadow, Artpark, Lewiston, New York
1978-	Sonfist plants *Time Landscape*, La Guardia Place, New York City Buster Simpson installs *Downspout-Plant Life Monitoring System*, Pike Place Public Market, Seattle, Washington Simpson places concrete plates in Niagara River's sewage outfall to demonstrate toxicity, New York
1978-1980-	Beaumont submerges a 150-foot long coral reef 50 miles off Atlantic Coast, New York
1979-1981-	Laderman Ukeles shakes hands with 8,500 NYC sanitation workers.
1981-1986-	Johanson transforms algal bloom lagoon into thriving ecosystem, Dallas, Texas
1982-	Denes harvests 1000 pounds of wheat, Battery Park Landfill, New York City Ocean Earth introduces scheme to tax polluters gauged by satellite-imagery data.
1982-1987-	Beuys' *Save the Forest* reforests Kassel with 7000 trees, Documenta VII, Germany
1983-	Lynne Hull carves her first water collecting hydroglyph, Albany County, Wyoming. Laderman Ukeles *Social Mirror* reflects citizens onto garbage trucks, New York City Viet Ngo creates his first wastewater treatment plant that uses lemnas. Simpson places first limestone pills in Tolt Watershed to counter acidity, Seattle, Washington
1984-	Simpson places vitreous china plates in sewage outfalls in Seattle, Houston, New York City, and Cleveland.
1985-	Harriet Feigenbaum rings coal-dust runoff pond with 60 Willows trees, Scranton, Pennsylvania
1987-1996-	Johanson designs *Endangered Garden* for sewer facility, San Francisco, California
1988-	Simpson conceives of a safe, inexpensive composting toilet for public use. Public Art Plan for Phoenix paves the way for ecoventions in urban infrastructure. Ocean Earth publishes satellite imagery proving algal bloom occurring off coast of Denmark.
1988-1991-	Denes builds responsive oasis, *North Waterfront Park*, 97-acre landfill, Berkeley, California
1989-	British scientists writing in the *London Times* confirm Ocean Earth's 1986 analysis that Chernobyl's siting on an unstable landfill, not the workers, caused the accident. Hull builds her first floating island in Wyoming. Georg Dietzler develops system to conserve acorn germination, Munich, Germany.

1990- Hull installs *Lightning Raptor Roost*, her first for eagles and
hawks, Red Desert, Wyoming
Betsy Damon founds Keepers of the Water to join communities,
artists and scientists.

1991- Simpson places a nurse log to nurture a forest, Oregon
Convention Center, Portland, Oregon

1991-2000- Aviva Rahmani restores town dump to salt water marsh,
Vinalhaven, Maine

1992- Finland announces Denes' forest at Rio Summit to counter
environmental damage.
Kathryn Miller first performs *Seed Bombing the Landscape*,
Santa Barbara, California
Miller lures butterflies by revegetating a neglected public park,
Isla Vista, California

1993- Cambridge, Massachusetts citizens contribute clear, colored and
stained glass, and mirrors for Laderman Ukeles'
Glasphalt Path.
Dietzler experiments with oyster mushrooms to clean PCB-
contaminated soil, Germany

1994- Miller and Michael Honer perform Desert Lawn, various sites
near Los Angeles, California
Reiko Goto, a botanist, entomologist and landscape architect
create *Cho-en*, an experimental butterfly habitat on the
Moscone Center's roof, San Francisco, California

1995-2000- Basia Irland directs *A Gathering of Waters: Rio Grande,
Source to Sea* along 1885-mile river.

1995- Harrison Studio openly discuss influential *A Vision for the
Green Heart of Holland*.
Miller revegetates plot of land under the Westgate Freeway,
Melbourne, Australia

1996- Brandon Ballengée begins *Amphibian Malformation Project*
with Stanley Sessions
11,000 people become stewards for 11,000 trees planted on
Denes' man-made mountain, Pinziö gravel pits near
Ylöjärvi, Finland.

1997- Portion of Harrison Studio's Future Garden is moved to
Rhineauen Park, Bonn, Germany
CLUI introduces tours, *Hinterland*, Los Angeles
Contemporary Exhibitions, California
Tera Galanti first breeds silkworms backwards to achieve
silkmoths that fly.

1998- Henrik Håkansson records sleeping anaconda for 3 hours,Yasuni
National Park, Ecuador
Håkansson monitors bats, owls, and insects residing in nest
boxes, Vischering, Germany
Simpson places *Brush with Illumination* in False Creek to measure
pollution, Vancouver, British Columbia
Hull builds owl houses and playground with Mayans, San
Cristobal de las Casas, Mexico
Hull works with Mayans to build monkey bridge and canoe trail,
Punta Laguna, Mexico
Denes' *A Forest for Australia* entails planting six thousand trees in five
spirals, Melbourne, Australia
Damon's *The Living Water Garden* features novel flow form
designs, Chengdu, China
Laurie Lundquist creates *Waterbridge* to circulate standing water,
Tempe, Arizona

1999- Ballengée begins breeding Hymenochirus curtipes frogs
backwards in studio lab.
Irland installs *Desert Fountain*, The Albuquerque
Museum, New Mexico
Team established to transform Nine Mile Run according to
community guidelines.
Eco-art on-line dialogue established after College Arts Association

2000- panel discussion on state-of-the-art environmental art.
Bundestag Speaker activates Haacke's *Der Bevölkerung*, The
Reichstag, Berlin, Germany
Håkannson constructs *A Thousand Leaves*, a beach-side
meadow, Helsinki,Finland
Denes delivers *Nieuwe Hollandse Waterlinie*, 25-year Masterplan,
Fort Asperen, the Netherlands

2001- CLUI installs Dutch Landscape information kiosk, Fort Asperen
Foundation, the Netherlands
Ballengée surveys malformed amphibians in ponds, Fairfield
County, Ohio
Håkansson installs Zeewolde Field Library, Zeewolde,
the Netherlands
Jackie Brookner's *Gift of Water* cleanses water re-entering pool,
Grossenhain, Germany
AMD&ART complete *Vintondale*, a 35-acre reclaimed mine,
Vintondale, Pennsylvania

Ecovention dovetails with Rio+10, the UN-sponsored summit on urban ecology.
Dozens of ecoventions are coming into fruition in 2002. To follow is a survey:

2002- Rahmani is restoring dozens of small eco-zones to stimulate the
St. Louis watershed.
Steinmann builds Forum for Sustainability, an ecological research
center, Kobi, Russia
Steinman, Lacy, and Kobayashi develop program for eco-tourism,
Elkhorn City, Kentucky
Mel Chin develops S.W.I.N.G., an economically sustainable
community model, Detroit, Michigan
Johanson's designs transform meridian strips, landfills, and a
sanitation facility into public parks in Salina, Kansas; Ulsan
Park and Millennium Park, both Seoul, Korea; and Petaluma,
California, respectively.
Damon begins to renovate 47 km portion of Wen Yu He River,
Beijing,China.

A Short History of Eco-Art Exhibitions (exhibitions with known catalogs are in bold)

1951- "The New Landscape in Art and Science," Massachusetts Institute
of Technology, Cambridge,

1966- Hans Haacke grows grass on a Plexiglas cube (anticipates Bob
Bingham's growing grass on slag for Nine Mile Run), Howard
Wise Gallery, New York, New York

1967- Gyorgy Kepes opens Center for Advanced Visual Studies at
Massachusetts Institute of Technology, Cambridge

1968- Newton Harrison grows a lily cell in a medium, Howard Wise
Gallery, New York, New York
**"The Art of the Real," Museum of Modern Art, New York,
New York (travels)**

1969- **"Earth Art" (Haacke, Smithson, Oppenheim, Morris + 5), Cornell
University, Ithaca, New York**

1970- Haacke performs *Ten Turtles Set Free*, Fondation Maeght, St. Paul
de Vence, France
**"Explorations: Towards a Civic Art," Smithsonian Institute,
Washington, D.C.**
**"Expo 70- New Art: Art and Technology," United States Pavilion,
Osaka, Japan**

1971- Helen Harrison performs *Fish Feast* for 500 people, The Hayward
Gallery, London, United Kingdom
**"Earth, Air, Fire, and Water: Elements of Art," Museum of Fine Art,
Boston, Massachusetts**
**"Art and Technology," Los Angeles County Museum of
Art, California**
**"Earth: Animal, Vegetable, Mineral," La Jolla Museum of
Contemporary Art, California**
Alan Sonfist presents 1969 air monitoring action, Reese
Palley Gallery, New York, New York

1972-	Haacke, *Rhinewater Purification Plant*, Museum Haus Lange, Krefeld, Germany
	Helen Harrison performs *Citrus Feast* for 175 people, Cal-State Univ., Fullerton, California
	Alan Sonfist, *Colony of Army Ants* (live indoor anthill plus videos contrasting urban dwellers and ant life), Automation House, New York City, New York

1972-
Haacke, *Rhinewater Purification Plant*, Museum Haus Lange, Krefeld, Germany
Helen Harrison performs *Citrus Feast* for 175 people, Cal-State Univ., Fullerton, California
Alan Sonfist, *Colony of Army Ants* (live indoor anthill plus videos contrasting urban dwellers and ant life), Automation House, New York City, New York

1973-
Helen Harrison performs *Making Strawberry Jam*, Cal. State Univ., Fullerton, California.
"Art in Space," Detroit Institute of Arts, Michigan
"Patricia Johanson: A Selected Retrospective," Bennington College, Vermont
Mierle Laderman Ukeles, *Maintenance Art*, Wadsworth Atheneum, Hartford, Connecticut

1974-
Beuys performs *Coyote. I Like America and America Likes Me*, Rene Bloch, New York City
Patricia Johanson: "Some Approaches to Landscape, Architecture and the City," Montclair State College, New Jersey

1975-
"Art in Landscape," Independent Curators Inc., New York City (travels 2 years)
"A Response to the Environment," Rutgers University Gallery, New Brunswick, New Jersey

1977-
Harrisons perform *From the Great Lakes Meditation*, Center for 20th Century Studies, University of Wisconsin, Milwaukee, Wisconsin
Laderman Ukeles, "I Make Maintenance Art 1 Hour Every Day," Whitney Downtown

1978-
Ocean Earth participates in "Earth Net: An Economic System," Baxter Art Museum, California Institute of Technology, Pasadena, California
"Artists Investigate the Environment," Municipal Art Gallery, Los Angeles, California
"Celebration of Water," Cooper-Hewitt Museum, Smithsonian Institution, New York City
"Patricia Johanson: Plant Drawings for Projects," Rosa Esman Gallery, New York City

1979-
"Earthworks: Land Reclamation as Sculpture," Seattle Art Museum, Seattle, Washington
"Dialogue, Discourse, Research," Santa Barbara Museum of Art, California

1979-1982-
Herbert Bayer's *Mill Creek Canyon Earthworks* cleans stormwater runoff, in conjunction with Seattle Art Museum exhibition, Seattle, Washington

1981-
Duisburg Oeffnet Sich (group show with Ocean Earth, Beuys and others), Ruhrgebiet, Germany
"Artists' Parks and Gardens," Museum of Contemporary Art, Chicago, Illinois (travels)
"Patricia Johanson: Landscapes," Rosa Esman Gallery, New York City

1982-
"Space Force in Action," Ocean Earth's acid-rain analysis, Kunsthalle Düsseldorf, Germany
"Common Ground: Five Artists in the Florida Landscape,"Ringling Museum, Sarasota, Florida
"Patricia Johanson: A Project for the Fair Park Lagoon," Dallas Museum of Fine Arts, Texas

1983-
The Harrisons, "Guadaloupe Meander,A Refugia for San Jose," San Jose Museum of Art,California

1984-
Ocean Earth, "Television Government," Kunsthalle Berlin, Berlin, Germany

1985-
The Harrisons, **"Arroyo Seco Release,"** Baxter Gallery, Cal-Tech, Pasadena, California

The Harrisons, **"The Lagoon Cycle,"** Johnson Museum, Cornell University, Ithaca, New York
Ocean Earth, *Command, Control, Communication + Intelligence (C3I)* performance, Walker Art Center, Minneapolis, Minnesota

1987-
Part-time Ocean Earth participant Ingo Günther exhibits Ocean Earth material at "Documenta VIII," Kassel, Germany
The Harrisons, **"The Lagoon Cycle,"** Los Angeles County Museum of Art, California

1987-
Grain from Denes' wheatfield travel in "The International Show to End World Hunger," Minnesota Museum of Art, Minneapolis, (travels to 13 countries/4 continents)

1988-
"Off Site:Artists in Response to the Environment," Richmond Art Center, Richmond, Virginia
Laderman Ukeles, "The New Urban Landscape," World Financial Center, New York City
"La Nature de l'Art," Parque de la Villette, CitÈ des Sciences et de l'Industrie and l'Institute Goethe, Paris, France.

1989-
The Harrisons, **"The Sava River,"** Yugoslavia, Neuen Berliner Kunstverein, Berlin, Germany
"Urban Sites:Artists and Urban Strategies," California College of Arts and Crafts Gallery, Oakland, California
"Ressource Kunst, Künstlerhaus Bethanien," Akademie der Künste, Berlin, Germany
Buster Simpson, "Face Plate," Hirshhorn Museum and Sculpture Garden, Washington,D.C.

1990-
"Revered Earth," Contemporary Arts Museum, Houston, TX (travels 2 years)
The Harrisons, **"The Sava River,"** Yugoslavia, Moderna Galerija, Ljubljana, Yugoslavia (travels)

1991-
"Europa," Ocean Earth present satellite monitoring of each of Europe's 13 ocean basins, Kunstraum Daxer, Munich, Germany
"Heimaten," Ocean Earth presents satellite monitoring of 4 Black Sea sites, Wiener Festwochen, Vienna, Austria
Mel Chin plants *Revival Field* with Dr. Rufus Chaney, Pig's Eye Landfill, Walker Art Center, Minneapolis, Minnesota

1992-
"Fragile Ecologies," Queens Art Museum, Queens, New York (travels 2 years)
Ocean Earth text exhibited at "Documenta IX," Kassel, Germany
"Completing the Circle: Artists Books on the Environment," Minnesota Center for Book Arts.
"Imperiled Shores," The Baxter Gallery, Portland School of Art, Portland, Maine

1993-
"The Coastal Project 1988-93 A Retro.," C.C.S. Gallery, U.C., Santa Barbara, California
The Harrisons, **"Serpentine Lattice,"** Cooley Art Gallery, Reed College, Portland, Oregon
"Ocean Earth: for a World Which Works," retrospective, Neue Galerie am Landesmuseum Joanneum, Graz, Austria
Ocean Earth exhibit *Oil-Free Corridor*, "Venice Biennale Aperto," Venice, Italy
"Creative Solutions to Ecological Issues," Dallas Museum of Natural History, Texas (travels)
Ocean Earth exhibit Giant Algae System/Clean Air Rig, Strategie Globale, FRAC Poitou-Charentes, Angoulême, France (travels throughout France 1993-96)
"Kunst-Kultur-Ökologie" (the Harrisons), Bea Voigt Gallery, Munich, Germany
"The Nature of the Machine (kinetic and biokinetic art)," Chicago Cultural Center, Chicago, Illinois

1994-
Ocean Earth, "Startbahn Österreich," a bird path, Galerie Metropol, Vienna, Austria
"Eurasian Scenario," Ocean Earth exhibit basins, Mark Joancou Gallery, London, United Kingdom
"Lure of the Local" (Lucy Lippard, curator), Colorado University Gallery, Boulder, Colorado
"Effect or Infect (Art and Ecology)" (Hull, Harrisons), Soho 20, New York City

"Art as if the World Matters," Dahl Fine Arts Center,
 Rapid City, South Dakota
"A Natural Dialogue," International Sculpture Center, New York City
 (travels to D.C.)
Laderman Ukeles, "Garbage! The History and Politics of Trash in
 NYC," New York Public Library, New York City
"Re: Regarding,Recycling, Revaluing," Step Gallery,Arizona State
 University,Tempe, Arizona

1995- "Eco Nation" (Simpson, Steinman, Collins/Goto...), Bedford Gallery,
 Walnut Creek, California
"Division of Labor: Women's Work in Contemporary Art," Bronx
 Museum of the Arts, New York
Harrison Studio, "A Vision for the Green Heart of Holland,"
 small chapel, Gouda, Netherlands
Ocean Earth *alternatives to dams,* Landkraft, Kunstlerhaus
 Thurn & Taxis, Bregenz, Austria
Miller and Honer, **"Lawns in the Desert,"** Municipal Art Gallery,
 Los Angeles, California

1996- Dietzler creates a mushroom column in situ, San Francisco Art
 Institute, California
Harrison Studio plants **"Future Garden-Part 1: The Endangered
 Meadows of Europe"** atop Bundes Kunst-und Ausstellungshalle
 der Bundesrepublik Deutschland, Bonn, Germany
Ocean Earth proposes to fix Chernobyl's hydrological pressure,
 Steffany Martz, New York City
"TRILOGY-Art Nature-Science," Kunsthallen Brandts Klædefabrik,
 Odense, Denmark
Art About the Environment, Center for Art and Earth,
 New York City
Lynne Hull (solo) "Trans-species," Adams State College,
 Alamosa, Colorado
"Post-Waste" (Dietzler presents portable mushroom patch), Arts
 Benicias, Benicia, California
Henrik Håkansson, *Z.O.N.E. for frogs,***"Nowhere,"** Louisiana
 Museum, Humlebæk, Denmark

1997- "The Grasslands: Urban Wasteland Transformed," Melbourne
 International Art Festival
Ocean Earth, *Circulatory System, Antartica-oriented maps,*
 "Desert Flood", New York City
Harrison Studio, **"Green Heart Vision,"** Kunstmuseum
 Bonn, Germany
Center for Land Use Interpretation, **"Hinterland: A Voyage into
 Exurban Southern California,"** Los Angeles Contemporary
 Exhibitions, California
Lynne Hull (solo), University of Illinois Gallery, Springfield, Illinois
Håkansson, *Out of the Black into the Blue,* Nordic Pavilion,
 Venice Biennale, Italy
Alan Sonfist, **"History and the Landscape,"** The University of Iowa
 Museum,Iowa City, Iowa
Laurie Lundquist, "Surface Tension," Joseph Gross Gallery,
 University of Arizona, Tempe, Arizona
Dietzler installs Oyster Mushroom Growing Experiment I,
 "Laboratory for Plant Growing," Le Jardin des Biotechnologies,
 La Cité des Sciences et de l'Industrie, Paris, France
AMD&ART, "From Rust to Renewal," travels for two years
 in Pennsylvania.

1998- Ocean Earth, sole-non Yugoslavian participant in ocean
 conference, Zagreb, Yugoslavia
"Watershed," Euphrat Museum, Cupertino, California
Håkansson, *After Forever (after all),* **"Greenhouse Effect,"**
 Serpentine Gallery, London, United Kingdom
AMD&ART, *Testing the Waters,* "Eco-Revelatory Design: Nature
 Constructed/Nature Revealed," Temple Buhl Gallery, University
 of Illinois, Champaign-Urbana, Illinois (travels two years).

1999- CLUI-**"Commonwealth of Technology: Extrapolations on the
 Contemporary Landscape of Massachusetts,"** List Center for
 Visual Arts, Massachusetts Institute of
 Technology, Cambridge
Nine Mile Run-Greenway Project, "Conversations in the Rust Belt:
 Brownfields into Greenways," Wood St. Galleries,

Pittsburgh, Pennsylvania
Håkansson, **"Tomorrow and Tonight,"** roof-garden surveillance,
 Kunsthalle Basel,Switzerland
CLUI, **"One Hundred Places in Washington,"** Center on
 Contemporary Art, Seattle, Washington
"Oil & Water," Arizona Museum for Youth, Mesa, Arizona
Jackie Brookner, *Prima Lingua,* "Drip, Blow, Burn/ Forces of
 Nature in Contemporary Art," Hudson River Museum,
 Yonkers, New York
"Natural Reality" (Collins/Goto, Dietzler), Ludwig Forum,
 Aachen, Germany

2000- Ocean Earth, *China Basin Plans,* "Ecologies," Smart Museum of
 Art, U.C.,Chicago, Illinois
"Our Planet, Ourselves" (Hull among others), St. Louis, Missouri
Jackie Brookner, *I'm You,* **"Abundant Invention,"** Wave Hill,
 Bronx, New York
Henrik Håkansson, **"Sweat Leaf,"** Galerie fur Zeitgenössiche Kunst
 Leipzig, German
"The Natural Order (Hull),**"** The Landmark Gallery, Texas Tech
 University, Lubbock, Texas
Brandon Ballengée, "The Red Bloom and Brown Tide: A Visual
 Survey of Toxic Microalgae," C.W. Post campus, Long Island
 University, Brookville, New York
"Sites Around the City," 26 projects in different locations, organized
 by Arizona State University Museum, Tempe, Arizona

2001- CLUI- "Formations of Erasure," Storefront for Art and Architecture,
 New York City
CLUI- "Curious Orange," Beall Center for Art and Technology,
 University of California, Irvine, California
CLUI- **"Back to the Bay: Exploring the Margins of the San Francisco
 Bay Region,"**Yerba Buena Center for the Arts,
 San Francisco, California
Ballengée exhibits backward bred frogs in "Paradise Now," Exit Art,
 New York City
Ocean Earth, "Sea Change growth of algae/fermentation/gas flame,"
 Exeter, United Kingdom
Ocean Earth, "Policy Models," Rockford Art Museum,
 Rockford, Illinois
"Six Proposals for Fresh Kills Landfill," Staten Island Institute of Arts
 and Sciences, travels to Municipal Art Gallery, New York City
Ballengée exhibits *Ever Changing Tide,* Queens Museum of Art,
 New York
"Post-Landscape: between Nature and Culture," Pomona College
 Museum of Art, California
Lynne Hull (solo) "Corridors and Connections," FC-MOCA, Ft.
 Collins, Colorado

2002- Aviva Rahmani, "If...," Center for Maine Contemporary Art,
 Rockport, Maine
AMD&ART's *Vintondale* project is presented at "Documenta XI,"
 Kassel, Germany.

In conjunction with *Ecovention* at the Contemporary Arts Center, Cincinnati, Ohio:

Hull places floating islands on ponds in Swaim Park and Rowe
 Woods, and launches water kites on Mill Creek,
 Cincinnati, Ohio.
Brookner works with Mill Creek Restoration Project, Cincinnati
 Recreation Commission, and Human Nature to develop bio-
 sculpture that cleanses street runoff before entering the Mill
 Creek, Cincinnati, Ohio.
CLUI photo-documents 20 man-made landforms in Ohio.
Simpson constructs complex vertical garden outside CAC to
 cleanse HVAC runoff before it dumps into public sewer.
Ocean Earth works with Robert Vitale of the Water Wheel Factory
 to adapt Poncelet undershot Water Wheel™ for deep rivers,
 North Carolina and Ohio.
Ballengée broadcasts experiments to determine cause of
 amphibian malformation via an internet connection from
 Queens, New York to the CAC.

Section 9

artists' philosophical statements

This section presents several artists' thoughts about either their particular practice's relevance, the necessity for particular values, or the role of ecoventions.

AMD&ART

AMD&ART is a community-driven design team. Our goal is to give voice and form to community aspirations for their spaces, environment, and future. Our challenge is to work closely with the community to bring successful results, rather than tell them what to do. Each contributor--the community, scientist, historian, designer, and artist must each consider the design successful. Each member of the design team (the historian, scientist, sculptor, and landscape designer), who worked most closely with *Vintondale*, never compromised his/her disciplines, but each had to accommodate the others'. There are no singular or formally sufficient members of the design team or the staff, only necessary members willing to contribute what their perspective, knowledge, and talent can bring to the larger whole. This is not an easy process, but the results are worth the effort.

AMD&ART's recently completed *Vintondale*, a large 35-acre art project, can provide a viable model for others to follow across the Appalachian coalfields. Our entire staff has been AmeriCorps members of great talent. Our director has been a volunteer throughout the years of project development and implementation, and our design team has functioned more like a visiting consulting service. Our website and printed materials serve as a kind of intellectual catalogue, providing other communities ideas and new perspectives. AMD&ART are determined to exchange the orange stains of a conflicted past for the clean water of a better future.

Brandon Ballengée

My work attempts to blur the already ambiguous boundaries between science and art. I use data obtained from biological field research as the basis for my ecological art. Since 1995, I have been studying declining populations and deformities in amphibians. These investigations have involved collaborations with numerous researchers throughout the United States. A recent project involves investigating wetlands in central Ohio with Dr. James Barron, Biologist at Ohio University, Lancaster. Dr. Barron and I are both field observers for the United States Geological Survey's North American Reporting Center for Amphibian Malformation (NARCAM). All aspects of the project are being documented and data obtained from our field work will be submitted to NARCAM. All deformed specimens will be collected and sent to Dr. Stanley Sessions, Developmental Biologist at Hartwick College, for further examination. Dr. Sessions has conducted extensive research on amphibian limb development and the abnormalities that can occur during cellular regeneration.

As a component to the Ecovention exhibition, at the Contemporary Art Center in Cincinnati, Dr. Sessions and I will web-cast an actual laboratory experiment involving mechanical disruption in developing amphibian limb buds. There is a significant amount of information not yet known about amphibian regeneration. Many of the malformations we have found in the wild can be induced through injuries caused by parasitic infestation. The intention of exhibiting our experiment is not to "shock" or "disgust" the viewer, but to inform viewers about the complex growth processes of other living organisms. We also hope to demonstrate the type of experiments necessary in order to understand what is happening in the environment around us.

Betty Beaumont

The first industrial revolution is now officially over, and another one is beginning to take form. It is in this space, this gap or cusp between these revolutions that my work has taken place over the past thirty-three years. It is in this new transformative space that I will continue to work. It is a political space that has the potential to align and integrate the ways we support life economically and ecologically. In order to imagine this space, it is vital to change our belief systems. I am suggesting a cultural transformation that will encourage our community to consider nature as a mainstay of the human value system.

I believe the future is created by the quality of the present and that art can contribute to making a difference; that the societal role of art is to explore the potentials within ecological, political, and economic landscapes, whether they form ideas (mental landscapes), or physical terrain (in the real world) and/or virtual environments (in cyberspace).

This is a critical historical juncture at which I feel we have the opportunity to make a huge difference. Material needs are simplified when we embrace a creative intellectual and spiritual life within the community. This moment of cultural transformation is based on a knowledge of interdependence, which is reflected in an economy of spirituality and a culture of ecovention. Art is central to the shaping of our world. We are participating in a revolution whose basis is in ideas, art and education. Today artists and industry are redesigning every facet of our physical and cultural terrain to create a sustainable internal and external environment.

Joseph Beuys (from a 1979 interview with Frans Hak)

Creativity isn't the monopoly of artists. This is the crucial fact I've come to realize, and this broader concept of creativity is my concept of art. When I say everybody is an artist, I mean everybody can determine the content of life in his particular sphere, whether in painting, music, engineering, caring for the sick, the economy or whatever. All around us the fundamentals of life are crying out to be shaped or created. But our idea of culture is severely restricted because we've always applied it to art. The dilemma of museums and other cultural institutions stems from the fact that culture is such an isolated field, and that art is even more isolated: an ivory tower in the field of culture surrounded first by the whole complex of culture and education, and then by the media which are also part of culture. We have a restricted idea of culture which debases everything; and it is the debased concept of art that has forced museums into their present weak and isolated position. Our concept of art must be universal and have the interdisciplinary nature of a university, and there must be a university department with a new concept of art and science.

Jackie Brookner

Water is our first mirror. Its surface symbolizes the surface of consciousness where what is obscure comes to light. Can we bear the tension and humility of what the mirror tells us? Waters that we thought endless turn out to be finite. What might it mean to think of ourselves as finite?

Each of us has an image of our body as a contained whole with a clear (and transparent) boundary. Instead, we could start by acknowledging our edges. This is difficult, in part, because it means acknowledging our limits. We don't seem to like limits much. They affront our desires for infinite power. Any individuated form, by definition, must have limits, edges, boundaries. We need to see the value of limits, and to see our edges as places of possibility, places of relationship. Every boundary that separates also connects.

As in ecosystems, these edges are opportunities for heightened diversity. Our membrane, that glorious and treacherous territory we must traverse to meet the world, must be negotiated. Such edges offer a territory of exchange, where all our senses vibrate in molecular excitement, and the world scratches its being on our skin, before it is named. Pores are where the world enters and leaves us, orifices that issue in and out–places of terror and delight.

Considering ourselves finite means becoming conscious of these limits. Less autonomous wholes, we are more like pieces of an immensely complex fractal jigsaw puzzle, entangled, interdependent with all the other finite parts for our meaning and existence. To bring about a future where we can move beyond reclamation, beyond an endless cycle of loss and repair and bandaging new wounds, we need a reclamation of human values that revise what we value and what we undervalue in the world, in ourselves, and in how we see ourselves as a species. What are some of the values and unconscious assumptions that lay at the root of our environmental disease?

We are entranced by our genius for categorizing and analyzing. We love to separate things. We separate water from fire, air and earth–but our waters can only be healed in relation to healthy soils and plants, which filter them (in turn dependent upon the sun, micro-organisms, etc). And we separate ourselves from those soils–they're dirty–repressing our own material nature, rather than acknowledge our ultimate dependence upon the earth for all our human needs.

Center for Land Use Interpretation

The Center for Land Use Interpretation is a research organization that examines the nature and extent of human interaction with the earth's surface. The Center embraces a multidisciplinary approach to fulfilling the stated mission, which is to "increase and diffuse knowledge about how the nation's lands are apportioned, utilized, and perceived." To these ends, the Center employs conventional research and information processing methodology as well as nontraditional interpretive tools. The Center collects, catalogues, interprets, and disseminates information about the contemporary landscape, through its archives and public programs that include exhibitions, publications, and tours.

The Center also exists to stimulate discussion, thought, and general interest in the contemporary landscape. Neither an environmental group nor an industry affiliated organization, the work of the Center can integrate the many approaches to land use – the many perspectives of the landscape– into a single view that emphasizes the shared, common ground.

The Center operates with the belief that the physical landscape embodies an inscription of the society that operates within it, and that in reading and understanding this inscription comes a deeper awareness of the relationship between humans and their environment. Learning and teaching the vocabulary of this "language of land use" is one of the functions of the Center. Another is to discover ways of seeing the utilization of terrestrial and geographic resources that have yet to be considered.

Tim Collins

As I read my way through the various disciplines which attend restoration ecology, it seems clear to me that the role of the artist, as cultural worker (and a participant in the emerging scientific and cultural effort to restore and steward nature), is to seek new relationships to experience, to seek the properties which will define the perception of systems, which provide the causal relationship in the experience of aesthetic diversity.

It is my hypothesis that the public realm is in need of interventionist care. The visual arts with a history of value-based creative, cultural inquiry are well equipped to take on this role. Any role in an arena complicated by capital and politics must be met with a sustained autonomy through careful funding. We must enable an advocacy that is free to raise questions, paid to voice alternatives and be willing to embrace conflict as a tool in the support of the goals of an expanded public realm. This calls for an independent, citizen-professional–a generalist with training in the techniques and concepts of creative inquiry, social-systems intervention and discursive democracy. The long-term goal is to develop a cultural discourse which will 1) expand the social and aesthetic interest in public space to the entire citizen body, 2) re-awaken the skills and belief in empirical analysis and critical dialogue and 3) disseminate the notion that "everyone is an artist."

Betsy Damon

Water is life: African Proverb.

Where is your well, your source of water for your home? Who cares for and shares this source? What does your community need to know to protect and restore their water? Why is this information not common knowledge?

Since 1985, water has been my instructor. It has transported me to unknown places both internally and in the world. It led me eventually to do projects that reach beyond my dreams. From sacred water sites to waste treatment plants, from engineered treatments to projects that employ the deepest knowledge of the properties of water, I learned about water. Water is such a miracle that to imagine it can be replaced by other liquids and that its quality can be compromised is suicidal. Water is the connecting media of our world. We can solve our water quality and quantity problems by connecting each with each other community by community.

It is now four year since *The Living Water Garden* was finished. Last November, I was hired by the Beijing Water Bureau to create with them an ecological design for the Wen Yu He river, one of the last running rivers in Beijing. We will start a demonstration project next week, May 9, 2002. As the only ecological designer working with a Bureau of 100 engineers in Beijing and 40 engineers on Dianshi Lake in Yunnan province, I've learned how tremendously efficient it is to reduce the world to a straight line. It remains to be seen whether the senior engineer who told me last week that I had changed them in six months was trying to reassure me or save me some face. Nonetheless, the dominant view that paves and straightens urban rivers lost yet another battle to systems planning and ecological design.

People at their best are like water
They serve as they go along
Like water they seek their own level
Loving living close to the earth
Living clear down in their hearts.
 – Lao Tse

Agnes Denes

My work ranges between individual creation and social consciousness. It addresses the challenges of global survival and is often monumental in scale. I plant forests on abused land, grow fields of grain in the heart of megacities and create long range master plans for large spaces in need of restructuring.

These works restore and enhance natural environments and benefit future generations with a meaningful legacy. They allow nature to speak its own special language articulated through human intelligence. *Rice/Tree/Burial* was my first ecological site work in 1968 that announced my commitment to environmental concerns, and the creation of a new aesthetic.

I believe that the new role of the artist is to create an art that questions the status quo and the direction life has taken, the endless contradictions we accept and approve, offering intelligent alternatives. In a time when meaningful global communication and intelligent restructuring of our environment is imperative, art can assume an important role. It can affect intelligent collaboration and the integration of disciplines. It can offer skillful and benign problem solving, motivate people and effect the future. Artistic vision, image and metaphor are powerful tools of communication that can become expressions of human values with profound impact on our consciousness and collective destiny. The artists' vocabulary is limited only by the depth and clarity of their vision and their ability to create true syntheses well expressed.

Georg Dietzler

My artistic work follows two directions. Both are rooted in a sense of social and political responsibility. One direction started in 1981 with an exploration of different aspects of nature. The second began in 1991 in response to "Operation Desert Storm," the focal point being war, violence and destruction. My work is still a kind of exploration of art, nature and ecology. Developed from sculptural works, the interior works relate to architecture and site specific exteriors, and the environmental works to conceptual pieces, which include current interdisciplinary biotechnological environments and interactive sculptures.

In 1993, I became attracted by the idea that one gourmet mushroom, the oyster mushrooms, has the unique ability to decompose soil contaminated by PCBs (polychlorinated biphenyl) without getting toxic itself. Oyster-mushroom's mycellium splits off PCB-chemical structures into non-toxic substances, which could thus be used to recultivate industrial ground contaminated by PCB and to decompose several kinds of waste. Could this knowledge be transferred to temporary site specific artworks designed for mostly industrial sites and former army bases?

I want to create itemized systems of sewage plants for soil bioremediation. I would thus like to research and develop additional biological systems. Finally, art is becoming open to visions of awareness and responsibility for environmental, social, and political issues related to an independent, interdisciplinary international network. Such a co-operation between artists, scientists, media, and the economy can use each artist's potential for creativity for the future.

Tera Galanti

I feel somewhat self-conscious discussing the scope of the environmental problems that we face on the planet at this time. Hesitation comes from realizing that my own experience and the culture in which I live frame my point of view. If I lived in a so-called third world country or even in a similar condition in my own country, I would not have the privilege of addressing any issues outside of my own and my family's survival.

However, being in a position of safety from external threats, one assumes responsibility to consider issues beyond basic survival needs. Anyone reading these words is most likely in a relatively safe position. I'd like to address the reader with the question: What is your relationship with your environment? What choices do you make? I believe it is a misconception to think that what is "out there" is not connected to oneself.

This perception of disconnection allows space for neglect, abuse or disregard. In all probability, an individual (or people) that is disregarded will

neglect him- or herself and abuse others, as well as the environment (intentionally or not). Only when a person is free from fear, can he or she make choices to improve the health of the environment.

With that being said, it is honestly incomprehensible to me how persons in positions of power can continue to make decisions about issues that have the largest impact on the health of our planet without realizing that they have the greatest responsibility to protect it.

Reiko Goto

My artistic subject matter is the life of nature. By contemplating nature, I seek to renew my own identity. When I was working on a permanent public art piece, *Butterfly Garden* at the Yerba Buena Gardens in downtown San Francisco between 1991-1993, the issue of native plants versus non-native plants was a very heated subject among plant and other environmental organizations. I was spending a lot of time investigating what butterflies were using what plants to get nectar and lay eggs in urban landscapes. I found that many city butterflies were using introduced species.

For four hundred years, immigrants have been bringing introduced species into this country. How were butterflies adjusting to these non-native plants as food sources? For this exhibition, I chose to work on Japanese honeysuckle (Lonicera Japonica), one of the invasive species in Cincinnati. According to the U.S. Department of Agriculture, an "invasive species" is defined as a species that is 1) non-native (or alien) to the ecosystem under consideration and, 2) whose introduction causes, or is likely to cause, economic or environmental harm or harm to human health.

Japanese honeysuckle originally came from Asian countries. In Japan, we call the plant Sui-katsura, Kin-Gin-ka, or Nindou. The "sui" in Sui-kat-sura means sucking. It is similar to the English name honeysuckle. Kin-Gin-ka means gold and silver flower, because the flower would change white to yellow a few days after it bloomed. Nindou means patiently waiting out the winter because the plant is evergreen.

I don't have any emotional reaction to harvesting the plants and making paper from them. The more time I spend with honeysuckle, the more I think about other plants. Simply getting rid of the plant would not be an ecological or environmental improvement. I am curious how other plants grow beside honeysuckle. What kinds of plants exist beside honeysuckle? How many kinds of native plants? How many of them are there? It is very difficult to predict the future without knowing what is happening here in the present.

Helen Mayer and Newton Harrison excerpt from *There to Here* (2002)

For *Peninsula Europe*, we propose a new form, a stability domain. This would be based on the principles that were variously expressed in *The Serpentine Lattice; The Shape of Turned Earth: A Brown Coal Park* for Südraum Leipzig: *The Mulde Einzugsgebiet; Breathing Space for the Sava River; A Vision for the Green Heart of Holland; Casting a Green Net: Can it be we are seeing a Dragon?* As well as *Future Garden Parts 1, 2 and 3* and inferred in *The Sacramento Meditations; Tibet is the High Ground* or *The Lagoon Cycle* and other works. These variously, sometimes only implicitly, proposed new ways of thinking about niches in the biosphere wherein cultural processes and forms can, over time, become nurturing and wastes can become either harmless or food for other lives.

These works also proposed ways in which the harvesting processes, when appropriate, can be modified to preserve the life of the soil and the cycle of growth. To bring about these outcomes requires accepting limits to growth. Thinking about quality of life and well-being must, we believe, be disassociated from the modernist notion that continuous growth is the only avenue to well being. We believe currency reevaluation needs to happen in which the currency of growth and the acquisition of wealth is revalued, rebalanced, if you will, in terms of correlation with the currency of intrinsic worth and well-being. The proposal for Peninsula Europe that follows is our first approximation towards that end.

Lynne Hull

My sculpture and installations provide shelter, food, water, or space for wildlife, an eco-atonement for their loss of habitat to human encroachment. Research and consultation are essential to project success. I prefer direct collaboration with wildlife specialists, environmental interpreters, landscape architects, and local people for design integration. The artworks function in the temporal gap between the time reclamation of a damaged site begins and the time nature recovers. The impact of natural, economic, and political events on wildlife continuously becomes more evident. Working with two Nairobi artists in Kenya, a country with fabulous large-scale biodiversity, I could see the coming impact of a human population boom. In Northern Ireland, we created spawning pools for salmon reintroduced when downstream cleanup made their survival possible, but we lost otter habitat structures to British army explosives.

Working in Southern Mexico with ProNatura in the high oak forests of Chiapas, I found the birds who nest during summers in California oak forests. The largest prairie dog town left in this hemisphere is in Northern Mexico. Birds I know from Colorado winter there. My current projects link communities from Canada to South America through our shared wildlife. While assisting wildlife, I often design projects with components of sustainable economic development for humans. Some raise human awareness of our trans-species relationships by offering harmonious ways to live that relationship in the landscape.

The greatest challenge faced by other species is the need for change in human values and attitudes toward conflicting rights, wants, and needs. As I create structures for other species, I hope that art can encourage the shifts in attitude we must have for all to survive in the long range.

Basia Irland *watermind*

I listen closely to the languages spoken along my shores as I flow toward the sea. My body is small, only a tiny moist molecule. Millions of years I have journeyed as a rivulet, creek, and stream, while wild tributaries, gaining in speed and strength, flow into me. Along the way, I supply recreation for bears, zebras, dogs, people, garter snakes, and flamingos; habitat for otters, platypus, crocodiles and salmon; drinking water for cities and falcons. Continuing past the estuary, I am greeted by dolphin, phosphorescent plankton, whales, jellyfish and seaweed.

A plethora of toxins, medical waste, raw sewage, pesticides, fertilizers, hazardous chemicals and even drugs flushed down household toilets find their way into my system. Often, just as I am meandering naturally along, my way is abruptly stopped by huge concrete structures where I remain pent-up until someone else determines when it is time for release. Once unconfined and breathing easier, I pass through mountain wildflower mead-

ows and cactus blooming deserts. An irrigation channel takes me to a field of corn, wheat, strawberries and cotton. I am used for turning turbines, cooling semi-conductors, powering steam engines, making a hot cup of tea and washing clothes, dishes, teeth and bodies.

I am ancient–older than trilobites, pyramids, fossilized shark's teeth and Cro-Magnon bone shards. I transmute. You will find me in worn down glaciers, rain, steam, snow, dew, mist and tears. Cascading over stones, merging into streams, forming lakes, evaporating, coalescing into clouds, and free-falling back to earth, my dance continues a timeless rhythm.

Patricia Johanson

Ulsan Park combines ecological restoration with art, culture, public infrastructure, recreation, and education. The challenge for this 912-acre site in Korea's leading industrial city was to create an island of sustainable nature while serving the needs of a million people. The Ulsan Park program required museums, playgrounds, shuttle-buses, and an Imax Theater, so my design needed to interweave major structures with restored ecosystems–marsh, pond, intermittent creek, floodplain, meadows, upland forest–using "art" to access and interpret nature. Because Koreans traditionally loved and worshipped nature, images for my design are based on animals, fish, and insects from Korea's myths, "Minhwa" folk tales, and living landscape. Thus cultural history is linked to ecological restorations within Ulsan Park, protecting and transmitting genetic information to the future.

One example: "Tiger Tail Plaza" surrounds a former concrete reservoir framed by skyscrapers. The engineering has been reconfigured to become a major wildlife area, with native vegetation as food and habitat for waterfowl, fish, and amphibians. The "reservoir" now reconnects to its natural drainage– wet meadow and cattail marsh–and tiger-stripe paths allow visitors to journey through shrubs, bulrushes, and marsh plants to open water where nesting-islands, waterfowl, and muskrats are seen. Tiger-paths move into a reforested valley, up the slopes of a mountain, and through a restored pine grove–each filled with sculptural park-features and living communities.

A "Tiger-Paw" spillway–incorporating bridge, seating, "Tiger-Claw" climbing structure, and ponds for flood control– reconnects the renewed "reservoir" to its natural flow–a stream cascading off the mountain and remnant floodplain. My educational program stresses the message of each animal– here, the beloved tiger is extinct in Korea due to deforestation and habitat loss.

Laurie Lundquist

I live and work in metropolitan Phoenix, one of the fastest growing regions in the country. The control of water is an essential feature in this Southwestern desert, where large aqueducts channel millions of gallons of water into Central Arizona everyday. It seems pretty clear that the place I call home is accruing ecological debt on a grand scale. As a resident and a consumer, I am keenly aware that I am part of the problem. As an artist, I am always on the lookout for ways to affect change. Ecological concerns began surfacing in my studio work shortly after I moved to Arizona. The ironies and contradictions evident in the desert cityscape provided good targets for critique. Then I encountered the work of artists like Helen and Newton Harrison, Buster Simpson and Mierle Laderman Ukeles. The integrity and persistence of their inquiry really raised the bar for me. I was no longer satisfied with a theoretical critique that did not offer solutions.

Public art has provided a way for me to get involved with projects that impact the local environment. In the Phoenix area most public art commissions are linked to some type of infrastructure improvement or municipal building project. I approach these large scale projects a bit like a detective investigating a crime scene. I ask questions and look for clues to determine where I can be effective. I am interested in finding ways to link the mechanical and engineered that we have come to depend on with the natural systems that we have come to take for granted. I look for ways to grapple with the dynamics of water in the desert landscape, like day lighting a life sustaining drip of gray water or, commandeering the condensation from an air conditioning unit and directing it to a thirsty tree.

Kathryn Miller

Since I can't decide which is more important–art or ecology–I incorporate both into my work. Artists can bridge the gap between science and technology to help interpret nature in a more user-friendly way. In the best-case scenario artists can educate, entertain, provoke thought and offer new ways of looking at things.

My work ranges from small non-sanctioned acts (seed bombing) to funded, sanctioned projects, and investigations. Respecting or restoring native landscapes and wildlife corridors while educating the public on these matters is of utmost importance in my art projects. I'm very interested in the role of artist as social participant as a means to strengthen the link between nature and culture.

While my projects are a less-than-flattering critique of our actions, they are usually coated in humor. This helps engage people in a dialog. We can laugh at ourselves and then fix things. It is clear though, that whatever we do to our water, soil, air, oceans and bio-diversity, we do to ourselves because there is no separation. We are all connected and interdependent.

I've watched land continuously disappear under asphalt, concrete, housing tracts, box-malls, and freeway expansions in Southern California. Native landscapes that took hundreds of years to establish are wiped out in a day or two. This is a crime. We need to start treating the natural environment with the same kind of love and respect, care, preservation, and security that we currently allot to great artworks.

Viet Ngo

Water, water, water everywhere! What a drag to be wet all the time. Yes, water is quite an important element in the life of an average Vietnamese such as me. I never questioned up until now whether this subconscious background has anything to do with my passion for slippery things.

My work is a fusion of engineering, architectural planning, and art. I design and build wastewater treatment plants for cities and industries. Having a strong interest in horizontal architecture, I like things that stay on the ground. People have asked me if my work is public art. That is my intention, but I do not like to use those words because they segregate me from the working people. I recognized early on that to be successful in infrastructure work, one needs to be in touch and to have the support of the general public. The work I do is utilitarian in the most basic manner– it is treating waste, and it is user-friendly and fairly simple to understand, but this is no ordinary task.

My background as a Vietnamese helped in the search for a simple and benevolent way to treat the pollution problems prevalent throughout the world. I am not interested in scale for the sake of scale. I am attempting to design and build meaningful infrastructure works to help people manage their waste problems. Wastewater is not a particularly glamorous thing, but it sure needs help. I devoted ten years of my life to develop and practice this stuff. The Lemna concept takes into consideration biology (plants to treat wastewater), engineering (ponds to contain waste), design (earth work and park environment), and socio-economics (cost/benefit, regulations, acceptance).

Ocean Earth

Ocean Earth Development Corporation (OEDC), as a for-profit company, is not an "Artist"–at least not in the usual sense of an individual who makes paintings, drawings, or sculptures to express his or her personal vision. Rather, it's a vehicle, created in the late 20th century, for realizing in our world, in our cityscape, landscape and media-scape, what has been recently envisioned by Artists. In prior centuries, this vehicle was provided by the Monarch. He or she would hire Architects to arrange the cityscape, landscape and media-scape using, of course, what were considered to be the best Artists. In our times, however, a profession called Art History has arisen, reducing the work of Artists to their individual expressions as manifested in publications and exhibitions, almost solely in the context of High Art. The natural function of Art is lost. That function appears in a review of original art, so-called cave art. Then, the artists produced wall drawings or sand paintings, sometimes just diagrams of surrounding terrain, meant to assure success in the hunt and forage. If there were no success, and if the tribesmen returned to their cave empty-handed, then, well, the artists would be replaced. In recent centuries, coincidental with the rise of Art History, there's been such a forgetting of Nature that the entirety of civilization threatens to ruin the planet, creating such deserts in the seas and on the land that nowhere can hunters and foragers come back home with enough.

Scientists know the problems; lawyers have drawn up legislation to meet the problems; even engineers have come up with solutions, though too ill financed. It remains for a vehicle of group practice, such as Ocean Earth, to bring the visions of artists practically to bear. Visual and physical imagination have made the human race survive for millions of years: rely on it again. Our vehicle, functioning as an Architect, adopts the job description made by Leon Battista Alberti: that architecture has to do with the city, the inhabited region, and therein it makes the material and technical arrangements to assure (1) clean air, (2) clean water, (3) circulatory space, (4) defense. None of these tasks is adopted by those now professed to be "architects", like Frank Gehry. Practically, who is going to prepare the plans and start the construction of those technical means which assure, for a city like Cincinnati, or even a broader area like the entire Ohio River and then Gulf of Mexico basin, (1) energy sources which don't pollute the air (or soil), (2) uplands with beaver, buffalo, prairie dogs, and other "keystone" species, as well as forests, for healthy water cycles, (3) infrastructure for easy movement yet low impact on animal habitat, (4) public knowledge of material threats to territory, like acid rain from up-wind, fossil-warmed rivers in Siberia, or desertification (hence misery) in lands breeding alleged terrorists.

On the latter point, Ocean Earth has been a world pioneer: bringing to mass media, for global decision-making, the often-concealed truth about the Persian Gulf, the Libyan Sahara, the Dead Sea Basin and the Levant, and even about preventable deadly events like Chernobyl and toxic microalgal blooms. The power structure in most sovereign states today has been afraid of what we attempt as Architect. That should well be: the territories they now govern are in physical, ecological decline. For four hundred years European civilizations, armed with technologies born in the Renaissance, have swept over the planet, and while they have afforded longer human life, net, they have sharply reduced chances for other species. What were once a glorious Americas, teeming with buffalo, antelope, crocodiles and fish, has become an expanding Desert. Restoring original animal numbers, along flyways and down rivers to the sea, remains–as in 1980, when we started–the No. 1 task of the Architect today. As Spenser wrote, "Art is that by which Nature makes more Nature." Well?

Aviva Rahmani

My ecological art focuses on the healing environmental effect of cumulative, triggering individual actions. My work is predicated on a commitment to a restorationist ethic in which the beauty of nature segues naturally into human created works, seamlessly blending and balancing human and wildland needs. In these areas, the light, sound, and other "formal" and sensory effects become performative manifestations of a spiritual practice. My particular interest and expertise is in coastal ecologies, which represent not only the meeting of waters but are emblematic of fertility and promise. In public art installations, small interventionist strategies function as wildlife corridors as well as aesthetic strategies. In creating public art, my goal is not merely to make a visual statement but to look at the entire landscape, find a critical trigger point that could affect the whole, and then develop something that focuses that healing energy. In areas that have been previously filled or disrupted, the local coastal geomorphology and vegetation can be day-lighted and focused to become a serene extension of a contemplative park for local families, tourists, and other visitors.

As part of a permanent art installation, recreational, trafficked, and reflective areas can be integrated into wildlife habitat and the re-establishment of wildlife corridors by the sculptural use of local rocks and clustered indigenous plantings. My premise is that natural elements can be used to enhance environmental perception and understanding while creating a comfortable and inviting, human scaled ambience. The public works I have created used local boulders with native vegetation to affect naturalistic but monumental groupings. Elements used include exposed bedrock, water and landscaping that echoes the shapes and habitat elements of the surrounding area. These are integrated into larger components as buffer zones that re-create natural eco-tones, thus serving to sustain the natural infrastructure.

Buster Simpson

I prefer working in public domains. The complexity of any site is its asset, to build upon, to distill, to reveal its layers of meaning. Process becomes part and parcel. Site conditions, social and political realities, history, existing phenomena, and ecology are the armature. The challenge is to navigate along the edge between provocateur and pedestrian, art as gift and poetic utility.

In the early 1970s and continuing to the present, I have been involved in an ongoing series of publicly sited temporary (sometimes becoming 'permanent') projects I have called "temporary prototypes." The work in this "laboratory" took on a form of agit-prop, melding social issues into a poetic aesthetic. Over the years, these projects have served me and others by informing and expanding notions of work that works in the public realm. First

Avenue (Seattle, WA 1978 to present) has hosted a number of innovations. Expanding the pallet of tree types, bench designs and other amenities, and innovative approaches to community design are a few of the issues involved in this work in progress. The *Composting Commode* (1978-1997) originally installed on First Avenue addressed the issues of a lost resource, the enrichment of tree pits, and gave the homeless the most basic of common decency. It was more than a public toilet, it was a strategic aesthetic for a compassionate urban design. *Shared Clothesline*, five stories between a condominium and a fixed income housing unit, illustrated that pretty banners (the usual solution) are not enough to reinvigorate a neighborhood being repopulated. The clothesline also functioned as an Aeolian Harp while the lines were bare.

Most recently, I have participated as an artist/consultant on the University of Washington/Tacoma Campus and Kings Cross Railroad Lands in London. Both of these projects exist on antiquated industrial lands awaiting their awakening. Mitigating the history of negligence and creating a holistic future are the challenges. The making of the new University Campus could be a laboratory, since architectural and landscape students rarely have the opportunity to document and work on a site that is both meaningful and in a state of flux. Environmental scientists, sociologists, anthropologists, writers, artists, and historians have equally rare opportunities to perform research and to participate in the growth of a living organism. The Kings Cross Design Team set goals to "develop popular, practical, and innovative links between art, technology, and ecology."

Alan Sonfist, excerpt from *Natural Phenomena as Public Monuments* (1968)

Public monuments traditionally have celebrated events in human history– acts of heroism important to the human community. Increasingly, as we come to understand our dependence on nature, the concept of community expands to include non-human elements. Civic monuments, then, should honor and celebrate the life and acts of the total community, the ecosystem, including natural phenomena. Especially within the city, public monuments should recapture and revitalize the history of the natural environment of that location. As in war monuments that record the life and death of soldiers, the life and death of natural phenomena such as rivers, springs, and natural outcroppings need to be remembered. Historical documents preserve observations of New York City's natural past. When the first European settlers arrived, they saw the natural paradise of the Native Americans. In a city, public art can be a reminder that the city was once a forest or a marsh. Just as some trees are named after trees, street names could be extended to other plants, animals, and birds. Areas of the city could be renamed after the predominant natural phenomena that existed there.

Since the city is becoming more and more polluted, we could build monuments to the historic air. Museums could be built that would recapture the smells of earth, trees, and vegetation in different seasons and at different historical times, so that people would be able to experience what has been lost. A museum of air sponsored by the U.N. can show different air of different countries.

Other projects can reveal the historical geology or terrain. Submerged outcroppings that still exist in the city can be exposed. Glacial rocks can be saved as monuments to a dramatic natural past. The sounds, controlled by the local community, change according to the natural pattern of the animals and the rhythmic sounds return to the city. Natural scents can evoke the past as well...Public monuments embody shared values.

Susan Leibovitz Steinman

My commitment is to employ my art skills in the service of community health and empowerment, urban greening, and environmental education. I am most interested in public art projects where art functions as an integral breathing part of daily community life. I believe communities are best served when stakeholders participate (at varying levels, according to time, interest, abilities) in both the decision making and the art making.

In 1987, after 18 years as a professional ceramic artist/sculptor, I began creating sculpture and installations to explore the links between local daily life and environmental issues. For me, this venue retains a healthy ceramist work ethic: community-oriented, earth-based, labor-intensive, and direct. More than visualizations of obvious connections (domestic to industrial; natural to human design), this genre can critique precarious situations while implying hope through community action.

Over the last 12+ years, the large scale outdoor projects have matured into clear visual symbols of ecological regeneration and restoration, positively reinforcing the use of indigenous plants and recycled materials in public urban venues.

Working with familiar objects and industrial materials culled from local waste streams, and adding organic elements such as endangered native grasses or fruit trees, I construct both large scale installations and human-scale assemblage in publicly accessible locations. Most are temporary. Many are audience interactive. Collaborations–with public school students, community action groups, community college horticulture students, public infrastructure staff, and other artists–are essential to this methodology.

The fruits of this work are the one-to-one and public discussions it generates. The best of assemblage makes extraordinary connections between ordinary materials. Collaborative assemblage installation in community settings with indigenous materials can create positive connections between us and our environment. It's a possibility.

Superflex excerpt from *Appropriate Technology and Design*

A technology is appropriate if it gains acceptance. So far, biogas plants have attracted little support. The simple biogas plants available up to now have presumably been inappropriate. Bicycles are appropriate: when someone buys a bicycle, one is proud. It is a sign of advancement, of personal progress...If one gets on the bicycle and falls off because one does not know how to ride it, it is not appropriate to one's abilities. One will then learn to ride it, and thus adapt to one's cherished bicycle...If the bicycle breaks down, and one has no money to spare to have it mended, one saves on other expenditures, because the bicycle is important for one's pride and convenience.

...A biogas plant is correctly operated and maintained if it satisfies the user's need for recognition and convenience...Biogas plants are appropriate to the technical abilities and economic capacity of Third World families. Biogas technology is extremely appropriate to the ecological and economic demands of the future. However, a biogas plant seldom meets the owner's needs for status and recognition. Biogas technology has a poor image. "Biogas plants are built by dreamers for poor people." If you do not want to appear poor, you do not buy a biogas plant. The image of the biogas plant must be improved. The biogas designer makes a contribution by creating a good design... As an investment, a biogas plant is in competition with bicycle or moped, a radio set or diesel pump, a buffalo or an extension to the farm-house. The economic benefits of a biogas plant are greater than those of most competing investments.

143

John Stephens

The summer after completing my law studies, I bicycled from New York to San Francisco to appreciate the culture and nature of our country. Among the nuances and beauties of our diverse landscape, I viewed the efforts communities were making to reconnect with their natural resources at the close of the industrial age. Towns large and small were building trails, riverfront parks, and urban forests to create attractive communities.

Upon my return to Pittsburgh I found myself starting an environmental law practice in a City struggling to redefine itself in the post-industrial world. It was a poster child for the scar of brownfields, its rivers lined with closed steel mills and railroads, and tributary streams buried in culverts or lined with slag.

Change needed to happen quickly for the region to compete in the new economy. But the inertia of policy, law and professional disciplines was making it difficult to transform our industrial lands to new public space. The artists at the STUDIO for Creative Inquiry provided a powerful mechanism for intervening community, aesthetics, and criticism into critical public decision-making affecting the future of Nine Mile Run and the slag pile it bifurcates.

To my joy, I learned that with access, and informed dialogue, an enlightened community can force policy changes much faster than the processes of legislation, regulation, or litigation. As a result of the community dialogues, concept designs, and restoration plans sponsored by the Nine Mile Run Greenway, a stream is saved, a verdant valley restored, and an urban habitat created.

The most important result may be that the Nine Mile Run Greenway Project process created stewards with the tools and knowledge to prevent a repeat of the environmental disrespect of the last century. By encouraging the community to become engaged with the decision-makers, the participants became engaged in the restoration of the valley. As a result, the ideas developed in the community dialogue and set forth in the conceptual plans, have a good chance of becoming real, and staying healthy.

Mierle Laderman Ukeles

What time frame are we talking about here in art with/for/of the "environment"? With the consecutive civil rights/human rights/planet rights movements of the '60s, I thought we'd fix things, one after the other, until the world was healed. My children cannot believe that I was so naïve. Now I realize we were full of hubris, because we wanted things fixed NOW, i.e. in my lifetime.

Penetration and Transparency: Morphed, my 6-channel video installation opening this week at Snug Harbor Cultural Center in Staten Island, captures 21 "pathfinders" describing their typical path through Fresh Kills Landfill. This installation demonstrates that there are many ways to see this site, poised at a cusp of transformation. This installation is the result of Phase I of a Percent for Art commission for the Fresh Kills Landfill, a site as big as 2.5 Central Parks. I've already worked for a year on the video with videomakers Kathy Brew and Roberto Guerra. Five more Phases, at least, are still to come over the next 8 years.

This installation encapsulates optimism about transformation—what many people thought this site could become one year ago, before September 11, 2001, before the landfill was re-opened to receive the debris of the World Trade Center. Since receiving this commission in 1989, I had looked forward to being a part of the group who would transform the world's biggest landfill into a healed public place. Now part of it will be a cemetery.

In 1991, the city of Cambridge accepted my project, *Turnaround/Surround*, for Danehy Park, which I hope to finish by 2003. I've now worked on the Schuylkill River project for about 5 years, the same amount of time that the Hiriya Landfill project in Israel has occupied me. Has this become a short length of time?

I long for studio art or museum art where a piece begins, middles, and ends inside a time when I'm still sort of the same person. But then the land calls, especially the screwed up land, the messed up water, the clogged up air..... Many of my works haven't happened or haven't yet happened. Or are slowly slowly unfolding. So who are they for? Who am I, as an artist, in all of this?

Shai Zakai excerpt from *Concrete Creek* (1999-2002)

In my quests for visual expressions which would bring man and the environment closer together, I have conceived of a reclamation plan which operates concurrently on the physical level –cleansing the stream, and on the social and spiritual level – healing people from their environmental indifference.

The quarry workers, welders, concrete bridge builders, cement-mixer drivers, foreign workers, Bedouins, moshav members, Palestinians, as well as the quarry and factory owners all took part in the artistic creation, whether knowingly or unknowingly. I believe that transforming them into "fleeting artists" makes it possible to put issues they have never addressed before on the agenda, thus inspiring a changed state of mind, and consequently, a higher level of awareness.

Rather than threats of being fined or standing trial (the current situation), I opted for the identification and collaborative approach. This is an eco-centric, eco-feminist approach which regards the "rehabilitation" of both man and nature – the stream, organic and inorganic elements found in it and its flora and fauna – with equal importance. Physical work – collecting the waste, hewing, filing, surveying, photographing - is an essential part of this course of action.

abiotic- part of the environment including temperature, humidity, light, altitude and chemical make up. These factors limit the types of organisms that live there.

algal bloom- fast-growing microscopic, single-cell algae, as opposed to beneficial blue-green algae, that block out light and kill water life, and alter marine habitats.

anaerobic digestion- bacteria's converting organic matter into combustible biogas.

anthropogeomorphology- the study of man-made land forms.

aquatic- pertaining to water, commonly fresh water or dwelling in fresh water.

autotrophs- organisms that produce organic material from inorganic material by outside energy, such as plants with chlorophyll and some types of bacteria.

biodegradable- materials that readily decompose to become soil over time.

biodiversity- the presence of multiple species, so as to balance the needs of all species.

biomass- total amount of living organic material in an ecosystem.

biomass heating systems- energy harvested from plants.

biosolids- solid by-products of waste water treatment processes.

biosphere- where living species are found, within a few meters of the earth's surface, in soil, water, or in the atmosphere.

biotic- living part of the environment, including plants, animals and microbes.

bog- a thick mat of sphagnum moss encircling or covering a small lake or pond containing cranberry, Labrador tea and bog laurel.

brownfields- post-industrial sites; abandoned or degraded sites, left over from industry

carbon cycle- process by which carbon circulates through the environment. Carbon is part of carbohydrates, proteins and fats. Plants absorb carbon from the atmosphere, which is changed into carbohydrates via photosynthesis, and eaten by animals. Animals release carbon through respiration or decomposition, when plants or animals die.

carnivores-animals that eat other animals. If they feed on herbivores they are called first-order carnivores. If they feed on other carnivores they are called second-order carnivores.

carrying capacity- the maximum population of an individual plant or animal species that the community can support.

cellulose- a complex carbohydrate making up a major part of plant cell walls.

channeling- rivers lined with concrete, Meant to protect the watershed from toxins, but channelization hastens flooding, as there's no soil or plants to absorb excess water.

chlorophyll- the green pigment of plants that converts light energy into chemical energy, see also photosynthesis.

chloroplast- the tiny spheres in plant cells that contain chlorophyll.

clean-air experts- specialists that improve ventilation, thermal comfort.

coniferous: cone- bearing trees or bushes such as evergreen, needle- leafed or softwood trees, and many tropical trees. Leaves remain on the tree for two or more years.

consumers- any organism that feeds on other plants or animals. Also called heterotrophs, which means other feeders.

conversational drift- an open dialogue that inspires imaginative ideas, brainstorming.

CSOs- combined-sewer overflow; the effect of the sewers, whose pipes follow the river's contour, overflowing into a waterway and vice-versa. Caused by silting and excess water entering both systems at accelerated rates during rainstorms.

culvert- a sewer or drain running under a road or embankment.

daylighting- returning streams from underground pipes to the open air, where sunlight can activate the microbial communities, providing sustainable water quality benefits.

deciduous- broad leaf or hardwood trees, leaves stay on tree for one growing season, change color in the fall and are shed for winter.

decomposers- organisms, usually bacteria and fungi, that get energy from breaking down dead organic matter into simple but useful substances.

detritus- decaying organic debris that forms silt like layers on the floor of the wetland, and creates a food base in streams.

E and R ratings- ratings that describe the eco-efficiency of building materials.

ecology- the study of how plants and animals interact in their non- living environment.

ecological niche- lifestyle unique to a species of plant or animal. Includes food chain, relationship to habitat, adaptations to ecosystem, and daily and seasonal activities.

ecosystem- living (biotic), and non-living (abiotic) parts of the environment. Includes plant and animals as well as chemicals, and climate.

emergent- plants with root systems submerged in water.

environment- external factors that an organism is exposed to, including living and non-living factors.

eutrophication- process by which a wetland becomes overloaded with mineral and organic nutrients (disturbed soil or animal waste run-off), thus reducing the oxygen.

evapotranspiration- plants cool the air by releasing water vapors through their leaves.

flow forms- objects placed in rivers to stimulate river's flow and aerate via movement.

food chain- transfer of energy cycle from one organism to the next. This chain starts with the Sun's energy, then to the plants, then to animals.

food pyramid- estimate of energy available at each feeding level shown in pyramid diagram. The energy amount is measured by weighing plants and animals at each level.

food web- diagram showing all feeding relationships in a given community.

global warming- the heating of the planet due to excess energy use and hot gases.

greenhouse effect- the heating of the atmosphere due to solar radiation's being trapped in ozone, water vapors and carbon dioxide in the earth's atmosphere.

greenhouse gases- carbon dioxide (CO_2), methane (CH_4), Nitrous Oxide (N_2O), and Chlorofluorocarbons.

green-minded "carpenters"- carpenters who use clean construction processes and non-toxic materials that are often recyclable. One alternative to standard dry wall is a formaldehyde-free biocomposite made from soybeans and recycled newspaper.

green roofs- self-sustaining shallow (3-30 inches of soil) gardens (usually an alpine ecosystem which endures harsh weather conditions) placed on a building's roof to reduce urban heat in summer and insulate in winter. Roofs typically reach 175 degrees Fahrenheit in summer, adding 8oF to city's temperature and cooking the pollution. Not only extends a typical roof's life from 15 years to 40-100 years, but reduces runoff by absorbing 58-71 % of the storm water and decreases building's energy use enough to cover the initial $15/square foot investment in two-three years. A feasible roof must be rated for at least 15 lbs/square feet.

greenwashing- non-green industries support green projects to alter their public image.

ground water- water which flows underground and keeps wetlands wet and streams flowing during droughts.

habitat- place where an organism lives.

harmful gaseous emittents- those like carbon dioxide, sulfur dioxide, nitrous oxide (NOX).

herbivores- animals that feeds on plants. Herbivores are at the second level in the food chain. They have specialized digestive tracts to convert plant fiber into energy.

heterotropic- organism that cannot produce its own food. All animals obtain their food, directly or indirectly, from plants.

horizon- a layer of soil that runs parallel to the surface. Different levels have different degrees of organic matter, the richest being the top layer, or topsoil.

humus- decaying organic matter, usually dark in color and rich with nitrogen.

hyperaccumulators- plants that selectively absorb and contain large amounts of metal or minerals in their vascular structure.

invasive species- foreign plants that alter the balance of local plants and animals.

LEED (Leadership in Energy and Environmental Design) certification- rating method created by US Green Building Council. Calculates environmental correctness and offers standards of achievement from certified to bronze, silver, gold and platinum (the top).

lichen- a symbiotic relationship between two plants, a fungus which provides structure and a green or blue-green algae, which photosynthesizes and produces nutrients.

life process- factors that separate living from non-living things. The common life processes are eating and digestion of food, ability to sense change, respiration growth and reproduction.

Love Canal- the 1950s community developed atop a radioactive landfill, despite Hooker Chemical's resistance. Story exploded in 1978.

methanogens- garbage-eating microbes.

native plants- local plants that sustain the balance of local animals and plants.

nitrogen cycle- plants can only use nitrogen after it has been converted to nitrate. Nitrates are made either by bacteria in the soil or in some select cases, by the plants themselves. Plants use nitrate to build plant tissue, which is then eaten by animals. When animals die and decompose bacteria and fungi return the nitrogen back to the soil and the cycle starts again.

non-point source pollution- less visible discharges, such as stormwater, rain, lawn and parking lot runoff that contribute to pollution.

off-gasing- a by-product of every day solid materials that emit toxic substances.

omnivore- animals that eat both plants and other animals.

organism- a living creature such as a plant, animal or single celled organisms like bacteria.

parent material- rock that has been broken down by either physical weathering, chemical weathering, or biological weathering

parasite- an organism that grows, feeds, and is sheltered on or in a different organism, while contributing nothing to host's survival.

pH - stands for potential of Hydrogen, a measure of a solution's acidity (<7) or alkalinity (>7).

phosphorus cycle- phosphorus from rocks in broken down and dissolved in water. This phosphorus rich water is used by plants to build plant material which is in turn eaten by animals.

photosynthesis- the process by which green plants use chlorophyll to convert light energy, carbon dioxide and water into carbohydrates. Oxygen is the by-product created in this process.

point-source pollution- observable dumping practices (air, land or water discharges) that are currently regulated.

population- number of the same species that are living in the same are at a given time.

post-industrial sites- brownfields or sites degraded by industry, awaiting a new vision.

predator- a carnivore that feeds on live animals.

producers- plants, which are the only organism that can produce their own food.

Also called autotrophs or self-feeders.

reclamation- altering a site, so as to highlight particular attributes that are overlooked.

respiration- energy for growth and reproduction comes from burning a fuel, namely glucose (a simple sugar). The by-product of cell respiration in plants is oxygen, and in animals it is carbon dioxide.

riparian zone- area of vegetation adjacent to a body of water that influences and is influenced by the water.

riprap- a loose assemblage of broken stones erected to form a foundation in water or on soft ground.

salmonid- a species of the family salmonidae, which includes salmons, trout, chars, and white fishes.

scavengers- animals that feed on dead plants or animals.

sick-building doctors- specialists who improve air delivery systems by detecting and eliminating off-gasing materials or toxin-emitting walls, counters and floors.

slag- a hard, gray, porous by-product of the steel industry.

soil erosion- the amount of soil eroded from the earth during rainstorms. Distributed via the watershed and often clogs local waterways. Each year, a self-contained forest loses only 5 lb/square mile, a farm loses 50 lb/square mile, but a house under construction loses 5000 lb/square mile.

species- a group of similar organisms that have a shared origin and the ability to breed freely with one another.

succession- the gradual replacement of one plant community with another due to environmental changes.

sustainable materials- healthy, long-lasting and kind to those who use them, make them and live with them.

3 Rs- reuse, reduce, recycle.

transpiration- the process by which excess water released by plants was water vapor from leaf pores.

trophic level- a species position in the food chain as determined by their place in the energy transfer in the ecosystem. Plants are first, as they derive their energy from the sun. Animals that feed on plants are second and animals that feed on other animals are the third.

turbidity- the level of suspended particulants in a waterway.

vernal pools- aquatic spot where amphibians lay eggs.

VOCs- volatile organic compounds; primary contributors to off-gasing.

waste stream- total flow of residential and commercial solid waste (not including hazardous or industrial waste) that must be recycled or put in landfills.

water cycle- the process by which water circulates through the ecosystem. Water enters the ecosystem by water vapors produced by plants and animals, as it rises, cools and condenses, it forms clouds that then produce rain, bringing the water back to the earth surface for consumption by plants and animals.

watershed- an area bounded by mountains or hills from which all rainwater flows to a single body of water. The system of visible and underground creeks, tributaries, streams and brooks feeding into a river.

wetland- a natural habitat of wildlife found in a lowland area, such as a bog, marsh, or swamp, that is saturated with moisture. Wetlands are often planted near buildings to clean either the building's storm water runoff or the gray water produced by its users. wetland types:

 1) **forested**- a forest floor of saturated, mucky soil. Trees found here include Sitka Spruce, Oregon Ash and cottonwoods.
 2) **shrub/scrub wetland**- water-saturated soil covered by dense shrubbery such as dogwood, crabapple salmonberry and hardhack.
 3) **wet meadow**- areas that often look like soggy pastures of grasses, rushes and sedges.
 4) **marshes**- small lakes and ponds full of cat tails, pond lilies and yellow iris. Marshes that occur along the coastline are salt marshes.
 5) **pool**- a deep, scoured portion of stream where water flows slowly, offering salmon a feeding and resting place, 6) **riffles**- shallow rapids where water flows swiftly over gravel and is home to aquatic insects.

xeriscaping- landscaping with drought-resistant plants that don't require watering.

section 11

critical diversity

This section features short essays by an array of writers, including a philosopher, art historians, an eco-poet, and others associated with this field.

Amy Lipton, What exactly is an *ecovention*?

In the course of co-curating this exhibition with Sue Spaid, we set out to define a new form of art making. In the sometimes overlapping realms of Earthworks, Land Art, Earth Art, Environmental Art, and Ecological Art, we looked for artists whose works literally had a particular transformative effect as an end result. Since all great artworks achieve transformation on some level, we chose to limit our search to art that fell into the following category: an ecovention is defined as an artist's aesthetic invention and/or intervention within the context of an ecosystem. Its aesthetic components may be both visible and invisible, with a primary emphasis on regional site-specific projects that concern restoration, reclamation, renewal and rejuvenation of polluted and damaged wastelands. Our next big concern was to demonstrate how and why this work is defined as art and not science, engineering, landscape design, architecture or eco-activism while at the same time not trivializing those important disciplines whose components might at any stage become part of the work. The key to this change in the viewer's perception is in challenging the predominant value system that determines what an artwork can be.

In this respect, the exhibition reflects my own exploration of the last several years to find artworks that cross the line from traditional art production and institutionalization, into the larger context of human and non-human natural communities. In the late 1990s, after more than a decade of working within the contemporary art world as gallerist, curator, and publicist, I began to have questions regarding my sphere of work. I wondered about the relevance of the art I was seeing, and was faced with a serious dilemma: the planet was deteriorating rapidly, while the prevailing art in galleries and museums was mostly autobiographical and self-referential.

For decades environmentalists have foreseen an impending disaster of immense proportions when the planet becomes truly unable to sustain life. Our basic life support systems of clean water, air and soil continue to diminish at an alarming rate. I wondered why this larger global picture was being overlooked in the art world internationally. Every other pertinent socio-political issue has been addressed within the framework of post-modernist critique. Through the nineties exhibitions focused on AIDS, gender, feminism, identity politics, ethnicity, multi-culturalism, consumerism, the body - these issues were being scrutinized thoroughly. I questioned if our planet's environmental problems were too big for artists to tackle, and why many were still more concerned with an aesthetic of critique or an insular dialogue about art itself. I wanted to see works that were focusing on our relationship with the larger, living eco-system, recognizing that our very existence depends upon its survival.

After some years of research and with great debt to both Barbara Matilsky's groundbreaking 1992 exhibition "Fragile Ecologies" at the Queens Museum in New York, and Heike Strelow's comprehensive "Natural Reality" (1999) at the Ludwig Museum in Germany, I began to see that an alternative vision existed. There is a small yet growing, world-wide movement of artists who are actively at work finding ways to creatively solve ecological problems. They are breaking out of the traditional confines of what is considered art by engaging in real world issues and daring for their art to have a function - thereby calling into question the very framework within which we define art. For years now, writers such as Suzi Gablik and Lucy Lippard have been championing a social role and function for art, rejecting the notion that aesthetics can not serve anything but itself and its own ends.

The purpose of *Ecovention* is to create public awareness of these innovative and inventive artist solutions taking place all over the world, where many artists have entered into the new scientific field of restoration ecology. They are reaching out across disciplines and helping to bridge the gap between art and life by raising awareness and appreciation of our natural resources. By giving aesthetic form to restored natural areas and urban sites, these artists are engaging in a collaborative process with nature, practicing a socially relevant art. They are helping to create a new paradigm by proving that art can contribute to society as a whole, not merely in the politically correct sense or as a social critique, but rather by participating directly in the world. By focusing on the interrelationships between the biological, cultural, political, or historical aspects of ecosystems, these artists are working to extend environmental principles and practices directly into the community.

By asking fearless questions that no one else thought to ask, these artists in *Ecovention* are taking on the role of visionaries, working collaboratively with architects, planners, social scientists, biologists, botanists, and communities. The goal for *Ecovention* is to present these projects as case studies. In this manner we hope that their experiences can provide access and information to those that might be inspired towards making works of their own, paving the way for a whole new kind of art that can help realize needed change in the world.

Special thanks to artist Ruth Wallen for sharing her insights with me which were elaborated on in the above essay. Also to Tim Collins for his clarity and information regarding the practice of restoration ecology and to Jackie Brookner who continues to inspire me with her ideas and passion for Eco Art. I would also like to thank the CAC, Charles Desmarais and Sue Spaid for having the courage to take this exhibition, one which truly pushes the boundaries of what is accepted as art in the museum world today. I would also like to thank Suzi Gablik for starting me on this journey in the first place and to all the artists in Ecovention for their vision and commitment to this cause.

Thom Collins, A Note on Ecoventions, Activist Art and Praxis

The philosophers have interpreted the world in various ways; the point however is to change it. — Karl Marx, 1845[1]

If not an outright paradox, Lucy Lippard's operative definition of "activist art," as proposed in her seminal 1984 essay "Trojan Horses: Activist Art and Power," is deeply compromised by a fundamental tension.[2] She conceives activist art not as a direct force for real material change, but rather as a process of "communicative exchange," and she brings this criterion to bear on her selection of exemplary projects from recent art history. Presumably, this communicative exchange is initiated and enacted in order to bring about an eventual shift in particular material circumstances and, thereby, political and social change. But this aim receives little attention, the processes by which artistic communicative action translates into material change are described as inefficient, and the outcomes are deemed unpredictable at best. Lippard writes dismissively, "few [activist artists] labor under the illusion that their art will change the world directly or immediately."[3]

The influence of postmodern theory is distinctly discernible in Lippard's implicit conception of the "act" in "activist" art as a speech act. This construction limits her to a discussion of informational networks, and alphabetic and visual texts as the definitive outcome of this brand of activism. Thus, the subversive potential of artistic activism is restricted to the realm of discourse. Most of the works she discusses in support of her argument are, not surprisingly, conceptually sophisticated agitation-propaganda.

Lippard's definition of activist art locates the practices it designates at some remove from the committed, theorized, strategic, and substantive actions that are identified by the term "praxis." This move highlights the distinction between abstract ideas and their enunciation in spoken/written/visual texts, on the one hand, and principled practical activity, on the other, and returns this discussion to the very roots of the historical debate about the nature and significance of praxis: Aristotle's writings on ethical life.

Briefly put, Aristotle argued that all human enterprises might be understood as either theoretical or practical. His classification system has been usefully summarized: The purpose of a theoretical discipline is the pursuit of truth through contemplation; its telos ["goal"] is the attainment of knowledge for its own sake. […] The practical disciplines are those sciences which deal with ethical and political life; their telos is practical wisdom and knowledge. [4]

It is the practical disciplines that are identified with praxis.

Lippard's communicative exchange certainly arises out of critical reflection, and it exceeds this first Aristotelian category of theoretical activity when it produces subversive and/or empowering speech acts and texts. But insofar as it fails to link theory to socially ameliorative practice or action in a relationship in which they modify one another reciprocally until a satisfactory synthesis is achieved, it never rises to the level of Aristotle's privileged second category. It constitutes activity without praxis. For this reason, the products of this communicative exchange—Lippard's activist art—can never be more than mere discursive residues.

Notably absent from Lippard's account of recent activist art is almost any discussion of public projects by the many artists, addressed in this book and exhibition, who have been engaged for more than three decades with issues in ecology and environmentalism. Perhaps this is because the very term "ecovention" was devised to designate a category of artistic activity exclusive of the purely educational, or fantastic and unrealizable environmental remediation and restoration activities that would correspond with Lippard's limited notion of activist art as communicative exchange. If a given project does not proceed from the producer's critical reflection on a specific environmental challenge through research, community dialogue and consensus building, and direct political action to concrete realization—if it doesn't actually change the world in positive ways—it is simply not an ecovention. In this sense, ecoventions may be considered the sine qua non of activist artistic praxis.

Notes:
1. Karl Marx, "Theses on Feuerbach," 1845, in Frederick Engels, *Ludwig Feuerbach and the Outcome of Classical German Philosophy* (New York: International Publishers, 1941): 84.
2. Lucy R. Lippard, "Trojan Horses: Activist Art and Power," in Brian Wallis, ed., *Art After Modernism: Rethinking Representation* (New York: The New Museum of Contemporary Art, 1984).
3. Lippard, 344.
4. Wilfred Carr and Stephen Kimmis, *Becoming Critical: Education, Knowledge and Action Research* (Philadelphia: Falmer Press, 1986): 32.

Chris J. Cuomo, Ph. D., excerpted from *Feminism and Ecological Communities*, 1998

Questions about human flourishing are particularly tricky, especially from a perspective that eschews the notion that there is some immutable or universal human good, but still locates flourishing in the well-being of bodies. Because human nature is not fixed or universal, and does not necessarily 'aim toward' any one telos, or end (as Aristotle thought it aimed toward wisdom and virtue), and because human capacities are expressed in vastly different ways and worlds, the meaning of human, and women's, flourishing is uniquely contingent on contexts, histories, and the stories that shape lives and social realities.

As far as the work of ethical theory and practice is concerned, useful and accurate notions of human flourishing can only emerge from richly contextualized, sometimes local, evaluations of what it means to be human, what people want and strive for, and what enables their living in ways they value in specific historical and cultural locations. Also, although physiological considerations must be part of what it means to flourish, human flourishing cannot be understood solely as the fulfillment of biological needs, and when biological criteria are used we must remember that these are always conceived and filtered in and through the social and cultural lenses. Even Aristotle believed that what it means to be human, and to thrive as a human, is determined through a variety of cultural considerations, including intellectual, emotional, spiritual, and political well-being. Finally, conceptions of human flourishing that are consistent with ecological feminism must be ecologically sensitive, or built upon an awareness of the fact that all humans are ecological, as well as social and individual being....

Typically, anthropocentrism, or human-centered values and ontologies, are believed to be the root of environmental degradation and exploitation. Ecological holists believe that the majority of humans, especially those in postindustrial, technological societies, ignore the extent to which we are dependent members of biotic communities and ecosystems, and that in order to halt the degradation of nature, radical ontological and ethical shifts toward a more humble 'citizen' perspective are necessary. Human placement within, as opposed to above biotic communities, calls for humility and a reconceptualization of our relationship to nature...

Consider: to what extent are most people and groups who misuse political or economic power exclusively *human-centered*? Is first-world mega-consumption and toxic dumping really allowed or encouraged with the interests of the human species in mind? Surely self-centeredness, corporate greed, ethnocentrism, militarism, and nationalism result more directly in questionable environmental ethical practices than anthropocentrism does. If so, the most pressing ethical questions concern the relationships among these various prejudices. But proponents of Deep Ecology and other holistic environmental ethics pay little attention to social justice issues, and focus instead on how and why humans, as a species, tend to devalue and destroy the biotic community and its members. Holistic conceptions of natural systems, and what it means to promote the well-being of these systems, are often based on scientific models, especially those inspired by ecological sciences.

Environmental philosophy must be critical of the scientific models and metaphors it inherits or assumes. Science informs ethics by providing data, models, feedback, and projections of risk and impact. At the same time, ethics must question science's models, methods, goals, and assumptions. Powerful metaphors encourage us to think that only two options are available: chaos or harmony; nature as pure machine, or imbued with full intentionality; human beings as selfish, atomistic utility-maximizers, or as wishy-washy group-thinkers with no autonomy. In fact, options exist beyond the cognitive universe evoked by any powerful metaphor and its opposite. Moral agents can decide how to negotiate the world without hopes of reaching a pre-determined, necessary state of harmony or static equilibrium, or any ultimate state.

ecoart*space*

ecoartspace is a nonprofit organization supporting artists who create works that raise environmental awareness and inspire visions of a sustainable relationship between humans and the natural world. ecoartspace activities include curating exhibitions, working with school children in an Art and Environment curriculum and serving as an information and consulting resource for artists and museums seeking to address ecological issues.

The organization's accomplishments as of 2002 include presenting exhibitions in galleries, public spaces and museums, such as *Ecovention* for the Contemporary Art Center, Cincinnati, Ohio; implementing an Art and Environment curriculum at The Earth School, a public elementary school in New York City concurrently with Pt. Dume Marine Science elementary school in Los Angeles; advising for an environmental exploration park and museum complex in Northern California; writing a third and fourth grade curriculum in conjunction with an exhibition titled "By Nature's Design" for a municipal art gallery in Southern California.

ecoartspace has organized and participated on panel discussions focusing on the topic of nature and its relationship to art and culture, including *Reconstructing Ecologies* at the Guggenheim Museum, New York (2000); *California Waterways* at University of California, Irvine (2001); *Taking Nature Seriously,* at the University of Oregon, Eugene (2001); Art Culture Nature International Conference in Flagstaff, Arizona (2001); *Art and Ecology* at the Pomona College Museum of Art, California (2001); *Art for Life's Sake the New Aesthetics of Participation* at the New York Open Center (2001); *The New Ecology of Culture:* A Terra Nova Evening, City University of New York (2001); and *Art, Culture and Community* at the Los Angeles Arboretum (2002) in conjunction with an exhibition titled Cross-Pollination.

ecoartspace was founded in 1997 in Los Angeles by Patricia Watts who developed the website in 1998. Watts and independent curator, Amy Lipton of New York traveled together to Germany to see "Natural Reality," curated by Heike Strelow of Frankfurt in June 1999. Following this trip, they decided to join forces and develop ecoartspace as a nonprofit organization on both the East and West Coasts.

ecoartspace seeks to develop relationships with institutions or individuals that share its vision and who are interested to develop a similar program and/or curriculum in their own community with the guidance of Patricia Watts and Amy Lipton. Currently ecoartspace operates out of both Topanga, California and a recently opened space in Beacon, New York. Their goal is to open a multi- disciplinary, community-oriented art and nature center that focuses on the ecological issues of a particular area and to present exhibitions that show how regional cultures are interconnected in vast networks of organic relationships.

Suzi Gablik, Art and the Big Picture

How do individuals overturn a world view and break free of its limiting ideologies? What makes us change our beliefs about something?

In Western culture, artists normally do not train to engage with real-life problems. They learn instead to be competitive with their products in the market place. Because we live in a society that is oriented around manic production, maximum energy flow, and upscale consumerism, profit has become the primary criterion by which we measure every good, every activity, every attitude, and every cultural product. All of our cultural institutions are subtly and lethally influenced by this ideology-based on set patterns of conventional success and its economic imperative. Artists are thus constantly being challenged in their identity as winners or losers in the success game, and "professional recognition," in the form of brisk sales and positive reviews is a primary incentive that colors the internal rhythms of art making.

So are we forever locked into the inevitability of a world view based on materialism-and with it, a certain kind of art fixated on the notion of saleable objects? Or can we recover, if we choose, from the estrangements of Western civilization? Instead of art-as-commodity, deprived of any useful social role, can art actually help us to revision ourselves and our way of living on this earth? Can we learn to participate in the "great work" of our time, which, according to the great geologian Thomas Berry, involves "moving from a devastating presence on the planet to a benign presence?"

In the dominant paradigm, art is understood mostly as static objects, existing in museums and galleries, separate from ordinary life. The work of artists who have been included in this exhibition goes against the prevailing current. It requires you to step out of line, to break with the past. Other people will feel the ripples and often, they won't like it. Make no mistake: to change the paradigm from which art operates is to change something about its fundamental nature. Beliefs tell us what is possible and what is not.

People will want to say, for instance, what do art and issues of chemical contamination have in common? What possible link can there be between concepts like

"endangered species," renewable and nonrenewable resources, or damaged forests, and the "personal problems" artists have in building a successful career today?

Until a few decades ago, artists generally were not motivated to express concerns about biodiversity, global warming, reclamation of wetlands, or acid rain in their work. Aesthetic paradigms acting in partnership with environmental impact statements was unheard of. But now, a whole cadre of artists has emerged with a new form of practice, loosely called "ecoventions."

Several years ago the University of Chicago alumni magazine featured the philosopher Richard Rorty on its cover, announcing that "there is no Big Picture." This is the very philosophy that has brought the world to the edge of eco-systemic collapse. Thus, for anyone who wants to change the tides of where our civilization is headed, the first step is to look at the Big Picture-and to become conscious of how profoundly they have internalized the values and dictates of the dominant paradigm. And then, as Annie Dillard suggests, you go home and soak your feet. Because the task at hand, the task of renewal, is very daunting-and will require a peculiar internal state which ordinary life does not induce.

If you are going to challenge the old Cartesian dualisms-like the one that separates art from life-with more participatory and engaged forms of consciousness, then you will also need a whole new language: one that expresses interdependence and reciprocity, so that the creative imagination can meet its new task. Changing paradigms is more than just a conceptual challenge: it requires that we personally leave behind certain things that have been a central part of our individual and cultural self-definitions. Hard-edged individualism will not apply. The bare white walls of the gallery and the aluminum frame will not apply. Recognizing an artist's worth through the fact of showing or not showing, selling or not selling, will not apply. The archness and bravura of postmodern aesthetics will not apply, because this art comes from a different vision. It is a vision dedicated to a single perception: how to live appropriately in an interconnected universe.

David Haley - the future and other creation myths

In water we evolved
Of water we are made
From water we are born
With water we live
To water we return
By water we may know

…time was before time that life hung by chance in a mist of water and dust not knowing which way was up as the winds drove atmospheres to spin and storm between volcanic ferocity and gravity clashing as the dice rolled a millennia or two for a few carbon atoms to meet in a droplet and then caught in the moment struck by lightning charged to live in multiple oceans of possible forms made of themselves splitting, joining and sharing each with each in seeming infinity far from equilibrium suspended in rich brine until the memory of potential fusion to become complex and diverse permutations some of whom used the sun's energy from the clearing skies to consume more carbon and issue oxygen making a new atmosphere in which to evolve as new species to become and inhabit new kingdoms but some returned from the mineral surface to enjoy their refuge in water…
…come to pass…

…time was when there was a shift in the weather, it got even warmer and the glacier stopped moving and melted where it was and life awoke as one droplet of water melted from the ice and joining another liberated droplet, they ran to a third and a forth, waited a wile for a sixth and seventh to run into them in quick succession over the ice they ran and fell and splashed, building-up behind ridges and brimmed over tirelessly joining and being joined by other drops again and again and again and again for millennia added to by the rains spilling forth to carve in the emerging ground a river channel that invented and improvised around shifting hills and through gaps joined other streams and pools taking its time invigorated by every twist turn confluence and diversion as it rushed from the mountains then meandered across the plain depositing silt and rich minerals looping back and forth to a mighty gorge where it met and spun into vortices of warm brine on a flow tide from the new ocean…
…come to pass…

…time was when it rained and rained and the aquifers filled and the river rose to meet the people watching as they spent so much of their time waiting for one in a hundred years to see if their defenses would hold against the moment and some prayed, some fled and some felt they were one with their property and refused to let go of the reassurance of re insurance so they waited and watched lifetimes in the moments of a million droplets falling that ran to the river see which droplet would be the one to break the surface tension of disbelief…
…all things come to pass…

Barbara Matilsky, excerpts from "Environmental Art: New Approaches to Nature," in *Fragile Ecologies: Contemporary Artists' Interpretations and Solutions*, 1992

The political and social climate during the 1960s encouraged a fresh approach to art and nature. As an increasing number of people began to question traditional values and governmental policies regarding Vietnam, racial segregation, women's status, and the environment, many artists began their own soul-searching. By examining art's relationship to society and the conventional materials and media of their profession, a group of artists in the United States and Europe started to challenge established assumptions about making and exhibiting art. Many turned to nature and began interpreting its life-generating forces to create radically new kinds of art. This movement became known as "environmental art (page 36)."

Environmental art relates to two other important American movementsó minimal and process artó that emerged during the 1960s. Both were concerned with extending traditional boundaries of form, space, and materials.... In contrast to the commercially fabricated materials used to create hard-edge minimal sculpture, process art was defined by nonrigid materialsó rope, fabric, lead- that could be scattered, thrown, or poured. The subject of the work was the process itself, which expressed the changeable aspects of the material and its potential to expand endlessly in all directions. In process art, the compositions were often determined by chance and the nature of the material. By allowing nature itself to determine the form and content of the work, environmental artists share many of the concerns defined by process art...

For environmental artists, nature embodied and inspired the freedom to forge new directions in art and move away from the commercial gallery system. The traditional art gallery, by exhibiting art objects and reducing them to a commodity, was perceived as limiting the artist's creative possibilities. Environmental artists joined a growing number of artists who created works that could not be purchased. This, of course, opened up the question of support and patronage. Some galleries responded favorably to the new art and exhibited indoor projects by environmental artists. University galleries and museums also provided opportunities to survey these new developments. The most important consequence of artists freeing themselves from dependency on the gallery was their beginning to work in the public domain, a fertile forum for the creation of ecological art (page 38).

During the wave of environmental activism of the 1960s and 1970s, many artists reestablished a link between people, plants, animals, and the elements of nature. Using a new vocabularyóthat of nature itselfó artists interpreted the processes, variations, and internal rhythms of the earth. These artworks often changed according to the seasons, times of day, and atmospheric conditions.

...Artists who addressed the processes of organic growth and other natural phenomena shared many of the same concerns as the earliest artists, who were awed by nature's powers and attempted to capture them through art and ritual. Environmental artworks continue an ancient tradition founded upon the symbiotic relationship between people and nature.

Although all environmental artists contributed to fostering a new awareness of nature, some were more ecologically conscious than others. Within the movement's diversity of approaches and range of attitudes, environmental issues were interpreted and solutions proposed or implemented to restore nature and revitalize the cities. From this new consciousness, ecological art would continue to evolve and expand in new directions (page 55).

Curator of the ground-breaking exhibition, "Fragile Ecologies: Contemporary Artists' Interpretations and Solutions," Barbara Matilsky is currently the curator of exhibitions at the Ackland Art Museum, The University of North Carolina at Chapel Hill.

Elizabeth Thompson, The ART of WHOLE SYSTEMS
GLOBAL CONTEXT
Noted futurist Duane Elgin identifies five Adversity Trends currently in full force
planet-wide: climate change, species extinction, population growth, resource depletion and poverty. If we take seriously the magnitude of these trends we are surely faced with what has been called a Whole Systems Challenge.

SYSTEMS THEORY
While each of these trends can be examined individually, as has been the case historically, Systems Theory provides a useful lens through which the inherent dynamic relationships between these trends can be understood. In brief, systems theory is able to account for the complexity and interdependence of all phenomena, and the embedded relationships between them. This includes both the internal properties of the system, as well as its external relationship to the environment; the latter of which includes space, time, viewer and society. Systems theory can be applied directly to an interpretation of the work included in Ecovention. The artists work collaboratively with biologists, community planners, educators, engineers and others, and employ innovative interdisciplinary problem-posing and problem-solving strategies to 'render' the work. The resulting installations reveal to us the complex web of dynamic interrelationships between natural and human systems. The art occurs within the relatedness and interaction between all parts of the system. The artist becomes active agent/strategist/ inventor and facilitator of a larger interactive process of social and environmental change.

From EARTHWORK to PLANETWORK
Artists involved in the land art and Earthwork movements of the late1960s and 1970s looked at the earth primarily as a 'resource' material for their work, engaging the land as a sculptural medium, concerned primarily with formal sculptural issues. This relationship to the earth recapitulated the prevailing cultural notion of the human being's distinct 'otherness' from the natural world, a solipsism which literally paved the way for a staggering exploitation of the earth's "endless" resources. The work in this exhibition directly challenges this notion and demands a humbling, Copernican shift in our perception of the human being's relationship to the earth, of the earth's fragility, and of the vastly complex planetary system in which we participate.

PARTICIPATORY AESTHETICS
Inherent in the perceptual shift required to engage this planetwork is what has been described as an aesthetics of participation. In this context 'participatory aesthetics' describes an art that is no longer a space for the personal subjective realm, but an art that seeks to re-integrate the human being into the larger ecological system within which he/she is embedded. It requires the surrender of an exclusively human-centric worldview in order to fully engage its meaning. This is an art and art practice that seeks to find a new relevance for itself in the face of enormous global challenges. It is an art that responds to the new understandings in science, philosophy and psychology that form the basis for an emerging 'new paradigm'.

The ART of WHOLE SYSTEMS
The artist as active change agent directly confronts the whole systems challenge we face as an earth community. Employing systems theory strategies, the artist creates an interactive 'space' in which the role of 'viewer' as passive consumer is transformed into that of active participant in an ongoing interdependent relationship with the earth's fragile ecosystems. The work inspires new understanding of the crucial role the artist plays in the creation of a sustainable future. It is a clarion call we must urgently heed.

I am indebted to Hans Dieter Huber and his essay The Artwork as a System and its Aesthetic Experience, 1989, delivered at The University of Florida and at The University of Texas at Austin, for this explanation of Systems Theory.
Gablik, Suzi. The Reenchantment of Art, London: Thames and Hudson, 1991

Section 12

index

This section cites key terms and indicates on which pages they can be found.